# THE INSIDERS

Ignorance may partially explain the masses' dislike of modern art, but there is also a vague distaste for something in it which they feel to be betrayal.

—ANDRÉ MALRAUX

Has ever a great work of art been breathed into existence wanting those formal elements which are now esteemed for their skeletal selves? . . . All art is propaganda. All art is tendentious. The communication of an artistic idea is an act of propaganda. . . . Cant is what we must excise, not content.

—LEONARD BASKIN

There are amateur artists, but no amateur humans. An artist is a human being with a particular talent for revealing himself. . . . To understand that which is outside of oneself one must plunge inwardly, and to understand that which is inside one must look outwardly.

—JAMES KEARNS

I made up a story once, of Duerer, Michelangelo and Gruenewald, painting from the same model. After a while Michelangelo says to Duerer, "What's that scratching noise, Al? And where's Matthias?" and the model finally lets on. "He's crawled right under my skin and inside me," she says, "and now he's scratching, trying to find his way out."

—RICO LEBRUN

The error of modern art lies, most often, in giving priority to the means over the end, to form over content, to technique over subject-matter.

—ALBERT CAMUS

SELDEN RODMAN

# THE INSIDERS

*Rejection and Rediscovery of Man*
*in the Arts of Our Time*

LOUISIANA STATE UNIVERSITY PRESS

# OTHER BOOKS BY SELDEN RODMAN

*Verse*   THE AMAZING YEAR
THE REVOLUTIONISTS
THE AIRMEN
LAWRENCE: THE LAST CRUSADE
MORTAL TRIUMPH AND OTHER POEMS

*Art*   CONVERSATIONS WITH ARTISTS
THE EYE OF MAN
PORTRAIT OF THE ARTIST AS AN AMERICAN
RENAISSANCE IN HAITI
HORACE PIPPIN: A NEGRO PAINTER IN AMERICA

*Anthologies*   ONE HUNDRED MODERN POEMS
ONE HUNDRED AMERICAN POEMS
WAR AND THE POET *(with Richard Eberhart)*
THE POETRY OF FLIGHT
A NEW ANTHOLOGY OF MODERN POETRY

*Travel*   HAITI: THE BLACK REPUBLIC
MEXICAN JOURNAL

Copyright 1960 by
Louisiana State University Press
Library of Congress Catalogue Card Number: 60-15433
Manufactured in the United States of America
Designed by Adrian Wilson

*For Carole*

# Contents

THE INSIDERS / vii

# Contents

# PART ONE

*The Rejection of Man*

# 1

## *Definitions*

We live in an apocalyptic age, but we are not the first to do so. Apocalyptic periods before us have produced great works of the spirit—works which signaled an emergence from darkness. Other times of crisis yielded supinely and left the record of their despair in labyrinthine decoration or tinkling symbol.

On the face of it, our civilization has already taken the line of least resistance. Truth, like mass and motion, is widely believed to be relative. Once established values, in morality as in physics, are overthrown. Aesthetics, in the same storm, drifts rudderless. Substitutes for quality become more accessible. The hypnosis of mass-media, the sterility of mass-living, the ever widening abyss between producer and consumer, and the ever present warnings of annihilation place a premium on a "High Art" that either celebrates chaos or ignores the threat of it.

Violence, neoprimitivism, compulsive doodling enlarged to dwarf human scale are accepted modes. Between the "dandy" riding high and the "beatnik" riding low, the "philistine" millions consolidate their identification of art with irresponsibility.

The typical artist of the age, instead of endeavoring to close the gap, rejects humanism. He identifies tradition with academicism, prizes innovation as an end in itself, and regards every form of social protest except the anarchic gesture as propaganda. He equates compassion with sentimentality and communication with advertising. He has become like Narcissus except that even his own image is too disturbing to confront; he studies the mystery of his handwriting or the ripples in the pool.

A growing number of artists, less esteemed by the taste of the time or entirely neglected, refuse to submit. They are creating an art of total commitment—and in the grand manner as artists like them always have. But the

fact that they are creating an art *about* man and *for* man does not imply that men are prepared to accept it. For a very long time now the public—inclined by the times to passivity in all its appetites—has been hypnotized by the apostles of an art of no-commitment into believing that humanism is an indecency. It follows from such counsel that the most decent art is one that eliminates the image of man entirely. The meaningful arts of the past must be explained away as mere manifestations of inventiveness—technical "break-throughs" in a presumptive and niggling concern with form for its own sake. To admit for one moment that the great artist has always been an idealist-moralist whose works have exerted their sway over lesser men by the passion of his will to communicate belief would be to admit the bankruptcy of modern art.

The contemporary artists whose art is most consistently based on such a will to communicate are the "Insiders" of Part II of this book. I have tried to avoid using the term "Outsiders" to describe the dominant formalists of Part I because the term has already been used—with quite a different meaning than I would give it—by the English literary critic Colin Wilson in his book with that title.[1] An Outsider from my point of view is an artist who makes noncommittal statements, whether in the modes of realism, abstraction, or subjective automatism.

What is an Insider?

An Insider is an artist who feels drawn to values outside himself strongly enough to examine them in his work.

Since "values outside himself" is taken to mean concern with the human condition, the Insider expresses that concern in some form of representational imagery, or (in the case of arts with abstract means) in an aesthetic vocabulary evocative of that condition.

Since humanism, from Greece through the Renaissance to the present day, has found varying but related means of expressing man's will to be godlike in tragic conflict with his bestiality and mortality, the Insider steeps himself in tradition, regarding his particular form of expression not as a defiance of the past but as a creative re-expression of the same aspirations.

---

[1] "The Outsider" as defined by Wilson is a sensitive modern man who "sees deeper" than the benighted Middle Class (or Hollow) Man, reading his subway ads in a glaze of incomprehension. This Outsider's depth of vision permits him to see only "chaos." He wants to be more free than anyone has ever been in history—free to think and do as he likes, to take his life, to destroy others—even for no motive at all except to express his freedom. Wilson's ingenious attempt to make "Outsiders" out of such profoundly engaged Insiders as Van Gogh and Dostoevsky is carried out by reading autobiography into such of their characters as symbolize despair and by completely ignoring the moral passion that informs their works as a whole. Behind Wilson's inability to discriminate between moral passion and nihilism is an intellectual snobbism which paralyzes creativity in almost every field of Western life today. His assurance—that the uncultured, those outside the pale of the *avant-garde*, are "not merely without purpose or direction" but *dead*—is the essence of true Outsiderism as I would define it.

## Definitions

Believing neither in "progress" (which assumes the inevitability of an un-realized and therefore abstract future) nor in "reaction" (a return to other styles as exotic escapes from present reality), the Insider searches for images of truth that will be meaningful to his contemporaries.

Concerned as he must be with the possibility of communication on the widest level, the Insider necessarily believes that ways can be found of ac-complishing this without compromising what he has to say.

To such purist doctrines as Mies van der Rohe's "less is more," he replies that the accumulation of all the meaningful particulars in the world may not be evidence enough to support that ultimate definition of art contained in the words "Ripeness is all . . ."

To the action-painter's statement that "to think while painting is a form of degradation" he answers that all the clarifying thought an artist is capable of may not suffice to convert a valid intuition into a great image.

Like Spinoza, the Insider believes that the full development of man (if man is to come to grips with himself as part of a total reality) requires the rational evolution of *both* thought and feeling.

Before turning to the Insiders at the end of Part I and considering specific cases (in art, nothing else counts), a look at the misanthropes is in order. What keeps their anaemic world alive? Affluently alive! Why, for example, has the formalist revolution in its extreme phase achieved a measure of popularity—but only in the fine arts? And, by the same token, why are the "counterrevolutionaries" of a committed humanism apparently sure of their ground only in this arena? There have always been Insiders; when and why, historically, did they lose face? What has been the role of the critics in mak-ing formalism fashionable? And by what appeals to cosmic divination do the formalists themselves justify the life-denying limitations imposed upon them?

These questions—together with related ones posed by the parallel develop-ment of the other arts—I hope to illuminate in the pages that follow. This is the province of art criticism. Intuitive response to the work of art must precede anything of value that can be determined about the artist's means and intentions. But analysis of the emotional impact itself leads only to the metaphysical confusion in which art criticism flounders today. Just as knowl-edge can be communicated but not wisdom, so the courses open to the artist may be clarified but not the business of creation itself. The value of the finished product will be determined finally by the judgment of those to whose hearts it addresses itself.

# 2

## *Primacy of the Visual Arts*

It is generally recognized that *painting* has been the dominant art of the West since World War II. Sculpture, especially the new kind of two-dimensional sculpture that approximates painting, has been close behind, followed by architecture—again, the kind of architecture that derives some of its values from painting and sculpture. Literature has lagged, and new serious music is listened to willingly only by those professionally trained to hear it.

Obviously I am talking about the Fine Arts and referring specifically to the amount of vitality discernible in each. Counting public heads can be misleading. The captive audience of modern music has no bearing; nor does the approximate number of people who look at modern architecture because they have to; nor the millions who still read as distinguished from the few who participate in a modern literary experience.

The dominant position of the visual arts can only be deduced from the acceleration of interest in viewing and collecting, and from the testimony of artists in other fields. From France, where this dominance goes back almost a hundred years, the peculiar "excitement" generated by modern art has spread to almost every country outside the Iron Curtain. What accounts for this widespread enthusiasm for an expression that heretofore has attracted only the top fringe of society?

The most obvious answer is illustration—the various means of reproducing a work that by its nature is originally unique, with increasing fidelity to nuances of color and texture. But this hardly accounts for the near-popular conversion to abstract work or the amount of first-rate talent that has been attracted into creating it. The similar reproduction and availability of sound has not made *avant-garde* music popular—or fertile. Estimates of the number

of laymen who have found time to become "Sunday painters" in the past decade or two run into the millions.

This suggests a clue. Could *time* make the difference? However much the enthusiast for "row" music insists that it expresses us, and however much we may agree with our minds, making it is out of the question and listening to it is a trial; that part of our deeper nature which has learned to respond to beautiful (and meaningful) sounds rebels perforce against an hour of "serial dodecaphony"—or any other kind of cacophony. Architecture exists in time, too; there is no getting away from it: one must live in it and with it. A sculpture must be walked around or handled. And even the most ethereal of poems takes time and effort to read and must not outrage the conscious mind by a total abstraction from sense.

Painting alone defies time. It *may* "grow on us," revealing hidden meanings or details that escaped initial inspection. But if it does not dissolve our resistance in the very first look, something is wrong. For in that instant of contact, as in no other art, we are assailed, at once, by everything that is there. If it does not exist as a totality, it does not exist at all.

It follows that one-dimensional painting—painting without content, without meaning, without depth, even without color—is possible. It is possible, and it can give pleasure. Every child makes it, and it is open to every adult to try to approximate the same spontaneity. But it does not follow from this that painting limited deliberately to conveying no more than the initial charge is the only kind of painting, or the best. Still less does it follow that painting *with* content, meaning, depth, in addition to the necessary impact which the sum of its parts must communicate, is inferior. I hope to persuade the reader later on that multidimensional painting is superior. But the question that comes up now is: why does our age prefer the one-dimensional?

The answer may be that the part of the "educated" public which bases its taste, in "other-directed" fashion, on the preference of the tastemakers follows the line of least resistance. The pressures in our period against anything requiring emotional involvement, thought, study, preparation, *time* are massive. The artist himself is subject to these negative pressures. In a world which lives from moment to moment, bent upon extracting pleasure quickly and cheaply before the holocaust, he paints that moment. Details, anatomy, inner truth are beside the point. If science's search for certainty finds its modern resolution in the principle of indeterminacy, may not visual ambiguity resolve the visual struggle? If relativity indicates that an object or event truly exists only in time, does it make more sense to represent it at a fixed point, as we see it, or as the fluctuating sum of its movements? The telescope and micro-

scope reveal the unattainably far and near; why not focus on these and ignore the messy creature in the middle distance? If man's need for religious truth or ethical principle can be answered on the analyst's couch by an exposure of the child-savage in him, what deeper truth can the artist reveal than the uninhibited scrawls and slashes of his own "natural" self?

Something of this reasoning underlies the present-day evolution of all the arts, but in the case of painting the abandonment of logical construction, representative forms, and moral content began long ago. In revolt against the factual sententiousness of the all-powerful academies, artists in France even before Cézanne were writing their own declarations of independence; they were proclaiming their right to create in defiance of any social, moral, or aesthetic conventions. The development of photography only confirmed their resolve to make a visual world answerable only to the laws of the artist.

# 3

## Form and Content in Western Art

The evolution of modern art repeats, in seemingly more extreme manifestations, the evolution of Western art itself. There is no "progress" in the sense that the word may be applied to the exact sciences, since qualitative values are involved. Every age has its own conception of beauty, and the artists of different ages who give form to that conception approach each other in stature to the degree that they communicate memorable depth-perceptions of their visions across the ages. Societies freely governed by a sense of purpose—religious, moral, political—tend to find expression in arts reflecting these faiths, just as societies without belief and given to complacency or fear beget—generally speaking—an appropriate imagery of noncommittal shapes or ambiguous demons. But "determinism" does not apply either, and because art (more than any other human activity) is a product of the individual conscience, exceptional nonconformists have always been able to defy the common climate of their time and thus initiate change.

Before coming to the exceptional nonconformists of today and the changes they may be expected to initiate, let us review briefly the cycles of pictorial formalism that have preceded formalism's extreme (nonobjective) phase in the dominant art of our time.[1]

Early Christian or Byzantine art resembles the Modern in its dehumanized grandeur, its lack of interest in appearances and objects, its emphasis on texture and flat patterns, its substitution of dematerialized "style" for content

[1] The strenuous efforts being made by critics to give this phase a universal, exclusive pertinency, and to bolster their contention by pointing to a presumptive strain of antihumanism in the arts of the ages, are discussed in Chapter 4. Much of the material in these two chapters is taken from Selden Rodman, *The Eye of Man: Form and Content in Western Painting* (New York: The Devin-Adair Co., 1955).

embodying human values or celebrating the world of nature. Like ours, it was the expression of the world viewed as a mystery and doomed to imminent material destruction. Byzantine art sprang from the world-despairing philosophy of Plotinus, whose followers rejected empirical knowledge. The artists who practised this dematerialization were decorators—sometimes sublime decorators—and while it has been truly said that it took as much genius to forget man in Byzantium as to discover him on the Acropolis, we cannot lose sight of the fact that this was the art of a disciplined caste subservient to authority and speaking to the people only in accents of grave warning or unearthly pomp.

Change, which takes place in our time almost overnight, in the Middle Ages required centuries. By 727 A.D. all representation in art was officially banned, and concentration on the play of geometric and floral motives took over, merging with the already encroaching decorative arts of Islam. Only in the monasteries, suppressed but not wholly extinguished by the emperor who wished to keep the priesthood his vassals and sacred art a means of maintaining his absolute power, were the monks still turning out icons with a remnant of pagan sensuality or decorating manuscripts with an irrepressible emphasis on natural forms. Not until the eleventh century did the fantasy and overstatement of the Romanesque pillar with its fabulous monsters emerge from the undifferentiated stream of decoration into the great dramas of the Last Judgment and the Passion in which the whole community is brought to trial. The individual participants in the Gothic portals of Autun and Moissac impress themselves upon us by the most inventive devices of facial distortion and exaggerated gesture. The fortress-like abbey yields to the soaring cathedral in whose building the whole people joyously participates. Malraux, who approves or at least accepts the anti-human foundation of modern formalism, nevertheless admits that the portrayal of a fully human woman (the Gothic Virgin) was Christianity's supreme discovery in art and had a stronger emotive appeal than idealization or symbolism or abstraction.

At the very threshold of the Renaissance, Giotto, who for the first time in painting expresses religious content in terms of visual actuality, prefigures the next period of formalism. In the great cycle of frescoes at Padua the story of Christ is told in terms of human values, and these values are conveyed by human forms. Mary watches the Ascension not in ecstasy but with sorrow. In the Pietá the eyes of every participant are focused on the body of Christ. Every gesture, every expression, every fold of drapery conveys sorrow. Yet in spite of this spiritual content, there is apparent something wholly un-Gothic, something that foreshadows five centuries of factual form-making. The figures are less individualized than those of the Autun tympanum, more

idealized than the saints of Rheims. These for the first time are *figures in space*, almost sculptural masses, and only Giotto's compassion, true to the ideals of Gothic thought, gives them tragic meaning. Giotto himself, the friend of Dante and the follower of St. Francis, was no materialist, but the materialism of commercial Florence begins to be felt. Florence wanted to be shown not mysteries but its own fleshly image.

It was not long before this fleshly image—how to render it "accurately" and finally how to project it without "distracting" human implications—became an end in itself. As early as Masaccio's "Crucifixion" of 1428 one is less impressed by the religious content of the picture, though it is rendered with deep feeling, than by the manifold illusions the artist has created. When Masaccio, in company with Brunelleschi and Donatello, rediscovered the statuary of classical antiquity, it was a discovery predetermined by the general loss of faith that had swept over Europe in the early fourteen hundreds.

The painting of the great and various artists of the latter half of the fifteenth century is characterized by a religious content almost devoid of religious conviction. It is significant that Filippo Lippi, the monk who seduced a nun and was indicted for forgery, never lost face either in the Medicean court or before the Church. Ghirlandaio's sumptuous Biblical frescoes were conceived more as settings for the introduction of a court favorite or mistress than as aids to worship. Michelangelo was incensed by the patent spiritual insincerity of Perugino's religious pictures, but Perugino's generation was not. The pageantry of Benozzo Gozzoli, the antiquarian spirit of Mantegna, the athleticism of Signorelli reflected without provoking protest the preoccupations of the Renaissance. It is noteworthy that the subject—if indeed there was a subject—of Antonio Pollaiuolo's epoch-making engraving of nude swordsmen has been forgotten. What appeals to our time in the painting of Piero della Francesca (whom Berenson calls the prototype of the universal artist, the purpose of whose art is to *be* rather than to represent) is his ability to paint the Christian story with exactly the same detachment he paints a marble façade or the portrait of one of his murderous patrons. Scientist and atheist that he was, Leonardo da Vinci treated his religious themes as human anecdotes, bringing out first by the geometric relationships and gestures of his figures and later by the play of light on their features, the meaning of their dramas. But in all his pictures, characteristically unfinished or fragmentary, the real protagonist is the artist himself, independent of the Church, alienated from society.

Leonardo was the friend and confidant of princes. Raphael and Titian were the first artists to become great lords themselves. They painted their secular allegories in churchly palaces but consulted no one except their dilettante

friends on questions of content. Since the Popes of the High Renaissance were seeking to glorify themselves rather than God through art, the religious images could be (and were) cold, intellectually self-contained, erudite, and out of contact with the people. In place of the *Quattrocento's* emphasis on the concrete, the direct, the homely, this art expressed physical and intellectual superiority. Although, as Hauser[2] points out wryly, we now praise it for the "universality of its appeal," it was actually "dedicated to the solution of sub-limated formal problems."

Michelangelo was the first of that lonely line of painters—it includes Tin-toretto and Greco, Gruenewald and Rembrandt, Rouault and Orozco, Rico Lebrun and Hyman Bloom—to paint a religious cycle inspired by acute personal experience and opposition to reigning complacencies, both spiritual and artistic. The agony of humanism begins. The Sistine ceiling, and to an even greater degree the "Last Judgment" on that chapel's end wall, with its "modern" connotations of rage, despair and propaganda, cannot be wholly understood without reference to the religious revival pursuing its course "underground" in the fifteenth and sixteenth centuries.

This revival, which assumed the form of Protestantism in northern Europe, found its most ardent spokesman in Rembrandt. Like the great Pieter Bruegel before him, Rembrandt sought the eternal in the most common objects and events of everyday life, and like Rouault in our time, he is most reverent (because most compassionately Christian) when painting sinners. Rembrandt's thematically religious pictures are distinguished by their sympathy for the subjects as suffering human beings—an understanding that perceptibly grows as the artist's fortunes wane, thus increasing their poignancy as autobiography and, in this fusion of the real with the visionary, making Rembrandt the greatest painter of expressive content the world has ever known.

It was in the same year that Rembrandt's art was being rejected by the burghers of Amsterdam that Poussin, the outstanding painter of seventeenth century France and the ancestor of modern formalism, was leaving Paris for Rome. Poussin, whom Cézanne two centuries later was (in his words) to "revivify upon nature," went to Rome, not only to absorb the classical, but to escape from a native environment momentarily hostile to it. Several years later the French Academy was founded, and although Poussin posthumously was to become its hero, in 1648 it sanctioned nothing but the then decadent and bombastic tradition of the Baroque. Poussin's obsession with logic and

---

[2]Arnold Hauser, *The Social History of Art* (New York: Alfred A. Knopf, Inc., 1951).

order must be appreciated against the background of a century that gave birth to the philosophers of rational enlightenment and witnessed revolutionary discoveries in the sciences, especially optics. In our time, similarly, it has been the revolutionary discoveries of Einstein and Freud that have provided the two major streams of modernist art, abstractionism and surrealism, with their antihumanist foundation. But Poussin's age of formalism is concerned with compositional geometry, the ostensible subject-matter becoming less and less important as he struggles to integrate forms with color, colored forms with landscape, and finally nature with space itself.

The century of increasingly formalistic disengagement which followed Poussin's death in 1665 is summed up in the art of Jacques Louis David, the painter of the French Revolution—and Napoleon. It is David's distinction to have been so fundamentally a child of the eighteenth century that he could express nothing of the greatest upsurge of sensibility and libertarianism in history except its doctrinaire cult of the Romans. When David painted Brutus he copied Roman sculpture directly. When depicting a bacchante he sent to Rome for an "authentic" coiffure. When he was painting the "Sabine Women" he said: "My purpose in creating this picture was to paint ancient customs with such exactitude that the Greeks and the Romans, seeing my work, would not have found me foreign to their way of living." David had the sensibility of an illustrator, but his spirit, that of a go-getter, made him address himself to ever more resounding themes. When Napoleon put his foot upon the rights of man, David, who had painted Marat as a martyr and gone to jail for espousing the cause of the fanatical Robespierre, outdid himself in glorifying the dictator. David's congenital respect for authority is betrayed in his constant use of the word "imitation." "What matters truth," he wrote, "if the attitudes are noble?" And it is the cynicism of this doctrine, coupled with David's prodigious skill in neoclassical dramatic painting, portraiture, and the art of imposing his taste on a whole generation, that may account for the esteem in which this frigid painter has been held in France to this day.

The confrontation of the "classical" Ingres and the "romantic" Delacroix in the French climate of the early nineteenth century is an unreal one. Ingres' "Odalisque," with its static linear appeal and muted colors, ushered in a century of aesthetic generalization that was to culminate in pure abstraction. David Robb compares this famous picture with similar images of nude women from the past: "Ingres was not interested in textures, either pictorial or natural, like Titian. Unlike Rubens he did not make the figure the symbol of a vigorous and vital humanism . . . nor an immediate recreation of material presence and appearance in the manner of Goya's nude Maja. With-

out physical allure or the sensual appeal of texture and color of pigments, it exists first and foremost as a marvelously integrated *pattern of lines, organized to suggest solid forms in space."* [3] By 1846 the French critic Thoré was able to call Ingres "the most romantic artist of the Nineteenth Century, if romanticism be an exclusive love of form, an absolute indifference to all the mysteries of human life, scepticism in philosophy and politics, selfish detachment from all common and socially unifying sentiments."

How different actually was the philosophy of Delacroix, who is considered (and considered himself) the opposite pole of painting in that time? From his *Journal* one gets the impression that Delacroix was more obsessed with recapturing the "objectivity" of the Greeks and the Romans than was Ingres. He makes the extraordinary but typically French observation that what elevates La Fontaine above Shakespeare or Michelangelo is "taste." He considers Watteau and even Rubens "too artistic" and places Ruisdael's landscapes "at the summit of art," above Rembrandt, "because the art in them is completely hidden from view." The famous "Massacre at Scio," with its self-consciously posed figures in a picturesque setting, conjures up less an atmosphere of the horrors of war than of shopping for curios in a gypsy bazaar.

The lives of Titian or Vermeer or Matisse offer no clues to their art because their art is self-contained. Daumier's life *was* his art. Balzac and Baudelaire and (to his credit) Delacroix recognized Daumier's affinity to Michelangelo; yet he was a failure in his time and is almost forgotten in ours. "It was he," said Théodore de Banville, "who first drew nature and material objects out of their anonymity, obliging them to take part in the human comedy, where sometimes trees share in the absurdity of their proprietor, or, in the midst of a domestic scene, the vases on the table start snarling with ironic rage." But love—love for the commonplace, the simple, the eccentric, the maimed, and for republican institutions that might permit such people to achieve dignity and even heroism—was Daumier's motivation; and what could be further from the dominant nineteenth century preoccupation with light, color, form, structure, as ends in themselves?

Van Gogh's motivation was exactly the same as Daumier's, and his gifts were as great, but to be that kind of an artist in the age of Manet, Monet, Seurat, Gauguin, and Cézanne was a far more scarifying experience—and Van Gogh was less endowed with fortitude to withstand it. Desperation, neurosis, and personal tragedy become in varying degrees the burden of the humanist artist from now on.

"Art should stand alone," Whistler said, "and appeal to the artistic sense of eye and ear, without confounding this with emotions entirely foreign to it, as

---

[3] David Robb, *The Harper History of Painting* (New York: Harper & Bros., 1951).

devotion, pity, love, patriotism." Whistler's contemporaries, the Impressionists, in their effort to capture the purely visual moment, tended to waive not only expressive content but subject-matter itself. Monet painted the façade of Rouen Cathedral forty times in order merely to record the changes that took place in its visual aspect from dawn to dusk. And it was in revolt (a palace revolution) against the Impressionists' tendency to make the picture no more than an amorphous shimmer of color that Cézanne and Seurat began to re-emphasize structure.

To understand why genius of the magnitude of Cézanne's concerned itself unremittingly with problems having so little to do with life, one must remember that the intellectual atmosphere in France at the end of the nineteenth century was distinctly hostile to psychology, humanism and religion. Villier de l'Isle Adam's Axel, preferring perfect illusion to perfect reality, had already made his famous announcement that life was something his servants could take care of for him. Mallarmé was about to write that "a beautiful line without meaning is more beautiful than a less beautiful one with meaning." Flaubert considered writing a book without any subject at all. Balzac's prophecy that the artist who estranges himself from life will end by destroying art fell on deaf ears.

Cézanne's sense of mission in carrying the scientific naturalism of the Impressionists to a logical conclusion eventually gave way to his passion for uncovering an abstract geometrical pattern at the root of the visible. How he painted still life after still life, cunningly distorting the shapes to emphasize the rotundity of an apple, the verticality of a vase; how he analyzed Mont St. Victoire until nothing remained but its impressive mass; and how he left a program for the generation that was to follow in his famous admonition to look for the sphere, the cone and the cylinder—all are too well known to recapitulate here.

Passing over such compromises with expressive content as are to be found in "reactionary" painters like Rouault, Soutine, Munch, Ensor, and certain of the German Expressionists, let us conclude this survey with a glance at Matisse and Picasso, the twin giants of dominant formalism in the first half of the twentieth century. They are the mother and father, so to speak, of the formalists of today.

Matisse's career began in the early 1890's when he became a pupil of Gustave Moreau and made a living copying pictures by Poussin and Chardin for the government. During this decade, interiors and still lifes were almost his only subjects. In his own work he was influenced by the Impressionists and Gauguin; but the big event of Matisse's artistic life (which is to say, of his life, for even his travels were uneventful and undisturbing to him) was

his discovery and purchase from Vollard of a small Cézanne. This picture, we are told, completely eclipsed for him Van Gogh's "l'Arlesienne" at the same gallery. "Expression in my way of thinking," wrote Matisse in 1908, "does not consist of the passion mirrored upon a human face or betrayed by a violent gesture." His aim, he said later on, was to paint pictures "free of disturbing subject-matter—like a comfortable arm-chair in which one can recover from physical fatigue."

Few will deny that he succeeded. All Matisse's subsequent art reflects the attempt to synthesize an instinctual response to visual reality with the architectonic equilibrium of Cézanne. The variation in his style may be traced to fluctuations in these two modest impulses: the will to indulge in liberating experiment, always formal, versus the need for discipline and security. Whereas in Van Gogh, and even to a certain extent in Gauguin, the colors and figures which form patterns are juxtaposed for psychological reasons, in Matisse the visual-pictorial effect is everything. In fact, a studied attempt is made to *dis*relate the figures in a landscape, one from another, in order to heighten the scene's illusion *as a painting*. Put philosophically, there are objects in Matisse but no subjects. The difference between this art and pure abstraction is very slight, and one is not surprised to find Matisse—in the cut-out-paper forms of *Jazz* (1944-1945)—experimenting with nonobjective shapes.

It may seem surprising that the nonobjective painters of New York in the late forties came to regard Matisse rather than Picasso as their true master —but not if one considers Picasso's eclecticism. The fact is that the lifelong search for formal innovations has been so compulsive with Picasso that he has not hesitated, in ransacking the arts of the ages, to draw upon the styles of the masters of expressive content themselves when it suited his fancy.

One should not be misled by the resulting works to think of Picasso as a humanist. The charades of Bohemian poverty derived from Lautrec in his Blue Period, the ambiguous portraiture of cubism and neoclassicism, the cutout caricatures of "Guernica" with their subtle references to Goya and Gruenewald, and the variations he has played from time to time on de Chirico and Velasquez—all bear witness more to Picasso's legerdemain than to his heart. The unprecedented skill with which the forms of Africa and Iberia, Greco and Uccello, Raphael and Rousseau were assimilated; the taste with which each successive assimilation was presented—and the cunning timing with which it was abandoned just as the dazed art world was preparing to accept it—amounted to genius. But it was the genius of an actor or a magician, not of a dramatist or a seer.

# 4

## Art for Art's Sake: The Critics

When Clive Bell's *Art* appeared in 1913, art criticism, in the English language at least, had pretty much confined itself to a scholarly appreciation of the arts of the past. Bell (and his friend Roger Fry, who had already written his famous *Essay in Aesthetics*) put an end to all that.

Bell began by asserting that the only quality common to every work of art—from a Persian bowl to a Cézanne—was "significant form" and that there is no way of recognizing such a quality except through "our feeling for it." His mention of Cézanne and, elsewhere in the book, of Matisse and Picasso, who were not only then virtually unknown outside of France but at the very thresholds of their careers, served notice that from then on the critics would call the turn and that the *avant-garde* could be depended on to hatch their cerebral eggs.

Bell's book was epoch-making in other respects. It established once and for all the assumptions of modern formalism:

The representative element in a work of art may or may not be harmful: always it is irrelevant. For to appreciate a work of art we need bring with us nothing from life, no knowledge of its ideas and affairs, no familiarity with its emotions. . . . The pure mathematician rapt in his studies knows a state of mind which I take to be similar, if not identical.

Bell went on to contrast the "cold, white peaks of art" and its "austere emotions" with the vulgar attitude of the public, poking about blindly in "the snug foothills of warm humanity." Henceforth, not only the human should be eliminated from art, but all detail ("the fatty degeneration of art") and all informatory matter ("In a work of art nothing is relevant but what contributes to formal significance.").

Looking back over the past, one is not surprised that Bell found the high point of European art among the sixth century Byzantines of Ravenna. In

the seventeenth century Poussin rather than Rembrandt or Rubens was naturally "the greatest painter of the age." ("You will notice that the human figure is a shape cut out of colored paper to be pinned on as the composition directs"—thirty years after Bell wrote this about Poussin, Matisse, as already noted, was to do exactly that.) As for poor Rembrandt, he was "a typical ruin of his age," losing his sense of form and design "in a mess of rhetoric, romance and chiaroscuro." Even Giotto, in Bell's canon, was hopelessly mired in content. ("He was always more interested in art than in St. Francis, but he did not always remember that St. Francis has nothing whatever to do with art.") Giotto was so "dreadfully obsessed," poor chap, "by the idea that the humanity of mother and child is the important thing about them." Cimabue "was incapable of such commonness." Was it not clear from this perspective that "since the Byzantine primitives, no artist in Europe has created forms of greater significance unless it be Cézanne"?

The most admired art critic of the past half century, Bernard Berenson, follows Bell in most respects, but because of his having a greater knowledge of art and being a philosophical humanist, his inconsistencies are more glaring. Since he began writing at a time when Ruskin and the Pre-Raphaelites had conditioned the public to think of painting entirely in terms of illustration, Berenson was naturally concerned to emphasize form—"tactile values" he called it. He was also inclined, from his close association with Italy, to go along with Benedetto Croce and the Italian aestheticians in upholding the instinctiveness, spontaneity and even "irresponsibility" of the artist in the act of creation. "He (the artist) indulges in the free play of his gifts and has nothing else in his head."

But conditioned very likely by his childhood in peasant Lithuania and proletarian Boston, Berenson the humanist could never quite rid himself of the nagging notion that a great artist should be a mouthpiece (even a popular mouthpiece) for great ideas. Could he have had Thoreau or Whitman in mind when he said that a poet must not only perceive the object but live it? The feeling that artists like Giotto, Raphael, and Goya were popular not merely for meretricious reasons disturbed him. Perhaps, he says in one essay, it was "because they created greater visual myths."

In his more guarded moments, however, Berenson was a typical spokesman of the new age of formalism. Art must be "intransitive," stimulating no desires nor appetites. It must not be a cry from the heart. It must not traffic in indignation or pity or tears. Greco is outlawed from this paradise of passivity for his "melodrama," Bruegel and Bosch for their "mild nastiness." Giorgione and Titian, the great Venetian formalists, are "the Keats and Shakespeare of painting." And finally Berenson states the credo of formalism

itself: "Real artists do not bother about feeling and vision, but only about learning how to draw and paint in a more satisfactory way."

There is some question whether even this last traditional ingredient of art has any point in the latter-day refinements of formalism as practised by the New York schools of geometric and abstract-expressionist nonobjectivism. Clement Greenberg, their leading advocate in terms of priority and articulateness, begins his defense with the axiom: trust your instincts. Admitting that everyone misses something in abstract work, he contends that most contemporary efforts to put image and object back into art result only in pastiche, parody, or the pseudo archaic. (The trouble could be, though Greenberg doesn't suggest it, that to paint image and object convincingly one must feel them, be sure of their relevance in a meaningful vision of life.) Greenberg assumes that the only thing we miss in nonobjective painting is the illusion of a three-dimensional world. It never occurs to him that what we miss is the emotional communication through visual symbols of spiritual and communal content.

More recently Greenberg has extended his defense with the argument that abstract art offers a unique "compensation" for the materialistic production and "purposeful" activity of Western life. It challenges, he says,[1] our capacity for disinterested contemplation:

It can teach us, by example, how valuable so much in life can be made without being interested in ulterior motives. . . . [It provides] the archexample of something that does not have to mean, or be useful for, anything other than itself. It gives us no imaginary space through which to walk with the mind's eye. . . . We are left alone with shapes and colors. . . . It expands our capacity for experience.

But does it? Only if we are content to go through life with the sensibilities of children. Only if our "capacity for experience" is to be lowered and limited to the amoeba's phototropic reception of "shapes and colors." Only if we have given up trying to humanize the materialistic and extend the areas of our "purposeful activity." Abstract art, outside any historical context, having meaning only in itself, is nonsense. Experience has meaning *only* in context, and only by being *interested* in that context and its meaning can we expand our capacities.

The only other extensive attempt to provide latter-day formalism with a philosophic-aesthetic base would not deserve serious consideration were it not currently so influential. It comes from Thomas Hess, editor of *Art News*, one of the two art magazines (both of them committed to abstract expressionism) that dominate art criticism in America. The fact that the editor of

---

[1] Clement Greenberg, "The Case for Abstract Art," *Saturday Evening Post* (August 1, 1959).

the other publication, Hilton Kramer of *Arts*, refers to his rival's writings as "flimflam," "garbage," "an insult to the intelligence," and "not a language in which it is possible to tell the truth about anything" indicates (accurate as the description may be) the hopelessness of the reigning confusion. Kramer's own criticism is too destructive to be susceptible of analysis. Hess's, if more obscure, seems to be generated by a positive enthusiasm.

Hess begins by attempting to pull the rug from under the humanists. He gathers the old masters into his fold. Being dead, they cannot protest. The feeling of satisfaction a spectator takes from an orderly Pieter de Hooch interior comes, Hess tells us, not "from any recognition of moral character or fidelity to historically ascertainable conditions, but from the fact that these forms and this paint are one and the same. . . . This art of an orderly society is indeed for art's sake, for only then can it be for anyone's or anything's sake." By isolating a fragment of a late Titian pastorale, Hess makes the further point that even this great formalist's modest content is irrelevant: "The thin, sticky flecks and streaks of pigment weave into a surface which is never so much sky, tree, deer, or hand, as it is an overwhelming affirmation of the existence of the artist's material." It follows from these examples, Hess continues, that what makes us enjoy a painting "has nothing to do with its species of subject, the accuracy with which this subject is represented, or the moral, political or subconscious motives of the artist." Indeed "the appearance of, and resemblance to nature in a work of pictorial art can have nothing to do with its aesthetic value, except possibly, to act detrimentally."

Expressionism, in so far as it involves painting emotion-loaded objects or situations, as Van Gogh or Soutine did, is ruled out. It is too risky. It would raise the possibility that the artist's sensations might fail to find corroboration in his craft. There is a safer way to paint pictures. "In the tranquil but vehemently flaming landscapes of Matisse and Bonnard, the tortured duality of subject and object do not exist."

But Hess does not go for tranquillity. He wants action,[2] *Sturm und Drang*, tragedy, even madness—so long as none of these is alluded to specifically or given human referent. The answer is "to make the crisis itself the hero" of painting. This is what Hess credits Willem de Kooning with doing: giving "pulse and motion to the unrecognizable" (whatever that may mean), endowing "the abstract form with tragedy or laughter, on its own terms" (whatever *that* may mean). Symbolism, as Hess calls de Kooning's "torn shape that dreams of humanity," is admissible to action painting, but only if it refers

---

[2] This term for the Pollock-de Kooning style of nonobjectivism originated in Hess's magazine. Lee Mullican, one of the nonobjectivists, was described by *Art News* as bringing to the attack "an uncontaminated frame of mind . . . Form, color, composition, drawing can be dispensed with. What matters is the revelation contained in the act."

to the act itself. Is such a gymnastic possible? "Symbols acquire added meaning (Hess is now talking of Adolph Gottlieb's primitivistic pictographs) from the increasingly complicated act that made them, *and they refer mainly to it.*" (My italics.) This, says Hess, is the place where Mondrian joins Soutine, and where Picasso can be left behind. The painter is not only painting the crisis; he *is* the crisis. Mark Rothko makes his unadorned rectangles of light eight feet high because, as he himself explains, he makes "a more personal contact" with his work when it "envelopes" him. Pollock "urges the spectator to join in the paroxysm of creation." What it feels like to join Pollock in this experience is testified to by Hess. "One feels," he says, "like the statuettes inside glass globes that, when shaken, are filled with snow flurries." [3]

Because there are no extra-aesthetic standards in the formalist criticism, judgments are wholly subjective. As in the cavalryman's evaluation of war, the object seems to be "to get there fustest with the mostest." There is no possible way of explaining what makes a good nonobjective picture good, nor a bad one bad. Thus when Greenberg asserts that Pollock's drips and skeins of paint add up to great art, but that the works of other artists painting in the same manner are less than nothing, we have to take his word for it. At least his way of asserting it sounds authoritative and is declaimed in straightforward English. What Hess and his fellow enthusiasts of the "poetical" school of criticism are talking about is anybody's guess. [4]

The testimony of formalist criticism could be ignored and the work of fully engaged artists permitted to emerge in good time, but for this circumstance: Not content with giving the imprimatur of their praise to the artists of their choice, the new critics have insisted from the outset that no other kind of art, no trafficking in representation for expressive purposes, is permissible. Not only have they endeavored to crush those artists who refuse to exclude man from their works, they have all but cornered the media of propaganda and are well on the way to cornering the marketplace as well— the galleries, the juries, the exhibition places, and the museums.

---

[3] All quotations in this paragraph are from Thomas B. Hess, *Abstract Painting* (New York: The Viking Press, Inc., 1951).

[4] In his latest work, a monograph on de Kooning, Hess declares that "de Kooning's paintings are based on contradictions kept contradictory in order to reveal the clarity of ambiguities, the concrete reality of unanswered questions, the unity of simultaneity and multiplicity. He does not aim at complexity nor mystery, nor exploitation by indirections; he aims straight at the mark—to grab the real by the throat."

# 5

## The Modern Artist and Science

What do the artists themselves say? Are the abstract-expressionist painters claiming to make more than abstractions—for the pleasure they derive from freely manipulating paint or from expressing themselves on this most primitive of levels? Or do they have, as the critics insist, transcendental aims, not only in respect to the history of art, but in line with an aesthetic verification of the latest discoveries of science?

Georges Mathieu, the most extreme, flamboyant and articulate of the abstract expressionists, is at the same time the one most concerned to relate his art with modern science. At the moment, for strategic reasons, it is fashionable among the critical arbiters of this school in New York to minimize the importance of Mathieu. *Art News,* which established his fame in this country by printing Tapié's "scandalous" account of the painting of "The Battle of Bouvine," was embarrassed later by the publicity arising from Mathieu's 1957 tour of Japan during which he was photographed painting pictures before cheering crowds dressed in a blue and white *yukata* and wearing a red *hachimaki* around his head.

I had read about this exploit in *Time,* which of course made the most of it, and though the opinions I had already expressed regarding the superficiality of this kind of art were reinforced, I saw no reason to condemn the pleasure its "action" must give to both artist and audience. Mathieu, for his part, was eager to enlighten me about the cosmic significance I was missing. On his way home to Paris from Japan, he stopped in New York for an exhibit of his work at the Kootz Gallery, and we met there. He invited me to watch him paint a series of replacements for the pictures in his show which had already been sold, and I invited him to my home in Oakland, N.J., where he warmed up for this feat by painting a picture on a sheet of

white masonite with which I had recently covered one of my living-room windows (Plate 1).

I had four tubes of oil paint: red, blue, black, and yellow. He asked me if I had any gasoline. We drained a little from the power mower, and he saturated a handkerchief with it. Squeezing some of the blue onto this, he made a preliminary flourish on the wall. His arm remained cocked. Mathieu turned his head. "Wait! I must go to my car. I'll be right back." Assuming that he had forgotten his brushes, I went out with him and watched as he flung open the trunk and dumped the contents of his suitcase on the lawn. "Ah!" He had found two small Japanese dolls, the kind with the wobbly heads. He rushed back and presented them to my daughter who had been playing with dolls of her own almost under his feet as he had started to paint. Rolling up his sleeve and seizing the red, Mathieu now superimposed his characteristic "sign" on the blue flourish, squeezing the paint directly from the tube. A spasmodic rasp of metal on wood filled the room. The paroxysm in which the artist was now caught up bore out what he had already told me: "When I paint, my mind must be a complete blank. No thought, no method, no deliberation, no choice." Oriana continued to play with her dolls, but while painting Mathieu was oblivious to her. Finally he stepped back a few feet, squinted at the result, stepped forward and added a black down-zag to the left and a small, decisive red circle off to the right. With another catlike movement he signed and dated the result, rolled down his sleeve and put his coat back on. I looked at the picture. It was as elegant and precise as one of the Japanese word-symbols he must have seen on a hundred shop windows a week before, and as inscrutable. I looked at my watch. Total elapsed time: one minute, fifty seconds.

The following day we drove to an office building that stands on the site of the old Ritz-Carleton Hotel. Kootz had arranged with the owner for Mathieu's use of the fourth subbasement, which had once been a winecellar. A dozen six-by-six-foot canvases and five hundred tubes of oil paint in cartons had already arrived. Mathieu arranged the canvases face-up on the floor and with some Turkish towels saturated each surface with a uniform over-all color. Then he stood all twelve against the wall and went to work, tearing the caps off the tubes with his teeth till his mouth and face were smeared with a dozen colors, tossing the empties into growing heaps on the cement floor, drinking beer from the bottle between pictures (it was a very hot day, even underground), building up his vertical and horizontal spirals of pigment. Up and over and across his arm would fly, sometimes whipping a snake of red from one end of the canvas to the other, at other times rubbing a solid

blot into the central tangle with his towel; then painting over that, and again with another color, piling complexity upon complexity. Sometimes he would throw a glob of paint into a "dead" area. And quite often (I thought) he would entirely "spoil" a bit of brilliant calligraphy, like the Oakland "signature," by not seeming to know when to stop. It took Mathieu about three hours to finish the twelve pictures; and that afternoon in an upstairs office before an audience now augmented to include the Kootzes, Saul and Hedda Steinberg and four or five others, he painted one very large canvas, perhaps six by twelve feet. I turned to Steinberg at the climax of Mathieu's action and said: "What do you think?" "I'm thinking," he whispered with a smile, "what would Ingres think."

I spent a final hour with Mathieu at his hotel before returning home. We discussed his theory of art—specifically his feeling that the artist today must explore through his intuition the "metaphysical" world of antimatter revealed by Einstein, Heisenberg, and de Broglie. Mathieu showed me letters he had received from all three of these physicists purporting to confirm the validity of this approach. Why? His answer was stated by James Fitzsimmons in the foreword to the Kootz show:

The contemporary artist has only one choice to make: will he live today or in the past? If he will live today, he abandons all preconceptions concerning the characteristics and means of art. He becomes like the modern physicist, aware that he can know nothing in itself and nothing in advance.

Ignoring for the moment whether this openmindedness has not always characterized the scientific spirit and whether it has anything to do with art, here is what Mathieu and his colleagues seem to be saying about the relation of their aesthetic work to nuclear physics:

The most diverse fields—modern mathematics from Cantor and Godel to Norbert Wiener, microphysics from Bohr and Heisenberg to Burckhardt Heim, literature from Joyce to Cioran and from Beckett to Ionesco, the plastic arts from Tobey and Pollock to Wols, music from Varèse to John Cage—all seem to bring us progressively nearer to a pre-Socratic outlook in which the thought of Plotinus, Dionysus or Nicholas of Cuse find up-to-date application in systems of logic such as that of Lupasco, and fit in just as well with the Celtic bases of our civilization as with the Zen or Taoist aspects of oriental civilization.

Thus wrote Mathieu, in a foreword to an issue of the *Paris Review* devoted to "New Trends in Western Civilization" and edited by him. There follows a dozen abstruse papers on science and metaphysics by, among others, Denis de Rougemont ("From Nicaea to the Atomic Bomb"), Matila Ghyka ("From Pythagoras to Heisenberg"), Hideki Yakawa ("Elementary Particles

and Space-Time Structure"), Philip Morrison ("The Overthrow of Parity"), C. G. Jung ("Synchronicity as a Principle in Causal Relationships"), etc. André George of the Poincaré Institute contributes an exegesis of Heisenberg's latest formula. After discussing a Greek-letter equation for a "non-linear parameter in the Lagrangean System," Professor George concludes guardedly:

We are on the verge of a difficult and highly technical domain where the ordinary reader is already lost, whereas the initiated will soon find the development inadequate. . . . The reader may wonder what are the philosophical consequences of the new concept, particularly in respect of atomic indeterminism. At the present time it must be admitted that *no relationship can be discerned between this domain and the theory in question.* (My italics.)

Now it is admirable that Mathieu (or any other artist) should seek to relate his art to the philosophic climate of his time. And it would be even more admirable if the scientist-specialist took any cognizance of art. But Mathieu's choice of contributions and his own statements indicate no real understanding of either science or the scientific method. Nor does a single one of the scientists marshalled to testify in defense of nonobjective art give the slightest indication of ever having looked at a picture. Far from being intimidated by Professor George's hesitancy, Mathieu draws his own inferences. "Previously," he writes, "signs were always invented for things; the thing came first, and a sign was created to designate it. Today the sign comes first, and will endure (and therefore really be a sign) only if it finds an incarnation for itself. . . . From the Ideal to the Real, from the Real to the Abstract, we pass from the Abstract to the Possible. . . . The sign must come before the meaning attached to it!"

After rejecting both the kind of abstraction that results from the reduction of an identifiable object to its essence, and the geometric kind, Mathieu pays his respects to the pioneer abstract expressionist, Wols, "for revealing the vacuity of Western tradition that had placed man at the center of his preoccupations." He salutes Tobey for his Orient-inspired "white writing," and among critics Sir Herbert Read, the pedantic English facsimile of Messrs. Hess and Greenberg.[1] "Art," Mathieu concludes his Foreword, "is the intuitive realization of the vacuity of existence."

---

[1] "The artist," says Sir Herbert Read in *Icon and Idea* (Cambridge: Harvard University Press, 1955), "must now create . . . images of a possible new world." This quasi-totalitarian idea of "progress" in the arts carries with it a basic antihumanism. In *The Tenth Muse* (New York: Horizon Press, Inc., 1957) Read objects to Suzanne Langer's definition of the artist's function to "create forms symbolic of human feeling." "Mrs. Langer," he says, "pays little attention to the possibility of unconscious motivation . . . artists have always spoken rather as if angels had dictated to them." Furthermore, he adds, "The word human, which looks so innocent in the definition, is a little suspect—if the Pyramids are works of art, what human

His first witness, Mounir Hafiz, bears him out. In a paper entitled "Introduction to an Era of Apparitional Forms," Hafiz invokes the Dark Ages. "Myths, religions, philosophies, sciences, have sanctioned a fundamental error, namely that man exists." At the "summit of all research" one must now place "alchemy . . . a science to which the finest minds of every age, and especially our own, have devoted themselves." And since it follows from this thought that there exists in truth "only one science, the science of metaphysics," man "has no need at all to know himself in order to manifest himself. His domain is the impenetrable night of absolute imperation, that turbulent thunder cloud where asylum is sought by all there is, and whose fulguration, which is history, simultaneously separates and unites, in its green fire, the dawn and the twilight of everything whose birth is sudden and nocturnal and thus originating the man of vision whose presence is apparitional."

From this Wagnerian cloud the last three contributors to Mathieu's symposium—Greenberg, speaking for painting, Pierre Boulez for the *avant-garde* composers, and Pierre de Boisdeffre for literature—emerge to testify almost rationally. Greenberg even admits with a dash of American common sense that "were the arts to become entirely themselves and nothing else, they would vanish." Would it be unkind to suggest that this may have happened already?

Boulez, whose specifically musical contribution to antihumanism will be discussed in Chapter 9, describes compositions which, since they have neither beginning nor end, are "globs of time." This leads us, he says, to a conception of creation "in which the 'finished product' is not the composer's responsibility." Chance is introduced into the work, and we therefore have "closed space—beautiful objects contemplated in uselessness and torpor."

De Boisdeffre contends that, for a truly modern literature to manifest itself, both subject *and* form must be destroyed. "The story is pointless, for it gives an illusion of liberty in a world that has no basis or object." After "the

---

feeling do they symbolize?" Then Read counters with his own definition: "The work of art symbolizes nothing but an intuitive apprehension of found relationships. . . . The significance of a work of art, be it a painting, a poem, a statue, or a sonata, lies in its formal organization. The work of art is not a stimulus to evoke feelings, nor a signal to announce them; it is a logical structure corresponding to the pattern of sentience."

Now no one denies the importance of spontaneity and unconscious motivation in a work or art, but can one imagine Blake or Mozart abandoning the proper contributions of thought, intellectual discipline, and tradition while engaged in being spontaneous? Isn't the *insistence* on this ingredient of the whole creative process one of the things that is compounding the present aesthetic chaos? Another is antihumanism. The Great Pyramid of Cheops is no more art than one of Euclid's Propositions. It is solid geometry. And the constructions of Gabo, Pevsner, and Mondrian, which Read places at the apex of modern aesthetic achievement, are limited to being masterpieces of design precisely because they, too, fail to communicate "human feeling." In the great works that speak to humanity, and not just to other artists, it is not the "angels" whose "dictation" we respond to, but the supreme consciousness (and conscience) of men. We respond because we all share, to some degree, these same two human traits.

silence of Rimbaud, the blank page of Mallarmé, the inarticulate shout of Artaud" and "the interminable monologues of Beckett, Faulkner and Joyce," what hope is there of achieving "pure amoralism"? "Even if the terms appear discutable, we have to recognize that modern art is permanently tempted by suicide, because suicide is the permanent temptation of the whole of our civilization."

I tried to get from Mathieu a clue as to what his "signs" signify. He began by telling me how he started to paint. "At first," he said, "came copying of postcards showing London by night. That was to get the feel of it, without any pretensions of subject or method." From there, he said, he jumped without further preparation into his present style—"which doesn't require any technical background or transitional period, since expressivity alone counts."

I told him that what gave me pleasure in his work was its decorative-improvisatory aspect. I mentioned the Baroque.

"The Baroque originated because men were tired with classicism. But I hate the Baroque precisely because of its addition of elements for decoration alone—*without necessity.*"

"Isn't there 'necessity' in painters like Kandinsky, Mondrian, Dubuffet? Yet you don't like their work either. Hasn't their automatism or search for primordial purity something in common with yours?"

"Kandinsky was a fourth-rate painter because with his means he conveyed so little. Mondrian, whom I like even less, conveyed the maximum with his means—but that means was so mechanical! Dubuffet will not figure in the history of painting because he merely fulfills a momentary need with his pseudo naïveté. He is more interested in matter than in form. He broke with Picasso, but he's at the end of the figurative world—"

"Whereas—?"

"My work is directly conditioned by the evolution of painting—and I do agree with Malraux on one point, that art builds on previous art. People in caves could have made Dubuffets, but not Mathieus."

He mentioned, among Americans he liked, Steinberg and Louise Nevelson. "Of the Italians, Burri—out of Schwitters—is the most interesting, because with such little means he is so meaningful."

"Then there is meaning in your signs?" I ventured.

He answered obliquely. "When the sign equals the signified, we'll be ready for the academy. Now that I have a vocabulary, my business is to destroy it and move on."

"To where?"

He answered in French. "*Les choses les plus evidentes sont les moins evidentes.*"

"You don't have to speak to me in French paradoxes."

"All right. For the first time in history a sign is made before its signification. The *idea* of the teapot preceded the teapot."

"Not according to your friend, Sir Herbert."

He laughed. "O.K. But now in art, as in science, the sign is made first and its significance decided upon later. I asked Dr. Yukawa, the Nobel Prize physicist, in Tokyo whether he was a determinist or a probabilist. Naturally he was a probabilist."

"Naturally," I said, "but isn't applying the laws of probability to painting like applying it to cooking, or driving a car, or choosing a wife, or bringing up a child? Even the scientists don't apply it except in fields where reality is too distant or too minute to be apprehended by the senses. Painting is a matter of the senses, of visual perception conveyed with manual skill, of the here and now evaluated in depth."

"But I agree with the Gestalt theory as giving a *raison d'être* to lyrical expressionism. You *can* react to something to which you have no sensory reference. Abstract expressionism is a direct language. Sooner or later it *will* appeal to the man in the street."

"Of course," I said, "but not for reasons given in your philosophy, Horatio! It will appeal once the man in the street stops looking for photographic 'likenesses' (or humanity!) and permits himself to enjoy your descriptive shorthand because it reminds him of our world of high speeds, high tension, night driving, ballistic orbits; your *controlled* madness of toothpaste-white and black tar on crimson. For you do control it, whatever you may think—or nonthink—to the contrary, just as an Oriental controls his long-practised and traditional brushmanship, Zen or no Zen."

"Well," he said, "I share with the Oriental artist these qualities: speed, nonpremeditation, psychic energy, but that is not the same as relating a language one doesn't know to another language one doesn't know—as people who say my work looks 'oriental' do."

"*Touché!* But Georges, one more question. In the Orient it seemed right for you to put on an act, even in a shop window. It was ceremonial and neighborly. But here, even your colleagues are beginning to wonder whether you can mean what you say and paint what you believe. Actors are not taken seriously off the stage."

"I know," he replied. "I take risks of ruining my reputation. There are things more important to me. I love adventure. I enjoy painting in public. Why should I hide the excitement I am experiencing?"

## The Modern Artist and Science

I liked that answer. I liked Georges Mathieu, the man. I responded to the unpremeditated act and its honest image, even if its "excitement" remained his, not mine. I have always responded in the same fashion to the unpremeditated signatures of Gottlieb, Kline, de Kooning. But why can't these artists leave it at that?

What connection is there between the scientist's compulsion to add a little to the respected accumulation of collective knowledge and the wholly individualistic "dandyism" of the Mathieus, so well expressed in Marcel Duchamp's ambition "to depreciate our ordinary and tacitly accepted notions of value in order to exalt the strictly private and sovereign choice which is accountable to no one"? Even should one ignore this discrepancy, there remains a fundamental unlikeness between the activities of man as a seeker after "natural" truth and man as a communicator of his emotional perceptions. "I spent many years in the study of the abstract sciences," Pascal wrote bitterly, "and the small amount of human contact which they afforded filled me with disgust. When I began the study of man I found that the abstract sciences were not suited to humanity, and that I was drifting farther from my proper condition by my knowledge than other men were by their ignorance."

Mathieu contends that this separation no longer exists, that the modern physicist has become a mystic, and that the modern artist now joins him in exploration of a universe beyond good and evil, unsubject to reason. Ignoring the fact that a scientist who believed that nothing was explicable would perforce retire, Mathieu likes to remind one of Keats's cultivation of what that poet called "negative capability . . . that is, when a man is capable of being in uncertainties, mysteries, doubts, without any irritable reaching after fact and reason." But Keats in the same famous letter also said:

I find there is no worthy pursuit but the idea of doing some good to the world. Some do it with their society; some with their wit; some with their benevolence; some with a sort of power of conferring pleasure and good humor on all they meet—and in a thousand ways, all dutiful to the command of great Nature. There is but one way for me. The road lies through application, study, and thought.

# 6

## *The Artist as Antihumanist*

Mathieu's American counterparts, whatever they may say,[1] are contributing to as great a limitation of art. Pollock may have graphed the cosmic turbulence in a more visceral way; Clyfford Still may come closer to visualizing "non-history" in its geologic barrenness; Rothko may have invented a more reticent radiance; Kline a weightier, more primitive protest; Tobey a denser, more sensitive description of energy; but all of them—and along with de Kooning, Gottlieb, Marca-Relli, David Smith, and the artists I am about to discuss these are the most ingenious abstractionists we have— by rejecting nature and man, have cut themselves off from the most fertile domain of art.

Some would deny any such rejection, but in rare instances where identification with nature or man takes place, it is readily recognized. In such a relatively early, quasi-impressionist picture as his "Edge of August," Tobey carries the viewer with him into a common experience. When de Kooning feels so strongly about even such a marginal emotion as hatred for the perverted aggressiveness of modern woman as to paint it, there is no doubt about what he is communicating. And the same goes for David Smith in his spikey symbols of war, fear, loneliness and anxiety. But these artists now apparently reject even this trifle of tainted humanism. What, then, is their general aim?

American abstract expressionism, though tending to be much more anti-intellectual than its French cousin, has attempted on several occasions to express these aims verbally. One such recent formulation was contained

---

[1] And few deny it. See Selden Rodman, *Conversations with Artists* (New York: The Devin-Adair Co., 1957), for the testimony of Tobey, Gottlieb, Pollock, Kline, de Kooning, and others. Rather than requote them here, I have chosen to augment the evidence by interviewing for this chapter some of the equally articulate painters of the same school.

## The Artist as Antihumanist

in the publication *IT IS: A Magazine for Abstract Art*. The lead article (1959) was entitled "The American Sense of Space on Space":

The Cubists left poised in mid-air the major art problem of the century. Their failure to reduce their space experience to a purer abstraction became the constant challenge to all original minds. . . . The answer to the challenge to refine space was born on Eighth Street. . . . We now know that the presence of an object in a painting intimidates space. . . . All artists have four elements in their inner make-up. . . . Just as the Greeks reduced nature for simplicity's sake to fire, water, air and matter—so we can reduce the nature of art to drawing, space, color and light. . . . The sense of second space itself becomes purer and more exposed only as it rejects the application of causes and effects (history). Non-history welcomes the turns, twists, and surprises of spontaneity.

Henry ("History is the bunk") Ford would have approved the know-nothing pragmatism of this conclusion though hardly, of course, its aesthetic application. Whether "non-history" will welcome it depends on whether civilization follows this self-styled *avant-garde* in totally abjuring the use of the conscious mind. ("To think while painting," writes painter Bob Richen-berg in the same publication, "is a form of degradation.")

The extent to which civilization in the past half century *has* rejected both reason and humanism is of course the prime factor in the climate of instability in which such an aesthetic can flourish. The narrow margin by which Hitler failed to impose his particular rejection of "the application of causes and effects" on all of us may seem difficult to recall. The man-made earthquakes of two world wars and the extermination camps seem to have left most artists and writers today with only a stupefying sense of hopelessness. They express neither rebellion nor compassion. They turn inward upon themselves, back to the tribe, to the prehistoric cave (painted, preferably), and to the womb.

"If I have a slogan," writes Jack Tworkov, one of the most respected of the New York school (in *IT IS*), "it is no committment; at a moment when there is admittedly little common ground, the best morality is not to have any. To will decision and clarity is to invite getting stuck with the mere appearance of it."

Tworkov was the first of these artists I talked to. In his case I hoped to find out why an artist who can (and still does) make classic drawings of the human figure abandons "decision and clarity" in his major statement— painting. During Tworkov's show, when I talked to him, the drawings were tucked away, as if apologetically, in an inner room. The paintings, as uncompromisingly "empty" as any abstract-expressionist work, hung defiantly in the

main gallery as if to invite "philistine" disapproval. Unevenly parallel strokes of color, against a ground of another hue, form sometimes a grid and sometimes an open arrangement, à la Kline, but less "menacing" in effect (Plate 2). The colors are generally muddy and not sharply contrasted. There is no elegance in the application of paint, as in de Kooning's abstractions of the late forties; no arrogantly majestic patches of color as in Gottlieb or Rothko; not even any specialized gesture of negation as in Newman, the artist interviewed next.

When I remarked to Tworkov that his pictures seemed to lack the personal trademarks that make these various styles readily identifiable, he explained his refusal to exploit what comes naturally to him in the moment of truth they all seek. "The other day, for example," he said, "I painted a picture that some of my friends found exciting. I had been excited myself by the ease with which it had come to me. This disturbed me. My friends' reaction disturbed me more. Much to their chagrin, I painted over it and changed it until it said something right—something I hadn't said before, something much less obvious, perhaps."

I was not surprised that Tworkov finds the painting of a humanist like Lebrun academic, or that in reply to a question about the poetry in a Wyeth he should reply, "I understand what he's trying to convey in literary terms, but the painting itself doesn't convey it." I was more surprised that Tworkov did not respond to the poetry of Mirò or Picasso, but perhaps it is logical that he should prefer the more "painterly" painters—Soutine, and above all Cézanne. Cubism and surrealism, he made clear to me, should be regarded as interruptions in the main line of expression, interruptions whose influences had been for the most part "unimportant." It is not a question of representation nor nonrepresentation—Tworkov feels that a nonabstract painter like Edwin Dickinson is painting significantly today, presumably because his "arrangements" of figures and objects are composed in such a way as to convey no "message." Perhaps it is precisely this! But then what of the artists of the past, artists Tworkov *does* respond to, whose "messages" cannot be ignored? "Isn't Rembrandt's greatness," I asked him, "at least in part his communication of deep characterization and love for man?"

Tworkov did not think so. "You can't possibly look at one of Rembrandt's portraits," he said, "and say anything specific about the character of the sitter. You can only say that through this vehicle, by such devices as eliminating the sharp outline of the face, referring from the object to the background and vice versa, Rembrandt finally did manage to make a great statement. Any student today can be taught to reproduce such effects in a few lessons. There is no challenge in doing over and over what has been done so

completely before." I mentioned Gruenewald. "The compassion you feel he communicates," Tworkov said, "the violence of suffering, would in the hands of a lesser man result in tear-jerking sentimentality. Only the great artistry of Gruenewald survives. And today, as in music throughout the ages, we are learning how to project artistry directly, without any limiting reference to objects or literature, or to subject-matter at all. That is why it is so endlessly rewarding to paint today. The challenge is so great, and so largely unfulfilled."

I do not question Tworkov's sincerity or the sincerity of any of his fellow abstract expressionists who do more than imitate each other. Nor do I deny that these artists find it "challenging" to paint nonobjectively. Nor do I deny, to quote from an earlier conversation I had with Gottlieb, that the challenge may indeed be "so largely unfulfilled" as to allow variations and elaborations over "a thousand years." Nor do I deny that the Lebruns and Wyeths dare the risk so many figurative painters fall prey to—of "doing over and over what has been done so completely before" and of coming out with "tear-jerking sentimentality" (though I think Lebrun and Wyeth have generally avoided both traps). But how false is the contention that the timeless artistry of the Rembrandts and Gruenewalds can be detached from their humanism, their interest in human character, their compassion and how blind is the belief that artists without any desire to communicate these emotions, or even to feel them, can (by the manipulation of mere paint, mere forms, mere objects, or for that matter mere "images of man," new or old) produce an art that will similarly stand the tests of time.

Barnett Newman is the extremist among the second (geometrical as opposed to spontaneously expressive) branch of the New York school of action painters, the branch that has been aptly described by Emily Genauer as favoring *inaction*. A typical Newman canvas, "Cathedra" (Plate 3) in eight feet high by seventeen feet, nine inches long. Its over-all dark blue is bisected near the center by a vertical white stripe a few inches wide and near the right end by a somewhat narrower bright blue stripe. That is all. This, according to Greenberg who wrote the foreword to Newman's 1959 show, "is part of the splendor of American painting in the past decade and a half." Newman's art "is all statement, all content; and fullness of content can be attained only through an execution that calls the least possible attention to itself. We are not offered the dexterity of a hand or the ingenuity of an eye. Skill and ingenuity cannot convey directly enough what has to be said."

What *is* being said? Critic does not say. Painter does not say. That would be vulgar in either case. "A poem should not mean, but be"—from which it

follows that the less it means, the more it *is*. Or, applied to painting, the less there is to look at, to distract one from the over-all impact, the better the picture. To convey a specific emotion—or even a vague one—how indelicate! "We are not offered the dexterity of a hand"—what could be more inartistic than that an artist exhibit artistry?—"or of an eye"—blindness is obviously the ultimate gift. "There is no program, no polemic in these paintings," Greenberg continues. "They do not intend to make a point, let alone shock or startle."

But unfortunately for this point of Greenberg's, Newman himself was at the show. When I asked him bluntly what he was trying to prove, he answered, "I've licked Mondrian; I've killed the diagram." You can't be more programmatic than that!

Or frivolous, come to think of it. It was clear to me from the rest of my conversation with Newman that this artist's major, perhaps *only*, preoccupation is to make an original statement. The evolution of geometrical abstraction being what it is, such a statement could only be an *emptier* one. Newman's anxiety took the form of insisting (perhaps with good reason) that *his* emptinesses came first—before Mark Rothko's, long before Ad Reinhardt's. "Reinhardt," he said bitterly, "merely fills up the corners of his pictures. He makes *designs!*" And that, I gathered from what he had already said to me about Mathieu, was the worst that could be said of any artist.

The fact remains that Mondrian did make impressive linear divisions of the picture-space—even beautiful ones—while Newman does not. Mathieu's "signs" vibrate with the artist's autointoxication. Rothko's patches of light do glow and pulsate and "envelope" one. Reinhardt's black crosses on near-black, like Albers' squares within squares, exert a hypnotic power over the retina. But to call even these "fullness of content" is to abuse language—and to deny the whole history of art.

I asked Newman whom he felt he was communicating with. "Myself, primarily," he said frankly. Then he added, "Perhaps after the act with the small band of creators who form one of the two divisions into which our world today is divided—the other being the philistines."

If only the art critics, who profess to speak for these artists, could be as refreshingly honest.

This much was clear. After Tworkov and Newman, action and inaction painting have nowhere to go. By process of elimination, originality per se has arrived at a vacuum. Even Gottlieb, so sure of the next thousand years, is repeating himself with "burst" after burst. Younger "geometricians" like Ellsworth Kelly display a real genius for layout (Plate 4), but how many

people who hang these blown-up posters of asymmetrical symmetry on their walls are going to want to live with them day after tomorrow? The only "new" gimmick in a terrain increasingly blasé to the *sine qua non* of modern art—shock—turns out to be at least as old as Marcel Duchamp, the Founding Father who gave up fifty years ago.

I visited Robert Rauschenberg, the foremost exponent of this new Dadaism, in the studio he shares with Jasper Johns, renowned for his meticulously painted "targets" and "flags." Rauschenberg's new look is typified by a fairly run-of-the-mill action painting in fierce reds and blacks which lies flat, just off the floor; what is new about it is that in the center stands a stuffed angora goat with a beat-up automobile tire around its stomach and a dab of paint on its nose. This "combine," which I had seen before, was now in the studio (Plate 5), together with others. One of them featured a stuffed chicken in a coop in front of which a pair of white beach shoes containing socks had been cemented into sand. Another was a shadow box containing a small academic landscape of the tropics in front of which dangled a brick dirtied with tar. Perhaps because I spent some time in Paris during the late twenties—at an age and in a time when any gesture flouting the status quo seemed worthy of support—I still find this sort of thing amusing. At least it provides material for conversation and looking, more than can be said of the nonsurrealistic forms of abstract expressionism.

"Some people read hostility to nature into this," said Rauschenberg, pointing to the brick. "But I placed it there simply for balance and the sense of reality." I asked him why the goat's nose was smeared with paint, and his answer was the same: "Because the goat had been damaged when I bought it, somewhat impairing the natural dignity of the animal—which was what attracted me to it in the first place. The smears not only cover the damage but emphasize the goat's integral note in the combine as a whole. Similarly, the brass nameplate fixed in the canvas came with the goat, identifying the woolen company that had had it stuffed as a display. That belonged."

"And the small ball fixed to the canvas?"

"Gives the eye a sense of transition between the flat canvas and the vertical goat." (It didn't give me any such sense.)

While Rauschenberg was attempting most articulately to define his aims, I took down the remainder of our talk verbatim:

R.R.: Surrealists, by forcing real objects into an unreal context, feed the imagination, whereas I try to present a number of objects or surfaces as free of any preconceived or personal intentions as possible.

S.R.: For what purpose?

R.R.: I *think* . . . to present them and let them exist with their own identities

instead of making them serve any purpose I might consciously decide upon. Thus the richness of associational values they may have is permitted to exist on as many planes as it can support.

S.R.: And you, the artist . . . ?

R.R.: I myself want to remain the spectator. I'm as much surprised by what happens in these combines as anyone. I've made them so that they can't be bought as "examples of my work" or as "investments." They have to be lived with. I hope they have an insistent presence.

S.R.: They have.

R.R.: I don't want painting to be taken for granted because then it gets involved with the sweeter side of life. Like money you have in the bank. I'd rather it be like the money you spend than the money you save. So the permanency of my combines isn't an important consideration.

S.R.: Do you like any of the representational painters?

R.R.: Yes. Larry Rivers especially. The paintings of "Berdie" are wonderful.

S.R.: How about Wyeth?

R.R.: I don't find there's any place for me to listen. He's giving me a lecture with everything spelled out. The situations and subjects are too exotic. I prefer the commonplace.

Both painters—Johns entered the studio at this point—insist that they paint compulsively, without any conscious aims or sense of what is happening while actually working. Johns says: "My primary concern is visual form. The visual meaning may be discovered afterward—by those who look for it. Two meanings have been ascribed to these American Flag paintings of mine. One position is: 'He's painted a flag so you don't have to think of it as a flag but only as a painting.' The other is: 'You are enabled by the way he has painted it to see it *as a flag* and *not* as a painting.' Actually both positions are implicit in the paintings, so you don't have to choose."

Johns pulled out a smaller painting, gray on gray with a gray wooden knob inserted near the top on which hung an ordinary wire coathanger, also painted gray. "This," he continued, "is not surrealism. I feel that what I am doing is quite literal. Some labeled it neo-Dada, which made me rush to the library to find out what Dada actually was. I still don't know, except that it seems to have been given shape by a political agreement of some sort. As for me, I'm only interested in *looking* at things, not in deciding, with other artists in conference, what they ought to be." [2]

---

[2] Since this book was finished, a brilliant critique of neo-Dadaism has appeared in the form of a column by Emily Genauer of the New York *Herald-Tribune*, April 3, 1960. Reviewing a show of Rauschenberg's combines and adding a note or two on the related efforts of Jasper Johns, John Cage, and others, and on the latest import from Paris, a show entitled "Construction and Geometry in Painting—from Malevich to Tomorrow," Miss Genauer concludes: "The doors of art swing so quickly these days that one must be careful not to get caught in them. One of the things the early Dadaists were protesting was the antiseptic purity of Mondrian

## The Artist as Antihumanist

It is unnecessary for me to say again that these artists, too, are serious and dedicated. Within the context of abstract expressionism, which accepts the larger modernist canon of visual exploration as the end of art (adding only that noncommunication and the destruction of form itself be added to the criteria), they are imaginative. But what a poor little world is left. The tragic nobility of Masaccio's Adam and Eve, the boisterous brawls and battlefields of Bruegel, Renoir's carnival of glorious wantons and Rouault's savage indignation at the betrayals of the spirit reduced to some smears on a stuffed goat's nose. Giotto's angels, Rembrandt's parables of the good life, Goya's terrible sermons against inhumanity, terminating in—what? I stepped up to John's "Target." Was I missing some hidden meaning, some ineffable secret? I opened one of the lidded boxes that adorn its top. It contained a plaster cast of a penis.

---

*et cie.* Now we have the purists being projected as a protest against the Dadaists.

"As a matter of fact, neither movement is actually concerned with art itself, only with its means. . . . The choice, as I see it, between the purist geometry and the Dadaists' shenanigans (and there are always in all schools the exceptions who rise above their isms) is the choice between a broom and the mess it sweeps out. It's the room itself that matters. It can contain 'infinite riches'—or nothing."

# 7

## The Artist as Metaphysician of God

One further branch of modern formalism remains—that presided over by the artist who employs sharp-focus realism to make an equally nonhumanist statement. In this third branch Salvador Dali is still the acknowledged master. On the surface nothing might seem more antithetical than the frenzied "signatures" of Mathieu, the void supercanvases of Newman, Rauschenberg's trumped-up world of chance, and the meticulously "academic" religious subjects of the Catalan surrealist (Plates 6, 7). But in each the ultimate appeal is to unreason. If art is not for man's sake, then it is for God's sake—or, to use the terminology of our less devout age, for art's sake. And since neither God nor Art can approve the contract (nor designate, as man can, which artist speaks truly or falsely in its name), these artists and their critics invariably invoke metaphysics.

I had been struck by the uncanny resemblance of the personalities of Mathieu and Dali long before meeting either of them. (I discount the flair for "publicity" in both artists, a proclivity one must try to disregard in assessing the value of their art.) Both subscribe to the code of "dandyism," sporting flamboyant moustaches and dressing extravagantly. Dali's gold vest and cane are the counterparts of Mathieu's wine-colored gloves and painting regalia. Both believe in hereditary monarchy, deplore humanism, dismiss rationality. Each believes that his kind of painting is in tune with nuclear physics and God. Dali's position was expressed most persuasively in the course of an electrically-taped conversation I had with him in 1959, of which the following constitutes extracts:

R: You speak of the decadence of modern art. Are you of the opinion, then, that your early work contributed nothing to that decadence?

D: Yes, I am also included in this decadence, but I can say something in my defense. It is that I am probably one of the only modern painters whose

work has never practised distortion. For me the photographic likeness is most important.

R: It seems to me you distorted all the time. You took a leg or a spoon and drew them out to extreme lengths; you took a face—

D: No, no, very sorry, this is not distortion.

R: You put a set of bureau drawers in somebody's stomach—

D: No, this is absolutely not distortion.

R: What is it?

D: When I create a soft watch, or a one-kilometer-long leg, I copy absolutely in the most honest and photographic manner one of my visions.

R: Picasso, when he distorts a figure, will undoubtedly say that it corresponds with his vision.

D: The greatest artists, Praxiteles, Vermeer, Velasquez distort almost nothing. The vision is the nearest possible to photography. When some distortion appears, in one way or another, it is weakness. Beauty is fortitude, and characterization is weakness.

R: What you have just said is based on the assumption that the only great artists are artists like Praxiteles, Vermeer and Velasquez. I agree that these are great artists, but for me they have less to say than the artists who give in to the "weakness" of characterization and employ a greater distortion, artists like Rembrandt, Gruenewald, El Greco, Rouault and Orozco.

D: It's extraordinary and significant that you name the painters that, among the great, I consider the worst.

R: I assume that. Because the ones you name are most concerned with idealized appearance and least with the truth of human emotions as expressed through distortion.

D: It is very interesting, this conversation. As for me, I believe that the most human and most divine Christ is the Christ of Velasquez. And the worst that exists in the world is Gruenewald's. Why? Because Velasquez expresses the most divine feelings and emotions and Gruenewald the weakest and ugliest, the most bestial. Every time they call a painter an "expressionist" it is because he has nothing to express.

R: Well, I think, on the contrary, that Gruenewald brings out the reality of Christ in a way that those other painters don't even approach. His Christ is a suffering human being who is exhibited with all the scars and wounds and the torture of his life on this earth; and therefore the person who gets in contact with that picture is close to reality, close to his own situation as a vulnerable human being.

D: Velasquez expressed something a billion times more important. He expressed the beauty of God.

R: I don't agree with you that Gruenewald's Christ is without beauty. Our difference is that you want a glazed representation of the ideal Christ and I want an expression of Christ the sufferer with whom a human being can identify himself.

D: I don't mean that I want a pretty Christ. I talk of beauty in the sense of the work of Praxiteles. Everyone recognizes instantly what I mean by beauty.

When you look in a street, a very beautiful woman passes by, and everyone recognizes that she is beautiful. Sometimes this degree of beauty is too frivolous or too prudent. There are many different levels of beauty, but if the Christ of Gruenewald walked down Madison Avenue, everyone would think that he was the ugliest man they had ever seen.

R: That is because the photographic, the ideal, figure as you depict it is exactly what appeals to the man on Madison Avenue, the man who is looking for the blandest, *least* expressive beauty.

D: Tragedy is a thousand times more violent, more impressing, more categorical, and more metaphysical when it happens to a very beautiful body. The sacrifice of Christ is more moving in Velasquez because the body of his Christ is supremely beautiful and young. But if the same tragedy happened to a very ugly human body, its meaning would diminish.

R: To enlarge the argument, do you approve of the mystical, nonobjective expressionism of painters like Tobey or Mathieu?

D: Yes, completely. Because there is no distortion at all in their work. In my opinion these people create microcosmic structures corresponding to the new nuclear physics, and these lines and patterns are absolutely photographic. You can look at a scientific photograph of the movement of nuclear particles and a painting of one of these artists, and the two compare favorably.

R: Do you make a distinction between their kind of abstraction and the less mystical pictures of, say, de Kooning or Picasso?

D: I approve of these painters, too, in so far as they do not touch the human face or body. When the abstract expressionist reproduces the trajectory of a proton or other microphysical particle in motion, he does something that corresponds exactly to the "brush stroke" of Velasquez. The pictures by de Kooning that depict weakness by caricature are interesting, but I like de Kooning's pure abstractions better. As for Picasso, I think that he is most outstanding in his early analytic cubism.

R: In other words, you like de Kooning least when he introduces the human situation.

D: Yes. I like very much his brush stroke, the collision of colors.

R: Well, I think he is more interesting when he is dealing with the human image, because then I feel he gives me his feelings about life and about himself. When he is dealing with paint, or action painting as they call it, he is so far inside himself that he doesn't make much contact with me.

D: But then he is more in contact with God.

R: This is something that I can't say, whether or not he is in contact with God. And I can't argue with you about metaphysics because I don't understand it.

D: There has been published recently a book on Pascal, written by M. Scholtens under the title *Etudes Medico-Psychologiques Sur Pascal.* It is a very scientific approach to the definition of beauty. The author is not at all an art critic. The criterion that establishes his hierarchies is not arbitrary nor based on culture or personal taste, but on scientific principle. And among the works of beauty he reproduces is my "Christ Crucified" at the Metropolitan that you don't like very much.

## The Artist as Metaphysician of God

R: Are you accepting the judgment of a scientist on the aesthetic validity of your art?

D: Yes, because only scientific people understand my work. The art critics know nothing about art because they know nothing about the theory of quanta, nothing about protons and electrons, nothing about antimatter and the energy of decay. They know nothing about the equation of Dr. Heisenberg.

R: The layman, including the intelligent art lover, doesn't know anything about physics or metaphysics either. How then can these painters be, as you say, expressing their time?

D: The man in the street knows by intuition the existence of mystery. When he sees a Vermeer, without being an expert he knows that behind this so-called coolness there is a tremendous strength. But the modern art critic, deformed by his culture and erudition, lacks intuition and is not at all receptive to this kind of phenomenon. The critics who like Picasso's "Guernica" cannot understand anything else because they are accustomed to this kind of grandiose caricature. The tragedy of our times is the dematerialization of substantial things. Matter no longer exists; only energy exists—and perhaps not even energy. There remains only a mysterious relationship between mathematical values. . . . In man, the only kind of emotions that interest me are those that are close to God. My ambition is to paint an angel.[1]

One of the few contemporary critics of stature who responds affirmatively to Dali's religious pictures is Alexander Eliot. Eliot makes the best case any critic has so far made for the "metaphysical" properties of great art. Eliot, like Dali, goes back to Vermeer as a precursor of modern abstractionism. The masters who preceded Vermeer, he says, were wont to exalt "mind-sight" over "eye-sight," often leaving the executions of their forms to apprentices. Not so Vermeer who "abdicated intellectual control in favor of some other power. . . . Vermeer kept rejecting the world of his imagination until it came back naked and invisible, to stay forever, storyless and impossible to grasp. It is not so much a mystery, this third world, as a non-mystery. It cannot be understood and yet it makes itself understood. . . . Vermeer had left out everything except what he could see. Mondrian did just the opposite: he left out everything that he could actually see. . . . The physicist, clawing and banging at his atom, is another such puritan. He digs for unknown principles within the here and now." [2]

In the period between Vermeer and Mondrian, Eliot asserts, artists had kept on painting ideas as before, but life and true significance had fled: "The

---

[1] *Controversy Magazine* (May, 1959).

[2] Alexander Eliot, *Sight and Insight* (New York: McDowell, Obolensky, Inc., 1959). Eliot does *not*, as the abstract-expressionist critics do, make metaphysical attributes the sole criterion for greatness. He honors, as they do not, contributions of the heart and intellect. But for the purposes of the discussion I mention here only Eliot's metaphysical claims—claims in support of which he sometimes neglects his other criteria.

time had come for a newly active and honest art, *far removed from the darkened fields of contemplation.*" (My italics.) All that remained, after the Impressionists' shift from "mind-sight" to "eye-sight," was for the subject-matter itself to be eliminated. All the Expressionists contributed, according to Eliot, was to do "ecstatic violence" to the details along the path of that elimination.

This reasoning, which permits Eliot to read "humanism" into the works of Vermeer and Dali on the one hand and into the works of the abstract precisionists Mondrian and Albers on the other, seems to me questionable on several counts.

First, metaphysics. I simply don't know what Eliot is talking about in this passage about Vermeer. If Vermeer leaves out "everything except what he can see"—I agree that he does, but would add that he *selects* from this seen world only what is not disturbing, what contributes most poetically to the clarity of the world seen through the wrong end of a spyglass—then how can his pictures be "invisible" or abdicate intellectual control "in favor of some other power"? This is Dali's language also—and Dali, whatever he says, is among the most deliberate and intellectual painters who ever lived.

Second, science. This persistent confusion is puzzling. Would it have been proper for Newton to have exalted the apple, or become angry with it for bouncing off his head, or eaten it? As a scientist his business was to deduce the law of motion that made it fall and the law of inertia that made it stay put. The artist's function is exactly opposite: to savor the particulars, to put himself into the equation, to explore the human implications, and with his five senses to *act*:

> *Who talks with the Absolute salutes a Shadow,*
> *Who seeks himself shall lose himself;*
> *And the golden pheasants are no help*
> *And action must be learned from love of man.*[3]

Third, man. To see the Expressionists simply doing "ecstatic violence" to subject-matter along the path to its elimination is to confuse the means with the end, form with content, the frenzied egocentric with the tragedian of the frenzied ego. The true Expressionist—Van Gogh, Barlach, Kollwitz, Kokoschka, Rouault, Orozco—was on the contrary conducting a counter-revolution against nineteenth century formalism, a counterrevolution in defense of heart, "mind-sight," communication.

"There is a tendency," Eliot says, "to say that humanistic painting must contain human figures, but why? Since human thought is itself an abstracting

---

[3] Richard Eberhart, *Song and Idea* (New York: Oxford University Press, Inc., 1942).

process, there is no basic conflict between abstraction and humanism." But *is* human thought an abstracting process, other than in the technical sense, except when it is dealing with ideas detached from emotion, i.e., in science? Art is the opposite of the abstracting process. It is the means of making emotions concrete. And man is not an abstraction either; he is born, he lives, he loves, and he dies. If one is concerned, as an artist must be, with this cycle of man's fate on earth, how can one eliminate either the central protagonist of that drama or the things perceptible to the senses that surround him?

# 8

## Morality and the Word

The novelist Joyce Cary has gone to great length to make this point about the pivotal role of ethics in terms of his own art.[1] Jane Austen's command of form, he assures us, is due to her command of a moral idea— "her greatness to the fact that her moral idea was true within its context." It follows that the great literary artist is invariably a propagandist: "He is convinced that his idea of things is true and important and he wants to convert others, he wants to change the world. . . . All serious artists preach, and they write to communicate the truth. . . . *The Kreutzer Sonata*[2] is completely successful as a work of art because, although it preaches, the message it is meant to give has been entirely assimilated into its form."

When Cary goes on to say that only the most trivial arts even pretend to serve a purely aesthetic end, that to "deliberately exclude such meanings, as in some forms of abstract painting and sculpture," is to come up with an "art of teacups and wall-paper," one is ready to assume that he applies the same high standard to *all* the arts. But not so! He hedges. Perhaps the clue to his timidity lies in the fantastic conception of a visual artist he offers in *The Horse's Mouth*. The behavior of Gully Jimson does not correspond to that of a serious artist, past or present, that I have ever encountered; this is a Bohemian, an anarchist, a hedonist caricatured to comic proportions. At any rate, here is what Cary has to say:

There is this all-important truth in the distinction between the arts. Painters, sculptors, architects and composers do not intuit a moral real, or attempt to express it. They are dealing entirely with sensuous reality in color, sound and form, and their works are aimed in the first place only at a sensuous reaction. . . . A friend

---

[1] Joyce Cary, *Art and Reality* (New York: Harper & Bros., 1958). All the quotations from Cary are from this book.
[2] Tolstoy's novelette about the murderous consequences of sexual duality which takes its title from Beethoven's violin composition of that name.

of mine tells me that a Beethoven symphony can solve for him a problem of conduct. I've no doubt that it does so simply by giving him a sense of the tragedy and greatness of human destiny, which makes his personal anxieties seem small. . . . But music, painting and sculpture do not take a moral problem as their theme and meaning, whereas all the written arts . . . do nothing else.

Now it is one thing to hold that the "message" of the visual or auditory arts cannot be given an exact equivalent in verbal terms; but it is quite another to contend, as Cary does in this passage, that painters, sculptors, and composers, unlike poets, are concerned wholly with sensuous effects. *All* artists are concerned with "sensuous reality," but only the great ones are concerned with moral reality as well. This, as I shall try to establish in the next chapter, is quite as true of music, the most "abstract" of the arts, as it is of the others. Suffice to say here that Beethoven himself, in his letters, gives endless testimony to the fact that he created music to express his feelings about life, to embody what he called "love of man and desire to do good." Even the *Pastoral Symphony*, which is generally interpreted as Beethoven's one venture into program-music, should be regarded, he insisted, as an "expression of feeling rather than painting." Artists even then were popularly supposed to reside, like Gully Jimson, in some beauty parlor of the senses, answerable to no common law, beyond good and evil. Beethoven knew better. "I know of no excellencies in people," he wrote, "other than those which make them count among better men; where I find these, there is my home."

It is curious that Stanley Kunitz, whose poems in their moral fervor compare (among still active poets) only with those of Robert Lowell, should make the same *apologia* for the nonliterary arts. The modern scientist with his "principle of indeterminacy" has restored "mystery" to the universe, Kunitz says; *ergo* the artist concludes that he can never know the nature of the universe because he is a part of it. "We, too, are drifting cosmic dust." Man being part of his very field of perception, "art gives us what the age seems to be demanding"—"disorder," "unending flux," "a violent gesture or signature," or "the purity of an equation in the crystal palace of geometry."

But since when has it been art's function to give what "the age demands"? Kunitz has not stooped so low in his own art. There is not a trace of "disorder," "violent gesture," "signature," or "purity of geometry" in his poems. They are one continual outcry against everything our age prizes. Kunitz admits that much contemporary painting is "cold" because it insists on destroying, in Mondrian's words, "particular form"; and he goes on to say boldly that "this is a moral universe; the great work of man is to set up a world of values, to shore himself *against* the ruinous dissolution of the natural world." But still he hedges. "I am not advocating a return to recognizable

subject-matter. . . . In the best painting of our time—but only in the best —one is aware of a moral pressure being exerted in the medium in the very act of painting." [3]

*In the medium* . . . Of course the artist must exert moral pressure in the medium! But Kunitz recognizes elsewhere[4] that this is not enough. "The human head, the human figure always tells a story. When the story was one the world wanted to hear, art was full of anecdotes. . . . The figure will return to art when it has a better story to tell." Kunitz's art is full of heads, figures, anecdotes, morals. And so, as we shall see, is the art of those painters and sculptors who have made similar decisions. They may not be telling stories "the world wants to hear," but neither were Bosch or Goya in their own parlous times—nor Stanley Kunitz today:

> *Fomenting pestilence, rebellion, war,*
> *I come prepared, unwanting what I see,*
> *But tied to life. On the royal road to Thebes*
> *I had my luck, I met a lovely monster,*
> *And the story's this: I made the monster me.*[5]

But Kunitz, even among contemporary poets and novelists, is atypical. With notable exceptions—Yeats, Owen, Frost, Jeffers, Williams, the early Auden, Spender, and Shapiro—twentieth century poets have retreated (in so far as writers can) from a human world of decision into a no-world of metaphysical probability. Their language is so far removed from common usage as to require learned "explication." Their content is so subjective as to defy communication outside the company of other poets or critics.

Formalism in modern poetry grew out of the same climate of art-for-art's-sake as formalism in modern painting. Its mother country was nineteenth-century France. Its practitioners were exiles—not only from their homelands, their roots, but from life. Its first High Priest was Arthur Rimbaud:

One must be completely modern [wrote Rimbaud in 1873 in *Une Saison En Enfer*]. . . . I loved meaningless door-tops, backgrounds, acrobats' backcloths, sign-boards, popular prints, old-fashioned literature, church Latin, misspelled erotica. . . . I invented the color of the vowels!—A black, E white, I red, O blue, U green. . . . I accustomed myself to simple hallucination: I saw quite freely a mosque in place of a factory, a school of drums made by the angels, a drawing room at the bottom of a lake. . . . I finished by finding the disorder of my senses sacred.

---

[3] Dore Ashton, report on Stanley Kunitz's lecture, "Order and Disorder in Poetry and the Visual Arts," in the New York *Times*, December 10, 1959.

[4] Stanley Kunitz, "Sitting for Rosati the Sculptor," *Art News* (March, 1959).

[5] Stanley Kunitz, "The Approach to Thebes," *Selected Poems, 1928-1958* (Boston: Atlantic Monthly Press, Little, Brown & Co., 1959).

## Morality and the Word

Poets who followed Rimbaud, if they did not carry this burden to the same extremity, were content to develop some facet of the hard symbolist jewel. The late Paul Valéry, for example, battened on the precious myth of the poet's unproductivity. Self-consciously he would work on a single poem for years and years, treating it as a piece of sculpture to be admired for its form only. Ruling out verse that is full of passion or deliberately intelligible, he likened poetry to a heavy load which the poet carts to the roof bit by bit and then drops all at once on the poor unsuspecting reader who passes below. "Enthusiasm," he stated, "is not an artist's state of mind." Small wonder that this doctrine (which found American spokesmen in Winters, Tate, Ransom, Stevens, and the whole school of academics who follow in their wake today) has been capable of arousing small enthusiasm in the reading public.[6]

The most influential of contemporary poets, T. S. Eliot, went so far as to say that the moral, didactic, emotional, religious, historical and political spheres belonged to prose alone. He pedantically defined poetry as "not a turning loose of emotion, but an escape from emotion; not an expression of personality, but an escape from personality." What Karl Shapiro now calls a cultural orthodoxy was established:

In politics the orthodoxy was anti-democratic, embracing either monarchism or fascism or, among some of our Southern poets, a nostalgia for ante-bellum days. In letters it prescribes antiromanticism, the annihilation of poets such as Blake, Lawrence and Whitman, as well as all anti-intellectuals and "optimists." In religion it prescribes ritual and dogma. . . . With the anti-religious moderns, the ritualism may extend to form, as in Wallace Stevens. And in the case of a poet like Pound, culture can take the place of religion itself. Pound's cultural evangelism shows all the characteristics of a new religion, one which presumably he would have tried out had the corporate state survived.[7]

Is it true, as Shapiro concludes, that new poets are beginning to turn away "from criticism and the dictatorship of the intellectual journals"—just as the more adventurous painters are beginning to turn away from the sterile dictatorship of *Art News* and *Arts*? Is it true that they are "seeking that audience which has for so long been outlawed by the aristocrats of the Word"? He does not mention any by name, but his reference to "a return

---

[6] Selden Rodman, *A New Anthology of Modern Poetry* (New York: Random House, 1938). The paragraph is from the introduction. I explored the limitations of formalism in modern poetry further in *100 American Poems* (New York: Signet, 1948) and in *100 Modern Poems* (New York: Signet, 1949).

[7] Karl Shapiro, "What's Wrong with Poetry?" *The New York Times Book Section*, December 13, 1959. In a subsequent book which includes this essay, *In Defense of Ignorance* (New York: Random House, 1960), Shapiro quixotically hitches his impulsive wagon to Henry Miller's nihilistic star—and declares *all* art to be "amoral"—an unexpected traffic hazard I have attempted to unsnarl in "The Bankruptcy of Modern Poetry," *Writers Digest*, October, 1960.

to Whitman" could mean that he has in mind Allen Ginsberg, the young poet, whose rhapsodical dirge "Howl" was first published in 1958:

*I saw the best minds of my generation destroyed by madness, starving hysterical naked,*
*dragging themselves through the negro streets at dawn looking for an angry fix,*
*angelheaded hipsters burning for the ancient heavenly connection to the starry dynamo in the machinery of night,*
*who poverty and tatters and hollow-eyed and high sat up smoking in the supernatural darkness of cold-water flats floating across the tops of cities contempalting jazz,*
*who bared their brains to Heaven under the El and saw Mohammedan angels staggering on tenement roofs illuminated,*
*who passed through universities with radiant cool eyes hallucinating Arkansas and Blake-light tragedy among the scholars of war,*
*who were expelled from the academies for crazy & publishing obscene odes on the windows of the skull.*

It is not suggested that this primitive chanting of the beatniks is to be compared with the profoundly thoughtful image-making of the artists discussed in Part Two of this book, nor is it of the same order as the work of poets like Kunitz who affirm more than they reject. But Ginsberg does break with the moribund tradition of formalism; he does identify himself with the sufferings and sins of his fellowmen; and he does speak in a language intended to communicate with nonartists. Two equally gifted young poets, Galway Kinnell and George Starbuck, accomplish as much, and with more control, in their first books.[8]

The path from tragic expression to abstract antihumanism and back to the beginnings of a new engagement in modern fiction parallels that of poetry and the other arts. But the path is much less clearly defined. For one thing it is pretty hard to be "abstract" in a medium devised to convey information and ideas as logically as possible. Only James Joyce and Gertrude Stein devoted any sustained effort to dissolving syntax or arranging words in arbitrary sequences. Joyce's monumental effort to convey the subconscious wanderings of a sleeper's mind resulted in a punning pedantry, not inconceivably the reflection of what Edward Dahlberg calls "the desperate obliquity of a man who can no longer look reality in the face." Stein's more frivolous word games, far from justifying the lifetime of arcane pontification devoted to their advertisement, are unread and without issue.

The novelists of the succeeding generation, the generation Stein called "lost," rejected in their works the anti-social abstractionism of these writers whom they professed to regard as their masters. Fitzgerald and Dos Passos in

---

[8] Galway Kinnell, *What a Kingdom It Was* (Boston: Houghton Mifflin, 1960); George Starbuck, *Bone Thoughts* (New Haven: Yale University Press, 1960).

their chronicles of jazz-age disenchantment; O'Neill, O'Casey, and Giraudoux in their dramatic parables of the depersonalized city dweller in search of a soul; Steinbeck in his early novels of collective regeneration; Faulkner in his tortuous epic of a region's suppressed guilt—each offers in his own spirit a terrible indictment of materialism. Even Hemingway, who is criticized for ushering in the era of mindless action and uncommitted sexuality, does celebrate the classic virtues: courage, endurance, honesty, and self-sacrifice. And the advice he offers young writers in the preface to his collected stories could be followed profitably by any artist with something to say but with too unhealthy a respect for the little gods of modern art to say it: "In going where you have to go, and doing what you have to do, and seeing what you have to see, you dull and blunt the instrument you write with. But I would rather have it bent and dulled and know I had to put it on the grindstone again and hammer it into shape and put a whetstone to it, and know that I had something to write about, than to have it bright and shining and nothing to say, or smooth and well-oiled in the closet, but unused."

Compare this with the advice Norman Mailer gives the present generation, to which he stands in something of the "fatherly" relationship of Hemingway when he wrote the passage just quoted. Mailer is defining for them what is "hip":

Its language describes the experiences of elation and exhaustion. . . . it is a pictorial language, but pictorial like non-objective art . . . the emphasis is on energy . . . orgasm . . . The God which every hipster believes in is located in the senses of the body. . . . Hip abdicates from any conventional moral responsibility because it would argue that the result of our actions are unforeseeable. . . . man's character is less significant than the context in which he must function. . . . Hip morality: to do what one feels whenever and wherever it is possible.[9]

The novels of Mailer and James Jones and William Styron are as outsize and boiling with vitality as the canvases of any of the abstract-expressionist painters. Their characters, acted upon rather than acting, express this vitality in similar disengagement, though in the case of Styron's *Set This House on Fire* strains of amoralism-foresworn invigorate the coda. A noble form once dedicated (in Pasternak's words) to "the familiar transformed by greatness" is given over to sports enlivened by little but their depravity. The plays of Tennessee Williams, William Inge, and John Osborne convey more artfully the same narcissistic worship of the self: indulgent, consumed with self-pity, drifting, sick.

But this is the mirror of our society (the defenders of these artists take

---

[9] Norman Mailer, "The White Negro," *Advertisements for Myself* (New York: Vanguard Press, 1959).

up the old refrain). They, and they alone, have the courage to reflect our climate as it really is! Reflectors! Every society has been sick. All wars have resulted in meaningless annihilation. The guiltless have always fallen with the guilty. Probably never before in history have public figures all over the world been forced by public opinion to talk and even sometimes to act so unremittingly for the popular view of the general welfare. And artists, as the saying goes, have never had it so good. But are Shakespeare's plays a celebration of the Elizabethan vices embodied in Falstaff and Iago, Coriolanus and Macbeth? Is Mozart's music a whine of self-pity for the menial poverty in which he was obliged to compose? Would the demonic Dmitri and the calculating Ivan in Dostoevsky's *Brothers Karamazov* have any universal significance in terms of a great work of art were they not contrasted with the idealistic Alyosha and the saintly Zosima? "Truly to understand a man who is sick," Edmund Fuller says, "you must understand a man who is well." And he goes on to contrast a typical novelist of this period with the Karamazovs' creator:

Charles Jackson is a novelist unmistakably gifted. His novels are terrifyingly preoccupied with modes of demoralization and collapse. They depict these faithfully, but take in no other aspects of life at all. He admires and partly emulates Dostoevsky, but he does not appear to realize that the difference between the dark tones of his own work and those in Dostoevsky's novels is precisely that Dostoevsky took sides. He was not neutral in the conflict between good and evil. The gulf fixed between Jackson and Dostoevsky is not one of literary craftsmanship but of moral sense.

Dostoevsky views Raskolnikov with compassion, for he sees and interprets for us the moral fallacy that entrapped Raskolnikov. If there were no such fallacy, if Dostoevsky had perceived no moral standard to be warped, Raskolnikov (whose name means "the dissenter") would have been a mere Robert E. Lee Prewitt, and there would have been no tragedy. The great depth of *Crime and Punishment* (the very title states it) is that both Dostoevsky the author and Raskolnikov the created character are conscious of the moral dilemma.[10]

Is it necessary to add that moral fervor of itself is only moral fervor, not to be held in contempt, to be sure, or done without, but requiring some special "additive"—the intensity, perhaps, that builds form as it burns—to become art. That fusion of poetry and moral fervor which takes place in the greatest (but only in the greatest) art is heard most rarely in "prose." It resounds through the novels of Dostoevsky and Melville. It echoes in passages of Emily Brontë and Strindberg, Balzac and Thomas Mann, D. H. Lawrence and the early Joyce, Pasternak and Camus, Faulkner and Thomas Wolfe. Its

---

[10] Edmund Fuller, *Man in Modern Fiction* (New York: Random House, 1949-58). Robert E. Lee Prewitt is a character in James Jones's *From Here to Eternity* (New York: Charles Scribner's Sons, 1951).

separate elements are to be found among novelists and dramatists of the American generation that includes the "Insiders" of Part Two of this study, but not in synthesis yet. Two examples will serve.

The late James Agee's *A Death in the Family* is unique among recent novels for the selflessness with which its author identifies himself with a small world of "normal" people. In the moment of crisis which it examines, their delusions and awareness, their anguish and fear, their selfishness and self-accusation, above all their compassion and love are recorded. The accuracy of observation and the charged language in which emotion is conveyed are unsurpassed. Yet by the very fact that the author himself never makes his presence felt, that he balances so scrupulously love against hate, faith against disbelief, good against evil, the only final meaning (as Donald Demarest has pointed out) is the stoic one that there is none. This dispassionate concern for all points of view poises the work of art short of whatever it is that involves one in a complete experience. "With greater artists—and this is the meaning of catharsis—there is a resolution, a conviction, a message, if you must, that colors their work: a compulsive need to communicate, a belief in the possibility of communication and even in the world's need for that communication." [11]

Every bit of this capacity of greater artists, without as yet much of the poet's capacity to create through formal means a resonance to match it, is Arthur Miller's. This limitation in the dramatist is recognized by his warmest admirers, one of whom calls him a composer of "tragedies for extroverts," and another the creator (in Willy Loman of *Death of a Salesman*) of a "suburban King Lear." [12] Lear, Karamazov, the "Ninth Symphony" appeal to introverts and extroverts alike, both in their content and in their form.

Yet Miller shares with these complete artists their identification with average life, their preoccupation with moral issues, their passion to exalt freedom and communicate truth. He has defined the theme of his early play *All My Sons* as "the responsibility of a man for his actions, a recognition of his ethical responsibility to the world outside his home as well as in his home," adding significantly: "I don't see how you can write anything decent without using the question of right and wrong as its basis." Willy Loman's tragedy is not his "failure" in the sordid world of salesmanship but the surrender to false ideals of success which makes him bring his sons up in a moral vacuum. His ultimate recognition of his failure as a father, the expia-

---

[11] Donald Demarest, "Posthumous Novel Examines Death Under Poetic Glass," *Mexico City News*, March 2, 1958.

[12] Richard Watts, Jr., in his introduction to the Bantam Classic edition of Arthur Miller's *The Crucible* (New York: The Viking Press, Inc., 1953); John Gassner, *A Treasury of the Theatre* (New York: Simon and Schuster, Inc., 1940).

tion to Biff in the act of his death, provides the "catharsis" one misses in the poetic novel. Similarly, in *The Crucible* it is John Proctor's heroism to recognize his own "pact with the devil" and, in confessing it, to sign his own death warrant rather than use the confession to consign others to the slimepit of intolerance.

# 9

## Inside Music

In music the divorce between artist and public has gone much further than in the other arts. In fact, it is complete. There are no Millers nor Agees, no Shahns, Wyeths nor Manzus—artists with a wide appeal yet generally recognized as inventive craftsmen who sound the depths. Even the works of revolutionary formalists like Alexander Calder and Jackson Pollock convey a pleasurable "charge" to the layman, invoking a common feeling through the lyricism or anguish with which they suggest movement. But the *avant-garde* composers have long since ceased to communicate outside their own ranks. The Gershwins and Menottis are regarded as brilliant compromisers in the borderland of entertainment. Jazz, which by its nature does not go deeper than sentimental melody and rhythmic improvisation, has eliminated the composer altogether. We are left with a serious music that is unintelligible to the layman—and wholly abstract.

Ah, but is not music abstract by its very nature? The question does not occur to the music lover who is not interested in forms-for-their-own-sake and seeks content where he can find it. Most theorists, however, insist that it is; and the modern composer is doing his best to prove them right. Stravinsky, whose early (and popular) ballet music—like Picasso's "Blue Period"—belongs to another age, now regards composition as the "solution" to a "problem" and claims that music signifies nothing. John Cage, like the abstract expressionists, makes a principle of chance and writes scores more pleasing to the eye than to the ear (see Plate 75). The proponents of electronic music, here and abroad, employ every mechanical device to produce sounds that can be analyzed only by audio-engineers and listened to only by other technicians. As in the other arts of the *avant-garde*, communicable content has long since ceased to be the aim. Any moral component is denied. Innovation is regarded as an end in itself, and an "original" pattern of "new" noises is the end product.

Strange goings on. Program of advanced music last night. Note word "advanced." Not merely "modern." Given at Young Men's and Young Women's Hebrew Association. More advanced than anything. . . .

David Tudor at the piano. Group named Audio-Visual Group helping out. First piece by Alfred Hansen. "Alice Denham in 48 Seconds" the name. Lasted 5 minutes 14 seconds. Joke? Dada? Instruments were ratchets, hammer, toy telephone, et cetera. Seven young people in street clothes carrying on with instruments.

One great effect: a bottle broken against a table. Sweet, simple, pure sound. Subtle. Brought tears to the eyes. Fellow kept pointing and operating toy machine gun against architect's drawing. Symbolism?

Suite by Christian Wolfe followed. Played by Mr. Tudor on semi-prepared piano. Music of the beep-beep, ping-ping, boing-boing school. Only eight minutes or so.

Dick Higgins next. Composer of "Six Episodes for Aquarian Theatre." Episode No. 1 named "The escape of the goose from the wild bottle." Sounded different to this listener. Sounded like "Female platypus on tightrope typing collected works of Macrobius," but let it pass.

Plenty of props for "goose." Man in hip bath; long paper on floor. He steps from bath (real water), stomps on floor with hands and feet. No rhythm. Result is Pollock abstraction on paper. Audience applauds. Union of art and music.

Episode No. 2 also beautiful. "The sound of animals dying 13 to 1." Five readers lined up in front of scarecrow. Attempt at *musique concrete*, only using real voices. Four intelligible words throughout the work. "Dear John," to begin with. Later, much later, "stinker" and, very distinctly, but once, "Freud."

Finally, after intermission, *pièce de résistance*. "Music of Changes" by John Cage. Plink-plonk school, as contrasted to Wolfe's beep-beep. Mr. Tudor again the pianist. Plinked and plonked the actual strings. But so old-fashioned! After Higgins, Hansen, the Cage music forlorn, a throw-back, bobbing quietly up and down at the side of the hitheringandthithering waters of. . . .

Thus wrote Harold Schonberg, music critic of the New York *Herald-Tribune* in a not-altogether-serious review of the (perhaps) not-altogether-serious *avant-garde*. But Cage means business; and so do Boulez and Stockhausen; and I had already made my own notes in an effort to come to terms with these acknowledged masters of serial (or "row") atonalism.[1]

*Boulez.* Intriguing sounds, more oriental than Western to my ear with no discernible over-all pattern of the notes: somewhat the effect of ping-pong balls dropping accidentally on the keys of a xylophone. Every so often this is interrupted by what sounds like a man out of breath trying to blow a wind instrument for the first time. . . . Silence . . . tinkling of a chandelier or glass-rods curtain. . . . A plain-

---

[1] A technique built on freely selected series of individual tones rather than on the key-oriented diatonic scale. Since there is no resolution in this kind of music, since dissonance, in Stravinsky's words, "is no longer a symbol of disorder, nor consonance a guarantee of security," the listener has no place to go. Or, as Henry Pleasants put it neatly in *The Agony of Modern Music* (New York: Simon and Schuster, Inc., 1955): "Where everything goes, nothing matters."

tive note. . . . Then singing of a tortured melody by an excellent voice (parody of an opera star?): pleasant but inconsequential, soon becoming very monotonous. . . . Then a rise in tempo, excitement of a sort, but soon drifting off into what Larry Rivers (describing his kind of painting to me) calls "a little bit of nothing." *Stockhausen's* piece seems more consistent and planned but duller. Stravinsky's "Octet for Wind Instruments" comes to mind occasionally though there is none of the melodic line or sprightly wit of that composition. . . . Try as I will, I can think of nothing but frogs, treetoads, radar blips, and the weird "signals" the astronomers sometimes receive from the disintegrating galaxies of outer space.

Perhaps that is what one is supposed to think. What does one think confronting a Pollock labyrinth? I can only speak for myself. "Chaos"—beautiful or terrible, depending on the artist's mood or one's own. The artist's sincerity and compulsion to create what he chooses is not questioned in either case. But as we have seen in the case of Mathieu, claims are made for both of these arts extending far beyond impressionistic reflection of the *zeitgeist*. What does the *afficionado* of serial music say?

Near me in the country lives a young pianist-composer who has become something of a Zen recluse. I had been told by a mutual friend that his sensibility has become so attuned to the modern idiom that it pains him to listen to any music older than Webern's. I did not believe this until one day he dropped in unexpectedly at my house. Our friend had told him about my Boulez-Stockhausen record, and he wanted to hear it. To satisfy my disbelief, I asked him if he would mind listening first to a piece of music that was giving me great pleasure—Schnabel's performance of the poignant slow movement of Schubert's posthumous "Sonata in B-flat Major." He agreed graciously, and I played it.

He shook his head.

"It doesn't do anything for you, does it?" I said.

"Nothing. Absolutely nothing," he said. "I've heard so many things like it—though not this particular piece—and so many thousands of times that I can anticipate how often each phrase is going to be repeated, and exactly how each modulation will be resolved."

"Then it's surprise you look for mainly?"

"That and something more, I'm coming to realize that what I'm looking for is expressed better, far better, in nature. For example the way the grain of the wood in my record cabinet curves around the knots. I can look at that "accidental" pattern endlessly without tiring of its beauty and strangeness, and rightness. Can any artist—even Morris Graves—do as well? Can any composer—even Webern? Isn't any art, in so far as it reveals even a trace of the conscious mind, belittled and corrupted by the messy ego of its creator? The more conscious it is, the more egotistical and, therefore, the more imper-

fect. Those cracks in the ice on your pond outside aren't trying to *prove* anything."

Before my friend left he mentioned that Webern had a new convert. Robert Craft's *Conversations with Igor Stravinsky*,[2] just published, indicated that the Russian master had at long last abandoned neoclassicism for the serial technique of the Viennese school. Of course Stravinsky may take Webern in his stride and assimilate him, as he has assimilated Russian folk rhythms, Bach, Tchaikovsky, Gesualdo, etc.—just as Picasso assimilated African sculpture, Lautrec, Greco, Ingres and Matisse. It is the measure of their restless geniuses to mine the present as well as the past, staying thereby mobile in their inventiveness, but remaining *outside*.

But the *Conversations* do more than call attention to the free-wheeling experimentalism of the typical twentieth century internationalist. They reveal a certain attitude, snobbism, which is at the base of the modern artist's compulsion to remain in the aggressive first wave of the *avant-garde* at whatever cost to his own mature development along lines dictated by expressive needs. Stravinsky quotes with approval Seurat's ascetic dictum that to compose is to solve a problem: "Certain critics have done me the honor to see poetry in what I do, but I paint by my method *with no other thought in mind*." Stravinsky also pays tribute to Monet's "huge, almost abstract canvases of pure color and light." Then, in a revealing disclosure of an encounter with Marcel Proust, he says: "I talked to him about music, and he expressed much enthusiasm for the late Beethoven quartets—enthusiasm I would have shared, were it not a common-place among the intellectuals of that time and not a musical judgment but a literary pose." The implication, clearly, is that admiration of great art for suspect reasons is enough to cancel out one's own natural response to it. Even intellectuals can be moved by what is unguardedly human, but Stravinsky steels himself against participating in a "surrender" so common.

Webern, the acknowledged master of today's *avant-garde*, was an intellectual ascetic resembling Mondrian both in respect to the purity and the paucity of that Dutch artist's output. Is it too Spenglerian to note that Webern became associated with Schoenberg and Alban Berg in the identical period (1904-1912) when Picasso, Braque, and Juan Gris were inventing ascetic cubism? Like these painters, Webern stripped music down to its "purest" essence. He insisted on a "vertical" nudity that was almost without chords. He analyzed the single note so rigorously that it had to be given accelerandos

---

[2] Robert Craft, *Conversations with Igor Stravinsky* (Garden City, N.Y.: Doubleday & Co., Inc., 1959).

and crescendos of its own. Schoenberg, Robert Craft points out,[3] was not so far away from Beethoven or Brahms except in the matter of his harmonic language; he tried to encompass at least their kind of form with his recognizably traditional rhythms, melodic construction and phrase design. But Webern's "monosyllables" aimed at (and achieved) "total variation." From his very first characteristic compositions, the Stefan George songs and the "Five Pieces for Strings," he "virtually abolishes sequence and repetition and the larger principle of symmetry."

Webern, for all that, was an expressive artist—as was Berg, whose opera *Wozzeck* must be considered the masterpiece of German Expressionism. Webern's teaching always began with an analysis of Beethoven's sonatas. His arrangements of Brahms and Schubert, as well as his reverential treatment of Bach's "Ricercar," which he orchestrated nobly, would serve to indicate his affinity with the earlier music of expressive content, even if his music itself did not reveal its spiritual descent. A devout Catholic and mystic, Webern lived "in and for music," Craft tells us, "and what love was left was for flowers and for the poetry of Hoelderlin and Rilke and the Greek tragedians."

Whether it was in the nature of the development of music itself to be carried by Webern to its logical limits of inwardness, or whether the scholarly and ascetic nature of the composer predetermined the relentless austerity of his search for "ultimate consequences," the music that has followed in the wake of this composer has been arid indeed. Without Webern's piercing expressivity, which manages at its best to be heard above (or through) the intellectual extremism of the means, there remains the fragmentation, the nudity, the monosyllabic punctuation of silences predicted by Webern's characteristic directions—"like a whisper," "scarcely audible," "dying away."

Desperate are the lengths to which contemporary composers are driving themselves in pursuit of this formal exploration of sound possibilities. The visual artist's flight to the junk pile at least results in the construction of symbols with familiar ingredients. But the composer's resort to artificially produced sounds carries him into the esoteric laboratory of the scientist. Stockhausen, as a matter of fact, worked in the fields of physics and acoustics at Bonn University before deciding to devote himself entirely to "electronic music." Varèse and Badings have experimented with the manipulation and superimposition of recorded magnetic noises independently. Vladimir Ussachevsky, who has established (with Otto Luening) the first American laboratory for tape composition, describes its use as making "any sound akin to a lump of clay in the hands of a sculptor; the sound can be shortened, elongated, cut apart, listened to backwards, have certain characteristics of timbre

---

[3] In his introduction to the Columbia recording of *The Complete Music of Anton Webern.*

emphasized or de-emphasized." Electronic synthesizers and sound generators, audio-oscillators, white-noise generators, and all sorts of sound-modifying devices extend the complexities of possible sound astronomically. By suppressing certain bands in the sound spectrum, Ussachevsky says, "the line of demarcation between 'noise' and 'musical sound' becomes further obscured." The so-called "white noise" produced by filters is described as "a perfect, electronically-produced noise, covering and extending beyond the entire audible frequency range." The composer boasts of imparting a sense of development in one of his compositions "by deliberately increasing the noise content of the thematic material . . . from a minimum noise content at the beginning to almost pure noise at the end." [4] Finally John Cage, not to be outdone by the abstract-expressionist painters, has introduced into music the element of chance, seeing "virtues in perpetuating structural ambiguity under the guise of restoring fluidity of interpretation."

Where did all this begin, and where will it end?

Neither question has much meaning if one assumes that music is abstract. If, on the other hand, one assumes that there has always been music with *content* expressed through form and music in which the emphasis is on form for its own sake,[5] then patterns equivalent to those indicated for the other arts come into view. I make such an assumption. The fact that the "specific" content of music cannot be approximated in verbal terms, that we lack counters to define with any precision the emotional or psychic states which the composer conveys to us directly, is beside the point. This is true to a lesser degree of all the arts. Let us take Beethoven's "content" as a case in point.

Do we delude ourselves in sensing that Beethoven is exploring (*with* us) the ultimate meaning of heroism in the "Third," "Fifth" and "Ninth" Symphonies, of despair in the "Hammerklavier Sonata," of "joyful" submission to mortal damnation in the "C Sharp Minor Quartet," and so on? [6] I have already referred to the testimony of the letters. There is scarcely a reference in them to a "composer's" problem, to matters of "technique" that bothered

---

[4] Vladimir Ussachevsky, "Music in the Tape Medium," *Juillard Review* (Spring, 1959).

[5] So-called "program music," in which the notes seek to imitate familiar sounds in the world outside music, is a third category, roughly comparable to illustrative art or straight reporting.

[6] This fact of the universality of Beethoven's content, which I can only touch on here, has been recognized by laymen and musicians alike. See E. M. Forster, quoted in Rodman, *The Eye of Man*, 169-71; James Agee, *Let Us Now Praise Famous Men* (Boston: Houghton Mifflin Co., 1941), and J. W. N. Sullivan, *Beethoven: His Spiritual Development* (New York: Alfred A. Knopf, Inc., 1927), the most searching inquiry into the subject. George Ballanchine, the noted choreographer, recognized it when he said, in an interview with the New York *Herald-Tribune*, June 14, 1959: "I can read almost any Beethoven piece, but I cannot *see* anything being danced to it. Beethoven's music represents something . . . and people like to put themselves into that picture . . . Mozart, Stravinsky and Webern—that is a different kind of music . . . The music of men like Beethoven and Brahms accommodates the individual because you can find a reflection of your personal feelings in it."

him, to invention, to form. The main problems discussed (beside the economic ones that plague all men) are moral problems. On the rare occasions when "art" is mentioned at all, it is with the humility of one who despairs of ever making it express the human situation profoundly enough. "The true artist has no pride, he unfortunately sees that art has no limits; he feels darkly how far away he is from the goal, and though he may be admired by others, he grieves not yet to have come there, to where his better genius lights him only as a distant sun." Asked to differentiate between the two movements of the "Sonata Opus 90," Beethoven did not talk about tempo or contrasting figuration as one would if abstraction were involved; he spoke of content only: over the first movement could be written "struggle between head and heart" and over the second "conversation with the beloved." What is *Fidelio* about? The answer is easy. It is about the rights of man. As for the general purpose of art, it is of course to communicate through self-awareness a state of joyous harmony with all things: "He who truly understands my music can never know sorrow again."

Few lives have ever been as wracked with sufferings, physical and mental, as Beethoven's; but the artist in him was never thereby twisted into believing that suffering was good, that a happy domestic life was not most to be desired, or that artists dispense their blessings for any more esoteric reasons than to exalt nobility, defy indifference, and comfort the wretched. Because he remained throughout his life naïve and deeply sincere, Beethoven never lost contact with his audience or his art.

Haydn, judging by a letter he once wrote to a distant community that had thanked him for his "Creation," was as simpleminded:

You give me the pleasant conviction . . . that I am often the enviable source from which you and so many families derive pleasure and enjoyment in domestic life. What happiness does this thought cause me! Often, when contending with obstacles of every sort . . . a secret feeling within me whispers: "There are but few contented and happy men here below; everywhere grief and care prevail; perhaps your labors may one day be the source from which the weary and worn, or the men burdened with affairs may derive a few moments rest and refreshment." What a powerful motive for pressing onward!

How different is the attitude of the typical modernist, convinced that what pleases the public must be (since it is recognizable and moving) banal and tawdry. Poor Tworkov, afraid even of giving pleasure to his fellow artists! But perhaps there is hope. In the field of music, at least, some of the foremost figures themselves recognize the folly of the flight from content. Hindemith's irony is unmistakable:

Never forget to assert your modernity. . . . Writing what is called modern music lifts you automatically into a world-wide society of composers with similar tendencies [having] a secret language understandable only to the initiated, removed from any musical desires of an ordinary music-lover, and thriving under hothouse conditions. . . . Still another group in an attempt to replace with an apparent rationality what is lacking morally, develops an over-sublimated technique which produces images of emotions that are far removed from any emotional experiences a relatively normal human being ever has. In doing so they advocate the esoteric *art pour l'art*, the followers of which can only be emotional imps, monsters, or snobs.[7]

The pre-Webern Stravinsky describes our musical culture thus. We are, he says, "day by day losing the sense of continuity and the taste for a common language. Individual caprice and intellectual anarchy, which tend to control the world in which we live, isolate the artist from his fellow-artists and condemn him to appear as a monster in the eyes of the public; a monster of originality, inventor of his own language, of his own vocabulary, and of the apparatus of his own art. . . . So he comes to the point of speaking an idiom without relation to the world that listens to him." [8]

Contempt for the audience and withdrawal into esoteric forms are only symptoms, self-protective attire the artist assumes when he has already lost conviction in what he has to say. Only one thoroughly conversant with the whole corpus of music and with an ear finely attuned to detecting expressive content could say how far back one would have to go to find the roots of modern impressionism and abstraction. Possibly as far as Beethoven. Even Schubert, Beethoven's great contemporary and disciple, found it difficult to sustain grandeur. Many of his longer pieces begin with resolution only to trail off into melodic "tone-poems" with a routine accompaniment of Alberti bass. Brahms and a few other nineteenth-century "reactionaries" broke through the main line of romantic formalism running from Chopin and Schumann to Debussy and Richard Strauss. The stage was being set, even by these masters of an easily communicated mood-painting, for modern music's absorption in tonal exploration for its own sake. At the turn of the century Schoenberg was already experimenting with a method of turning the dissolved tonality of Wagner's *Tristan* into a serial technique, and Busoni was announcing that the "progress" of music was being hampered by the limitation of existing instruments.

The first significant sign of a countermovement away from preoccupation with form for its own sake and toward a revival of expressivity is an article by

[7] Paul Hindemith, A *Composer's World* (Cambridge: Harvard University Press, 1953).
[8] Igor Stravinsky, *Poetics of Music* (Cambridge: Harvard University Press, 1947).

another outstanding modern composer, Virgil Thomson. Today, Thomson writes,[9] there is little active change apparent in the whole realm of music. "There is only tradition, and that tradition includes all the modernisms of yesteryear. As always, there is a diatonic and a chromatic style, the former neo-classicism and the latter serial dodecaphony. In neither camp is there much novelty of expression or method." As for the second (the camp of Boulez, Stockhausen, Cage) Thomson says: "I find this music utterly charming in sound and refreshingly innocent in expression. There is nothing wrong with it except the publicity advanced in its favor that it is another 'music of the future' and consequently abolishes, save for museum purposes, all other music. . . . It is a game (one might almost say a children's game) played with classical elements, and less a pioneering adventure than one in which all the still-open roadways, one by one, get closed to the traffic."

Thomson could be writing about his old friend Gertrude Stein, with whom he collaborated on an opera that is both utterly charming in sound and refreshingly innocent in expression. He could certainly be describing the identical dilemma of post-Mondrian painting. Mondrian, by carrying purism to its logical absolute, closed all the roadways to geometrical abstraction. Then the abstract expressionists, by concentrating on the only other remaining roadway to art for art's sake—subjective "spontaneity"—enlarged the anarchic gesture, the inkblot, and nothingness itself to the point where every further personal act of defiance has come to look like every other. And, ironically, completely *im*personal.

After analyzing the doctrine of novelty for its own sake, Thomson faces up boldly to the conclusion that none of the major artists in visual abstraction have yet braved. He urged his fellow composers to forget for a time "novelty and change":

It is better to work with the ideas one already has, however small they may be, than to try to follow an outworn line of modernism-at-any-price. . . . *We may well be reduced to seeking innovation through expressivity, instead of expressivity through innovation, and to finding expressivity through sincerity.* . . . It will require, of course, the private efforts of a great many people all over the world, many of them working underground lest they be denounced, to counteract music's present incipient sclerosis.

---

[9] Virgil Thomson, "Ending the Great Tradition," *Encounter* (London, January, 1959).

# 10

## *Transition: Outsiders and Insiders*

"Music," Beethoven once told an interviewer who asked for definitions, "is the mediator between intellectual and sensuous life. . . . It is the one incorporeal entrance into the higher world of knowledge which comprehends mankind but which man cannot comprehend." The point to note is that the supreme artist did not regard art as an end in itself but as a means of comprehending life. Science, J. W. N. Sullivan pointed out, gives us knowledge of structure but not of substance; art, when analyzing subjectively what is objective, projects the substance itself. Note also that Beethoven, in calling music "the *one incorporeal* entrance into the higher world of knowledge," recognized the unique character of music's "abstract" *means*. The content is the composer's reaction to the situation, not the situation itself. In a poem or a painting or a sculpture of similar scope, the literal content is manifested in its "subject" which we can clearly see or define in words, but the subject of itself is not art. The art is in the tension set up between literal and latent content.

The fact of, and some of the reasons for, the primacy of the visual arts in formalism's ascendancy (and in the present revolt against it) have already been mentioned. The new—that is, the postabstract expressionist—Insider is apt to be more naturally a sculptor or draftsman than a painter because he wishes to convey as directly and clearly as possible his involvement with man. If he uses color at all, it is primarily in an effort to intensify the emotion behind the idea he is projecting, always as a complement to the drawing, never for its own sake. A deliberate defiance of the sensuous, atmospheric colorism of the School of Paris may also be implied.

By the same token the Insider employs distortion, sometimes violent distortion, of the human body, to emphasize an imposed affliction or an inner crisis.

If his choice of subject is apt to be the sick, the maimed, the rejected, the isolated, this choice is dictated not by morbidity but by compassion.

If one of his favorite subjects is death, that is because as a man he finds himself frustrated in his fellow-feeling for life—and as an artist insulted by modern art's contemptible shallowness.

Whether religious or secular in his ultimate allegiance, the Insider is not apt to lose sight of man's everlasting struggle to better his lot.[1]

In an age of mass suicide and almost universal indifference to the sufferings of others, the Insider calls attention to the unspeakable degradation of the *individual*. He never depicts misery in the mass, as does the Communist artist, because he conceives of evil and redemption in personal terms, soluble only through the volition of the free spirit. [Baskin's "Hydrogen Man" (Plate 35) is being annihilated *alone*. Each of Kearns's "Seven Viewers on a Wall" (Plate 26) reacts to the tragedy in his own way.] But in his search for values that give meaning to life, the Insider does not divorce man as an individual from man as a social participant. Machines employed for any other purpose than liberation enslave; and the State is to be tolerated only if it serves to distribute freedom.

Since the Insider believes in every man's right and capacity to arrive at his own solutions, he rejects the purists' authoritarian reliance on the direction and umpiring of art by an élite of intellectuals (*Art News*) together with the messianic absolutism of abstract expressionism as contained in Gottlieb's dictum: "We are now going to have a thousand years of non-representational painting."

It follows that the Insider opposes the dominant school of modern art on another front: he believes in the potential of education. He concurs with Leonardo's pedagogic aphorism that "strength is born of restraint and dies in freedom." He seeks as much schooling as he can absorb. On the living body of the past, with love born of understanding, he endeavors to beget a style of his own. Failing this, he will not scorn to contribute his share of dedicated craftsmanship, recognizing that without it tradition cannot be kept alive.

Who are the Insiders?

That is for every art lover who concurs substantially with the argument so far to decide for himself. I present candidates of my own, to have done with further generalities. The word Insider is no more than a convenient handle to a complex distinction. Readers—including very likely some of the living artists mentioned by name—will disagree. And that is as it should be.

---

[1] John of the Cross, whom Dali admires and whose poetry he compares to Franz Kline's painting, is the great Outsider of Christianity: "The soul that sets its affections upon created beings . . . will in no way be able to attain union with the infinite being of God."

## Part One: The Rejection of Man

Not all born (natural) artists are Insiders.

Neither are all philosophically inclined Insiders artists.

Insiders among painters and sculptors of the past: Giotto, Donatello, Michelangelo, Bruegel, Gruenewald, Greco, Rembrandt, Goya, Blake, Daumier, Van Gogh, Eakins, Rodin, Bourdelle, Barlach, Rouault, Orozco. Among the living: Shahn, Levine, Bloom, Wyeth, Lebrun, Manzu, Baskin, Kearns, Cuevas, Landuyt.

Artists whose commitment to human values is variable but whose stature in some instances may be greater than that of some of the more relentless Insiders listed above are: Piero della Francesca, da Vinci, Velasquez, Titian, Rubens, Cézanne, Picasso, Chagall, Balthus, Tobey, Lipchitz, Moore, de Kooning, David Smith, Matta, Dubuffet.

Outstanding artists who are not Insiders: Raphael, Vermeer, Tiepolo, Watteau, Poussin, Chardin, David, Ingres, Monet, Gauguin, Matisse, Bonnard, Maillol, Mondrian, Marin, Léger. Among the living: Braque, Sheeler, Calder, Nicholson, Dali, Afro, Tamayo, Mathieu.

It is the emerging Insiders whose art I now celebrate—without any intention of calling them a "school" or implying any inevitable mutual regard; without any wish to question the sincerity or minimize the fervor of the formalists; without any injunction that the Insiders' ethos and imagery will necessarily prevail; above all, without any presumption to speak for anyone but myself or to offer in the pages that follow more than my admiration, thanksgiving, and hope.

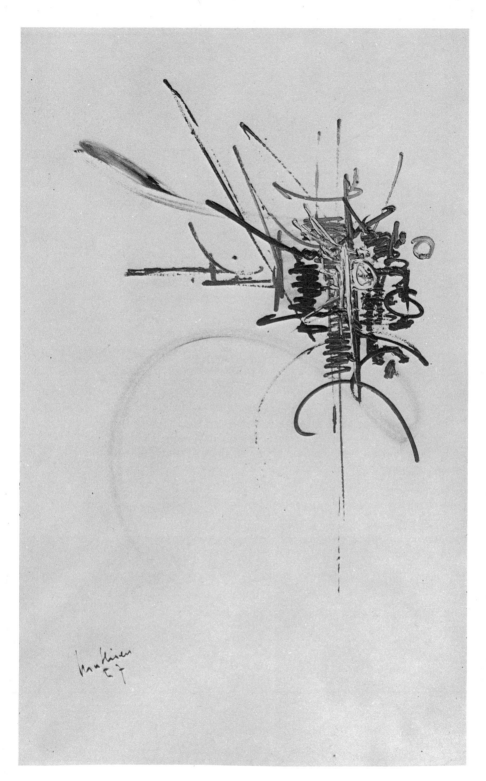

1. Georges Mathieu's "Sign," French décor with Oriental overtones, was painted on the author's wall in a minute and fifty seconds. "When I paint, my mind must be a complete blank," Mathieu says. "No thought, no deliberation, no method, no choice."

2. Jack Tworkov's "Transverse" is a rougher American counterpart of Mathieu's signature. "If I have a slogan," this abstract expressionist says, "it is: no commitment. At a moment when there is admittedly little common ground, the best morality is not to have any."

3. Barnett Newman's "Cathedra," a monumental blue vacuum eight feet high by seventeen feet long, is good example of "Inaction Painting," dead end of the artist's compulsion to "innovate" at any cost—in this case with the dry bones of Mondrian's geometricism.

4. Ellsworth Kelly's "Paname," the other phase of contemporary geometrical abstraction, has positive values of sharply contrasted and cunningly "cut" color-shapes. But no matter how magnified or provocatively titled, the result is limited to design.

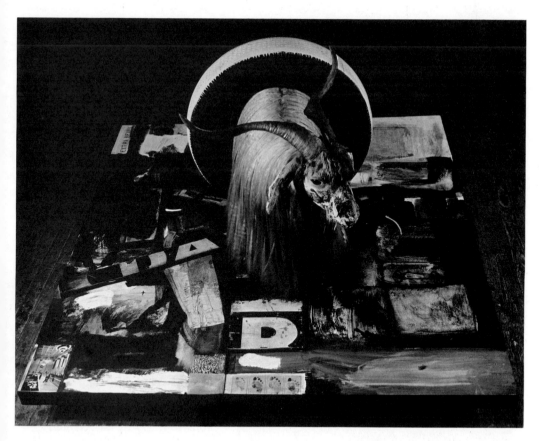

5. Robert Rauschenberg's "Monogram." This neo-Dada "combine" of a stuffed angora wearing an old tire bespeaks beat-generation defiance of noncommittal abstract expressionism itself. Denying both communicable content and form, value is limited to success or failure as symbol of protest against "world without meaning."

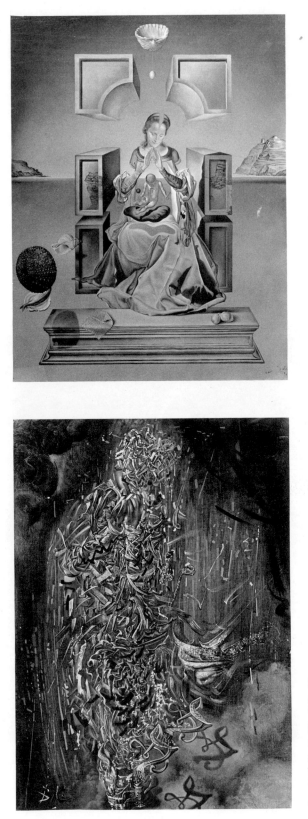

6. & 7. Salvador Dali's 1949 "Madonna of Port Lligat" and 1956 "Sainte Entouré de Trois Pi-mesons" represent deliberate (and academic) efforts to fragment image. Both sharp-focus and abstract-expressionist pictures are supposed to convey "nuclear" and "metaphysical" nature of reality.

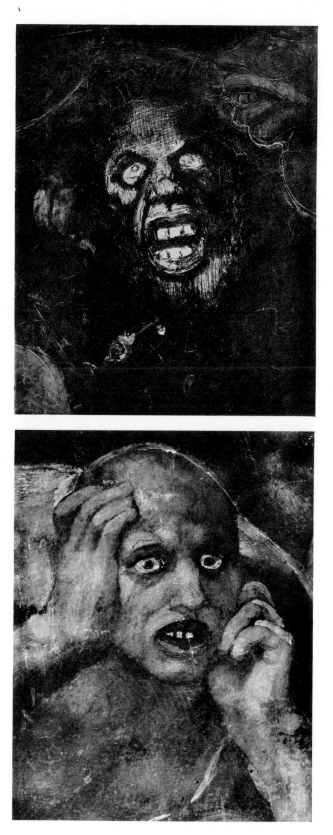

8. & 9. Michelangelo's two details from "The Last Judgment" represent (in contrast to Dali's) the artist's distortions of the human image for maximum expressivity in terms of communicable meditation on the human plight.

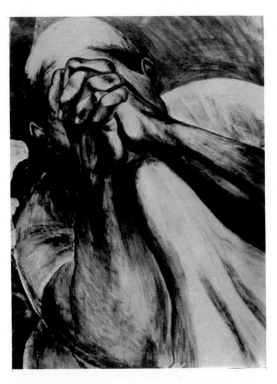

10. Orozco's head with clasped hands from the fresco of "The Trinity" in Mexico's National Preparatory School. This early work (1924) in the Michelangelesque tradition of expressive distortion rivals the Tuscan master's great images.

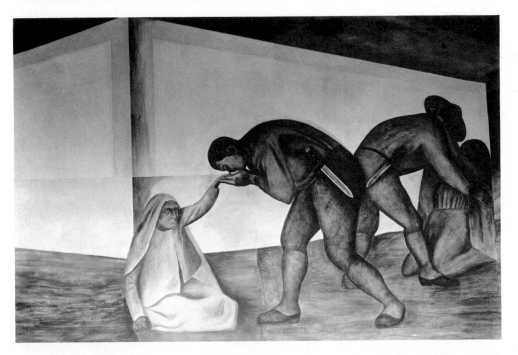

11. Orozco's "Mother's Farewell," another fresco from the National Preparatory School series, illustrates the late Mexican painter's narrative power as well as his ability to convey compassion. Against a pale blue wall the fatalism of the blind mother is a foil arresting the tragic "action" of the Revolution.

12. The overwhelming simplicity and power of Orozco's draftsmanship are well exemplified in this rare pencil sketch on wrapping paper (34 inches high) for one of the figures in the National Preparatory School. It was found in a New York junk shop.

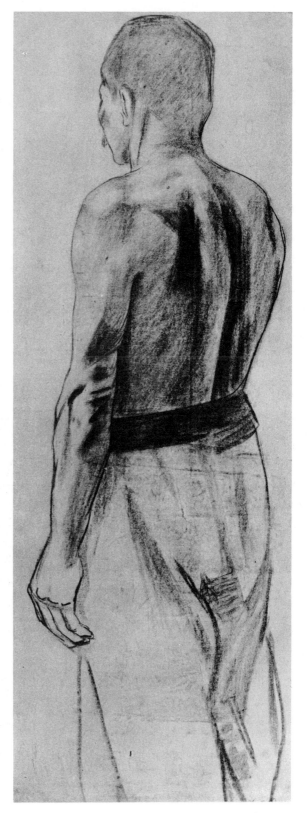

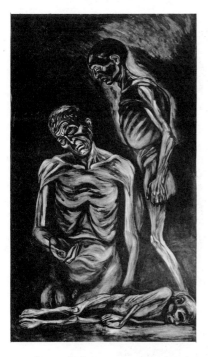

13. Orozco's later expressionist style guides the anguished distortions of this comment on "Starvation" from the frescoes in the University Theatre at Guadalajara. Painted in the late thirties.

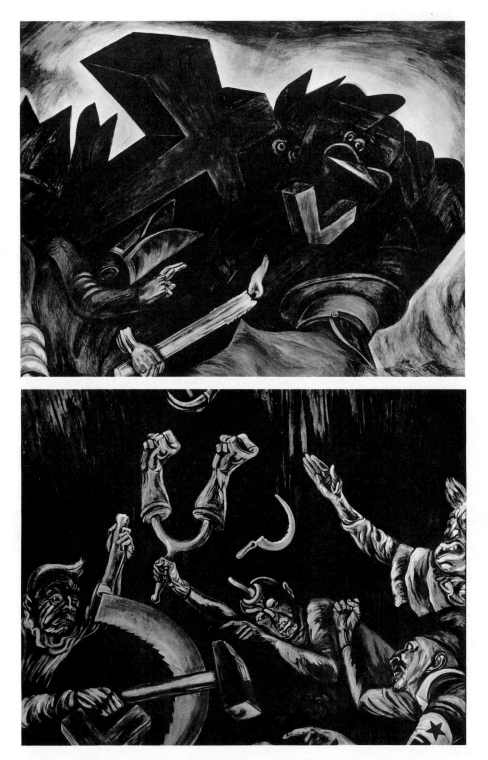

14. & 15. Orozco's "Shadowy Forces" (top) and "The Circus" are among the master's most successful essays in monumental group action and satire. The former represents the retreat of the forces of organized religion; the latter totalitarianism rampant. Both are in the Government Palace at Guadalajara.

16. Orozco's masterpiece, the frescoes in the dome of the Orphanage chapel at Guadalajara, contains figures symbolizing the Four Elements. This one, "The Wind," was photographed by the author from a temporary repair platform constructed seventy feet above the crossing from which the figures were designed to be seen.

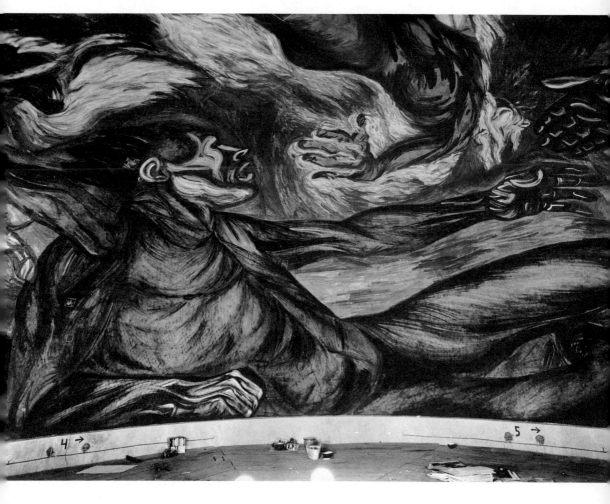

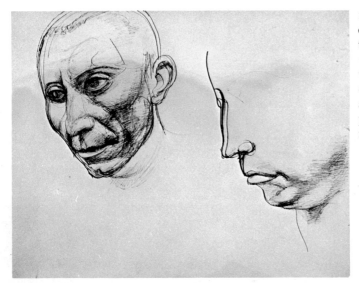

17. Rico Lebrun's pen-study of heads dates from the late thirties or early forties when this artist had just broken with a highly successful career as a commercial artist and was beginning to improvise freely in classic modes.

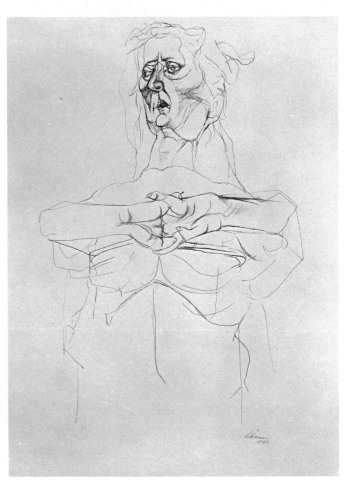

18. Lebrun's "Mary" is one of countless pen-studies for the figures of the "Crucifixion" series of the early fifties. The influence of Picasso's expressive shorthand may be detected in all the works of this middle period.

19. Lebrun's "Sleeping Soldier" from the same period as the "Mary" bears witness to the Italian-born artist's Mannerist antecedents. "These soldiers," Lebrun wrote at the time, "are animated combinations of turtle and man . . . reality treated metaphorically."

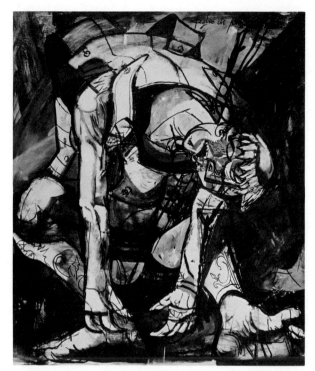

20. "Study for Buchenwald Cart" is one of several very large oils Lebrun painted in 1956 as preparations for the major picture in the Pennsylvania Academy of Fine Arts. Measuring forty-eight inches by seventy-two inches, its thunderous blues, blacks, and whites orchestrate a terrible indictment.

21. Lebrun's huge cartoon-study in inks and washes of the central group in Goya's
savage portrait of the family of Charles IV is at once a tribute to an earlier Insider
and a declaration of independence. Lebrun seems to be saying not "I, too," but "We."

22. "Study for Dachau Chamber" was the last and probably most complex of the concentration-camp cycle Lebrun painted before leaving for Rome in 1959 to begin work on the mural that will face Orozco's "Prometheus" at Pomona. The simultaneous presentation of events results in so much "abstraction" here that emotional impact is not easily read.

23. Lebrun's "Study of a Woman" in charcoal and ink (1959) attests the great draftsman's mastery, divested of influences. Here nothing stands between the artist's "artistry" and his deep feeling for the subject's aging flesh and vulnerable spirit.

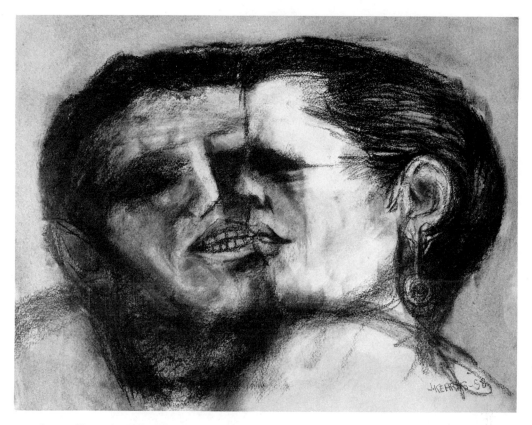

24. James Kearns's "The Kiss," an early drawing by the New Jersey Insider, is the first in a series of memorable images that includes "Dethroned" (Plate 27). The separation of a single flattened head into two might be said to signify man's agonized effort to become more than just himself.

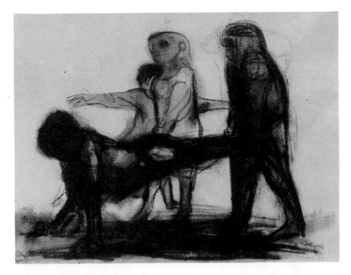

25. Kearns's "Wheelbarrow" is one of the earliest in a series of drawings and paintings suggested by children's games. Sympathetic observation of the artist's five children is translated into sympathy for adults who have lost the capacity to play.

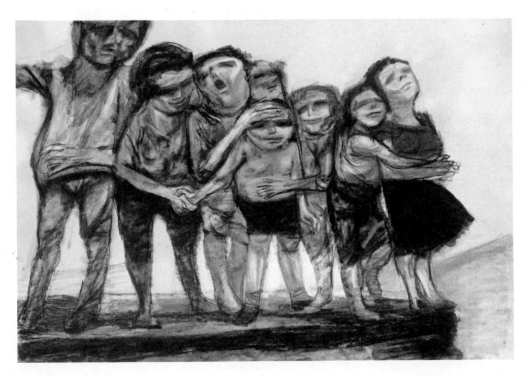

26. Kearns's "Seven Viewers on a Wall," a charcoal drawing thirty-six inches by twenty-four inches, was suggested by the spectacle of children leaning against each other as they watched the aftermath of an automobile accident. He had "seen" them many times, before and after.

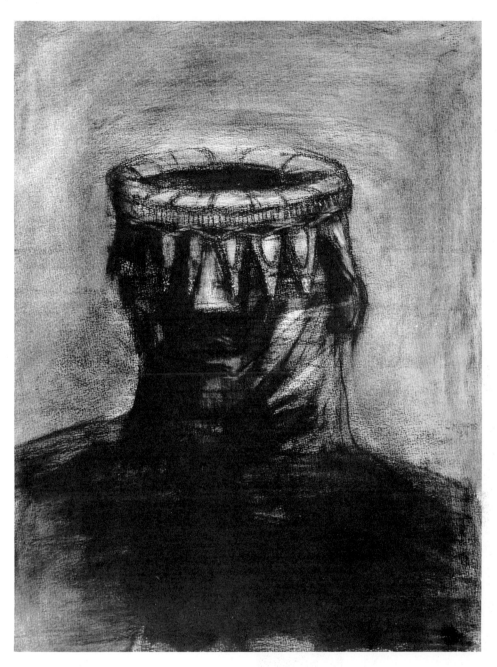

27. In Kearns's "Dethroned" the self-blinding effect of this ironic coronation—the triangled highlights of the nose perhaps suggesting the reversed points of the crown of thorns—may be compared with the image of the man in Orozco's "The Trinity" (Plate 10).

28. Kearns's "Minotaur" in cast stone twenty-three inches high is an early sculpture suggested by Picasso's famous print. Like the symbolic portrait of Picasso on the next page it suggests both affection and satire—admiration for the durable poise of the Spanish master's protagonist; aversion to the egocentricity of the pose.

29. "Boy with Sculpture" of the same period, medium, and approximate size is Kearns's more affirmative symbol of innocence and creativity. The idea that the head which the boy carries might be his own when he grows older occurred to Kearns, he says, as the work progressed.

30. Kearns's "Portrait of Rouault,"
like Lebrun's tribute to Goya and
Baskin's tribute to Ernst Barlach, is
in line with the Insider's respect
for tradition, specifically the tradition
of humanity and expressive content
in the arts of other times. Other
fine portrait drawings by Kearns
include Beethoven, Epstein, and
Wyeth.

31. Kearns's "Picasso," a fairly large oil in acid greens, yellows, and reds against mat brown,
was suggested by certain photographs of the artist-magician in bathing trunks with costume
jewelry. Picasso's eyes have here become jewels, yet the picture is not hostile. It could be
called a love letter with regrets.

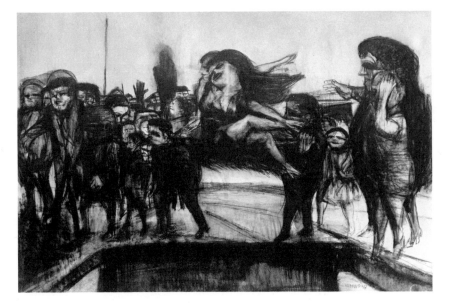

32. Kearns's drawing "Processional" preceded by almost two years the painting with the same title reproduced below. It represents one of many attempts to enter into group activity, not as a "detached observer," but as a "participating interpreter."

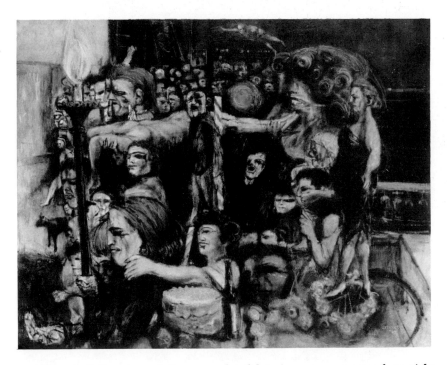

33. Kearns's first major painting, completed late in 1959, measures forty-eight inches by sixty-two inches. The colors are predominantly dark greens, blues, and black, accented by rose—the birthday cake and the swirling central "sun." Like all of Kearns's work it has comic as well as tragic aspects.

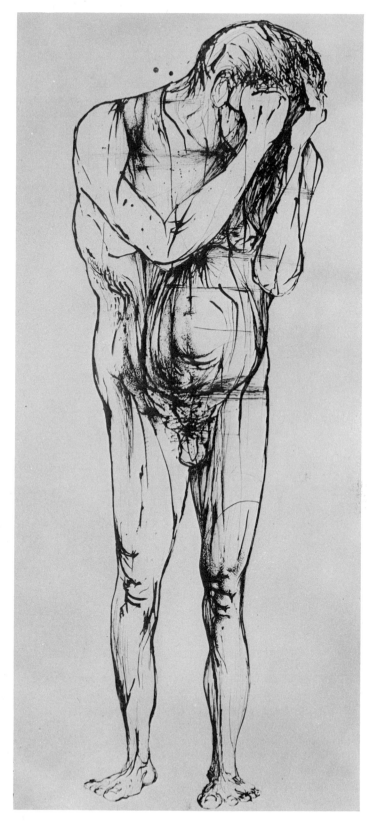

34. Leonard Baskin's "Mid-
Century Dirge" is one of
the first and one of the
most moving of this artist's
almost life-size pen draw-
ings. In all of them the
subject is Man—whether
incarnated as Beast or De-
mon, Victim or Avenging
Angel—and in all he stands
alone.

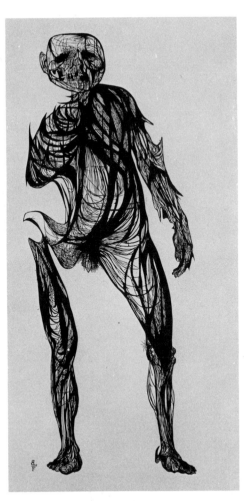

35. Baskin's "Hydrogen Man," a woodcut of commanding size and fearful import, conveys its unmistakable warning. This once-characteristic, weblike calligraphy Baskin has now put aside in favor of blunt stroke or elegiac contour.

36. Baskin's finest print and a wood engraving without rival for virulent impact and technical brilliance is "Death of the Laureate." So withering an indictment of the betrayal of art could only come from one who worships poetry.

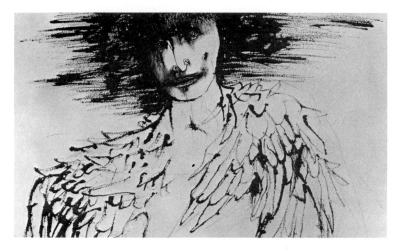

37. Baskin's "Isaac" (detail from a very large drawing) catches the victim at that mythical moment when he partakes of the identities of beast and angel. A poem by Wilfred Owen triggered this great image of unwilling metamorphosis.

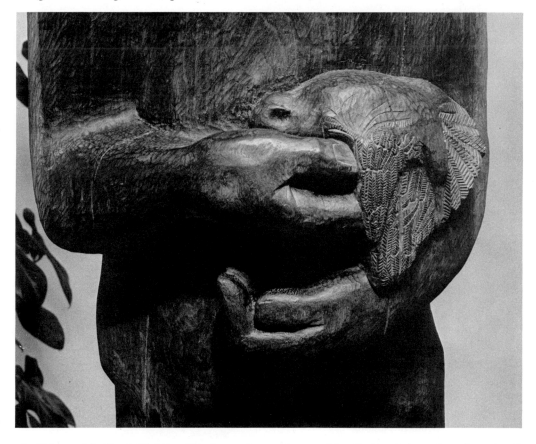

38. "Man with Dead Bird," a life-size sculpture in wood by Baskin, is seen here in a detail of its central section emphasizing the artist's great skill in conveying the gesture of protective tenderness and in contrasting complexity with plainness.

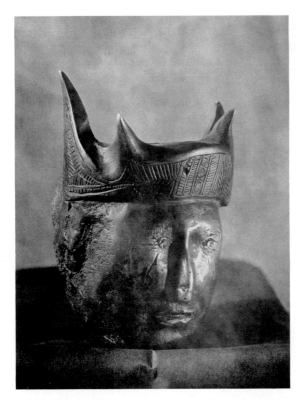

39. Baskin's "Queen Vashti," a very small bronze three and a half inches high, may refer to that punishment for failing to show herself crowned at her husband's bidding, lest "all women shall despise their husbands in their eyes." (*Esther* 1:17)

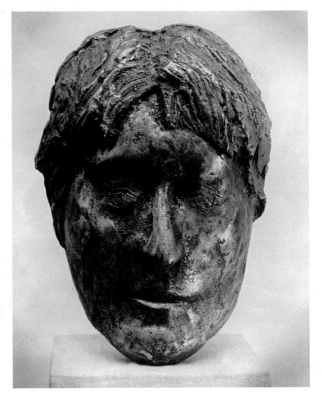

40. The life-size bronze head of his wife Esther was completed by Baskin in 1956 and is unique among his works as a portrait of a living person. It is unique also for its celebration of womanly grace and virtue, a charity undisfigured by gall.

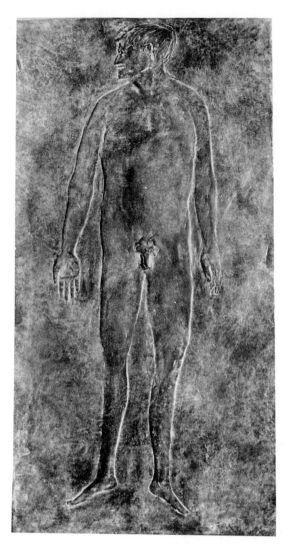

41. Baskin's "Homage to Gustav Mahler" is one of a number of small bronze bas-reliefs, some honoring the artist's culture-heroes, some carrying on his private war with the forces of evil. The composer's religious intensity rather than his pretention to grandeur is conveyed here.

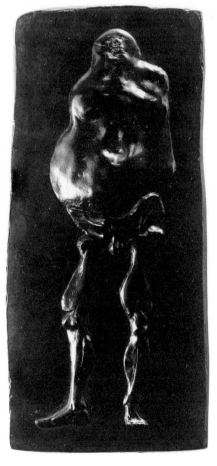

42. "Glutted Death," a somewhat smaller plaque, is a good example of Baskin's more sombre vision. The patina is appropriately black and appropriate too is the stripping of flesh from everything but the malignant mouth and inflated belly.

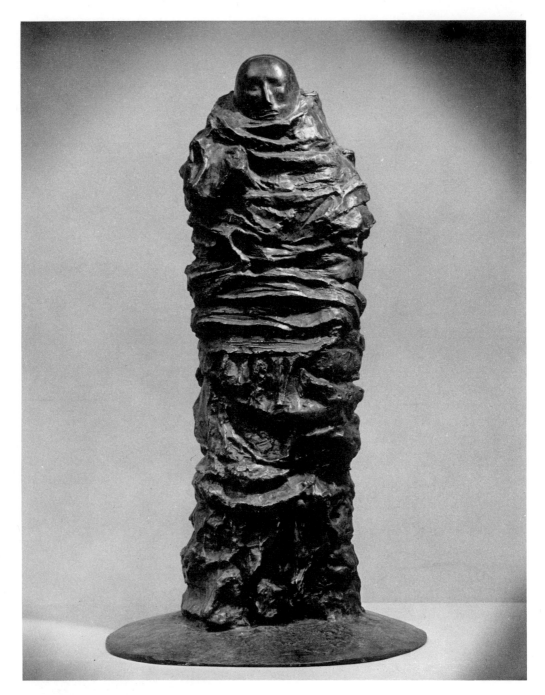

43. Combined in Baskin's "Lazarus," a bronze masterpiece thirty inches high which was completed in 1960, are the artist's capacity to draw as intensely as he feels with his more intellectual predilection for columnar impassivity.

44. Nicol Allan's "Image" is an ink-brushed monotype by a young California Insider. The expression of anxiety and defenselessness may owe something to Edvard Munch or merely resemble the art of that emotionally high-keyed humanist.

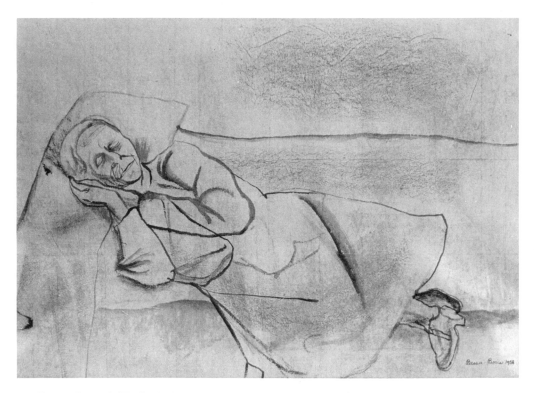

45. Bessie Boris' "Old Lady Sleeping" is a pen drawing, thirty inches by twenty inches, by a Pennsylvania artist who studied with Grosz but whose capacity to communicate what others feel and are is her own. (The works illustrated on this page were discovered after the text was closed to further comment.)

46. Aubrey Schwartz's "Poe" is a pencil drawing forty inches high by the ablest young master in the "School of Baskin." The smouldering eye has looked into Hell, and it is the measure of the artist's success that no suggestion of contrivance is conveyed by the "device" of leaving the other entirely out.

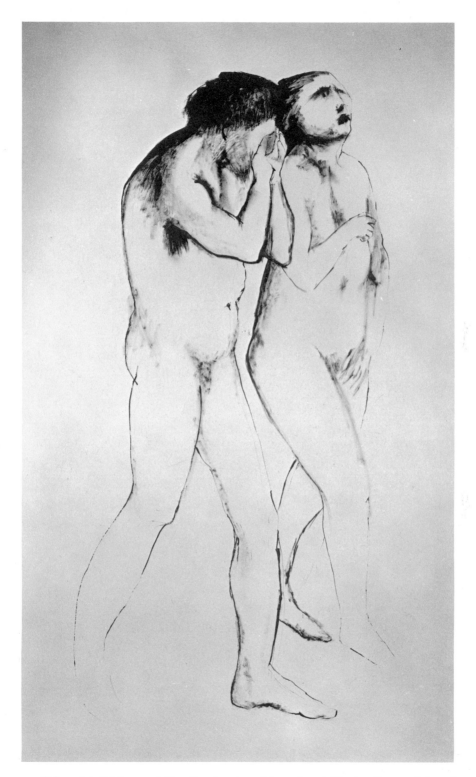

47. Schwartz's "Adam and Eve," a drawing of two almost life-size figures, is based on Masaccio's famous fresco of the "Expulsion from Eden." Man is as defenseless in all the armor of his modernity as in his original nakedness, Schwartz could be saying.

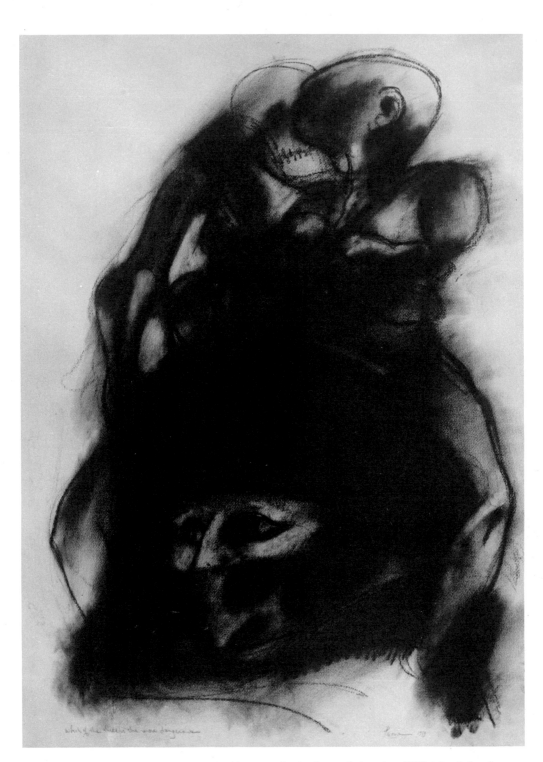

48. Peter Paone's large (twenty-two by thirty inches) charcoal drawing "Which of the three is the more dangerous . . . ?" is a political cartoon that goes far beyond cartooning and its immediate provocation; this being as true of Paone as of Daumier, one of Paone's Insider-ancestors.

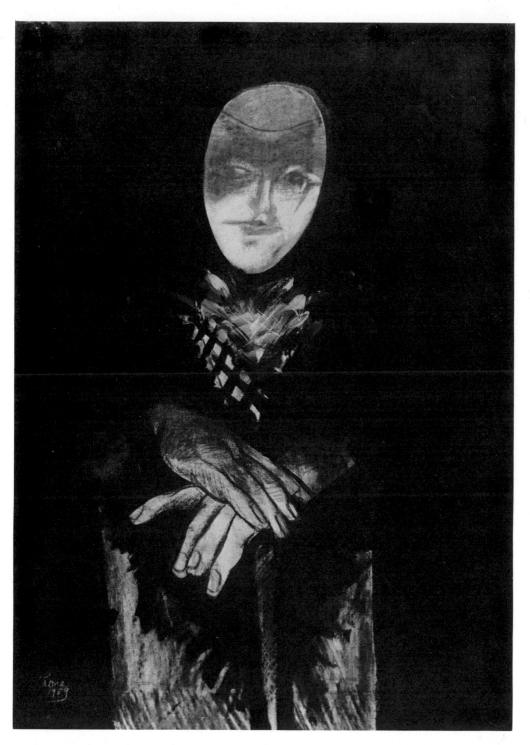

49. In Paone's "The Artist," an outstanding oil by the young Philadelphia artist, everything is subordinated to the face and hands, as in certain portraits by Titian and Rembrandt. The face is a mask—but with one eye focused very clearly on something outside itself. The enlarged hands are ready to shape what the eyes see.

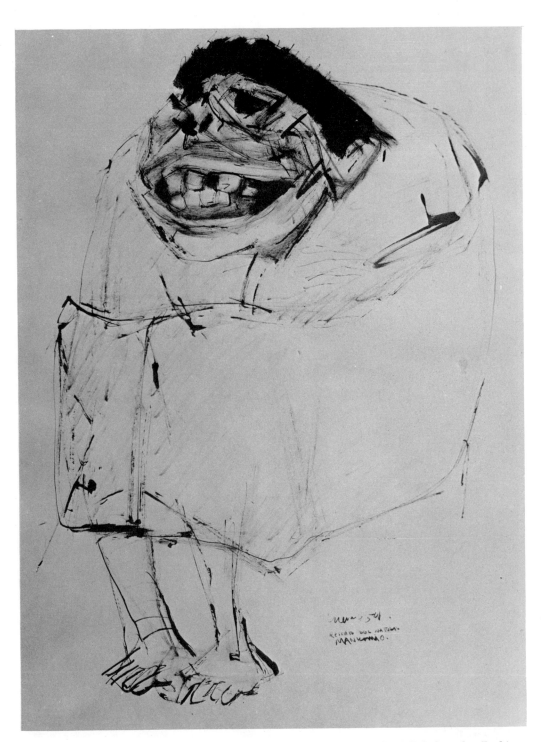

50. José Luis Cuevas' "Madman," though no madder than images by Michelangelo, Baskin, and Kearns reproduced here, has a grotesque quality that could only have come from the country of candy skulls and Nayarit sculpture. Personifying aspects of a mad century, the artist gives his protagonist more lunkhead strut than dignity.

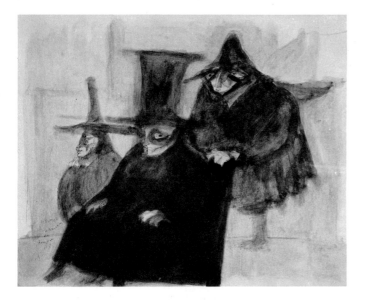

51. Cuevas' "Gentlemen of Frans Hals" is one of the young Mexican's earliest variations on themes from the Old Masters— in this case a fellow master of tragi-comic disillusionment.

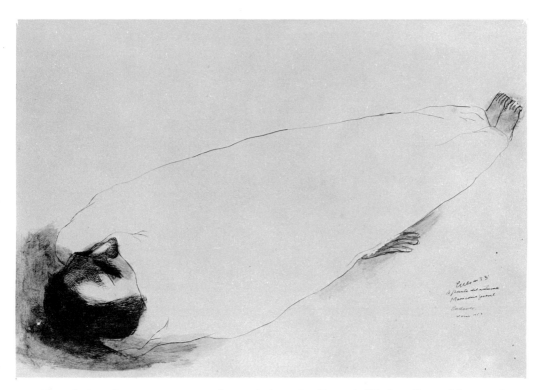

52. Also dating from 1953–1954, the variations in Cuevas' "Cadaver" on Mantegna's foreshortened corpse express a more elegiac, less compassionate, mood and in their purity of line may owe something to Ingres or to the wonderful pen drawings which Picasso has made under the spell of that classic draftsman.

53. Ink over gray, pink, and pale blue washes is the characteristic medium of "Arnolfini Marriage No. 1," the first of a series of variations by Cuevas on the famous portrait by Jan Van Eyck. "It was the mystery emanating from the forms of these strangers that obsessed me."

54. The same medium is used by Cuevas in this more satirical "Bishop and Prostitute," also dating from late 1959 while the young Mexican was visiting the United States. It reflects the ambiguous religious emotions of the Latin who can be sometimes devoutly Catholic and anticlerical at the same time.

55. Jonah Kinigstein's "Madonna," seemingly more an expression of religious sentiment than Cuevas' "Bishop," is actually less so, having been inspired mainly by admiration for Latin devotional images and the sentiment their ornate richness conveys.

56. The same New York artist's "Calavera" is another tribute to Mexican imagery, in this case to the symbols of mortality, "dressed to kill," omnipresent in folk art south of the Rio Grande. Popularized in Posada's broadsides, Orozco, Siqueiros, and Rivera painted them into their frescoes.

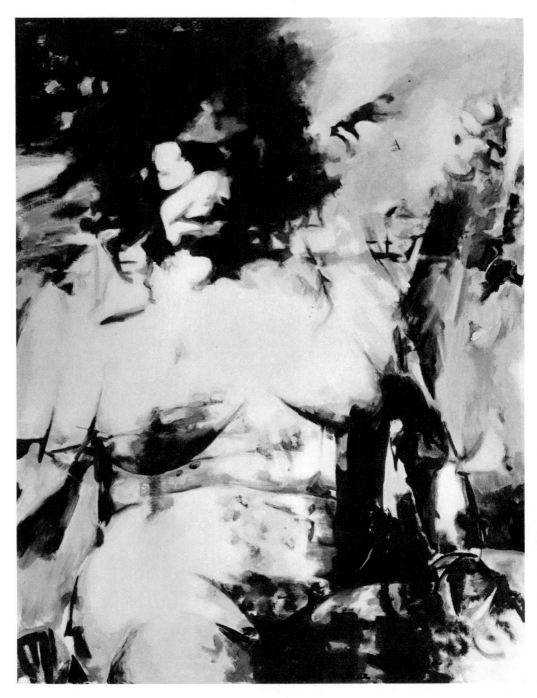

57. Balcomb Greene's "Seated Woman," an oil measuring forty-eight inches by thirty-eight inches, remains along with de Kooning's "Women," among the few successful attempts to evoke some measure of expressive representational content by way of abstract-expressionist means.

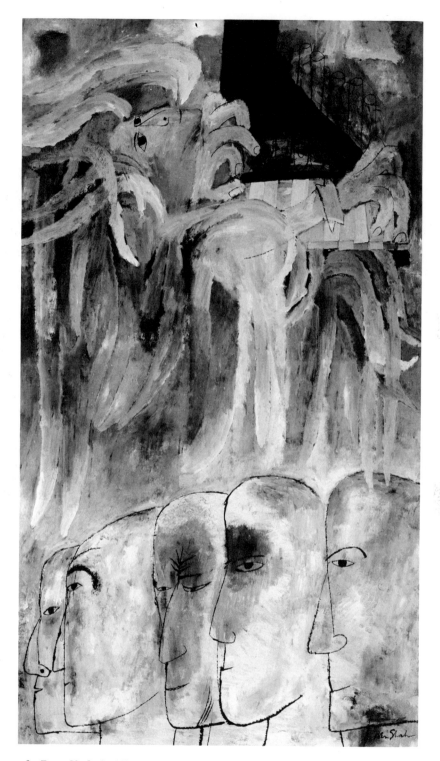

58. Ben Shahn's "Poem of Ecstasy" is an example of the reverse proce-
dure. Greene's image "emerges" out of painterly bravura; Shahn's
illustration of a text is illuminated with nonlinear "automatism."

59. Like all this "realist's" work, Andrew Wyeth's "Mother Archie's Church," transcribed from local observation, is so intensified by composition and muted color as to seem pure imagination. The symbolism, as in all great art, is simple but not obvious.

60. Most magical of modern land-scapes, Wyeth's "River Cove" must be seen in the transparency of its colors, alive with reflected and refracted light. In photograph it looks like a photograph—as the score of the Waldstein Sonata's rondo looks like a score.

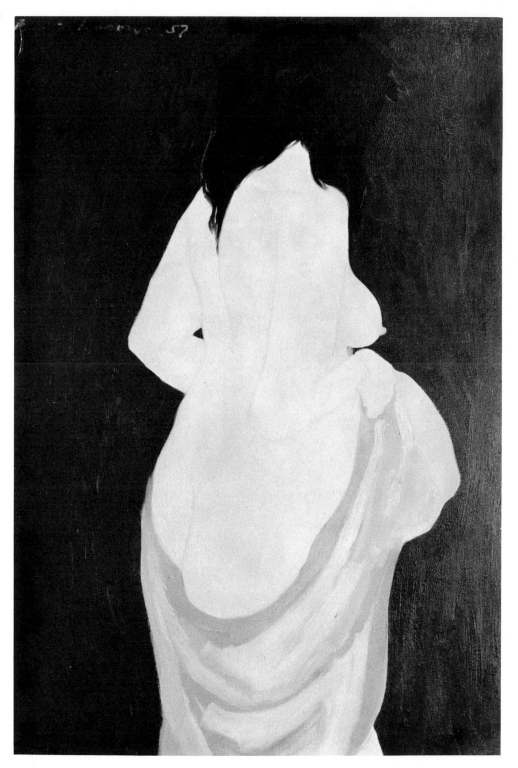

61. Ben Johnson's 1958 "Nude Bather." "No nude, however abstract, should fail to arouse in the spectator some vestige of erotic feeling, even though it be only the faintest shadow—and if it does not do so, it is bad art and false morals."—Sir Kenneth Clark.

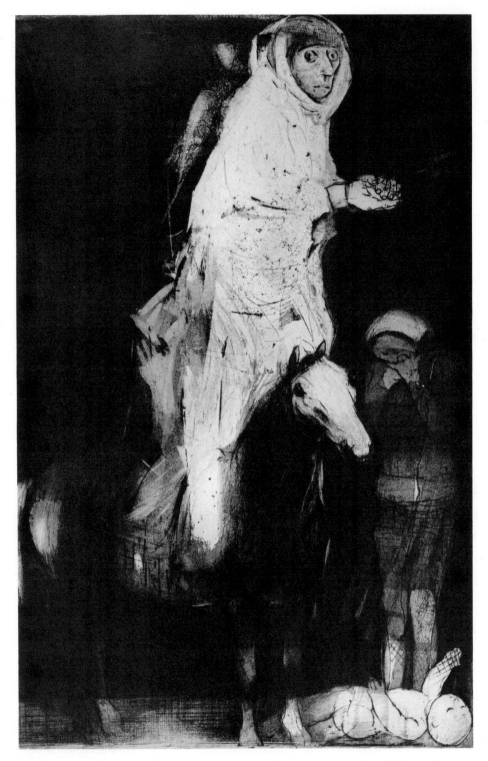

62. Goya would surely recognize "Spain" in Mauricio Lasansky's "España."
Born in Argentina, now an American citizen and professor of art at the State
University of Iowa, Lasansky is considered by many to be the world's outstanding
printmaker.

63. June Wayne's "Whatever dyes was not mixt equally" is a pen drawing from the series of lithographs executed by this California artist in Paris in 1958–1959 as illustrations to certain poems of John Donne.

64. Jacob Landau's "Status Quo Ante" is a woodcut in the German Expressionist vein, owing something to Barlach, Kollwitz, and Ensor. It satirizes American politicians who would set the clock back.

65. Giacomo Manzu's "Descent from the Cross with Woman," a bronze bas-relief twenty-nine inches by twenty-one inches, was one of a series created by the Italian sculptor in 1955–1956 in connection with a commission to design a set of doors for St. Peter's in Rome.

66. Elbert Weinberg's "Captive Angel," a large sculpture in wood, reflects the Insider's will to communicate the spiritual anguish of the present with an appropriate iconography derived from the past; religious faith is involved only in the broadest sense.

67. Cast in bronze from wax, Weinberg's "Bridal Rite," eighteen inches high, is one of many sculptures large and small suggested to this Connecticut artist by the ritual of Jewish religion.

68. Jack Zajac's "Easter Goat I" is the first of four versions of this animal staked for sacrifice, observed by the young California artist during travels in Greece.

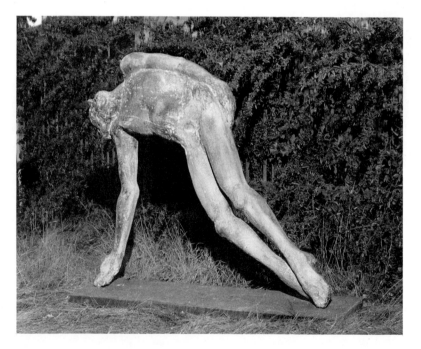

69. Zajac's "Deposition" in fiberglass for bronze casting is larger than life size—or gives that impression. Its monumentality and simplicity are achieved with no sacrifice of emotion which flows from dejected feet to outstretched hand.

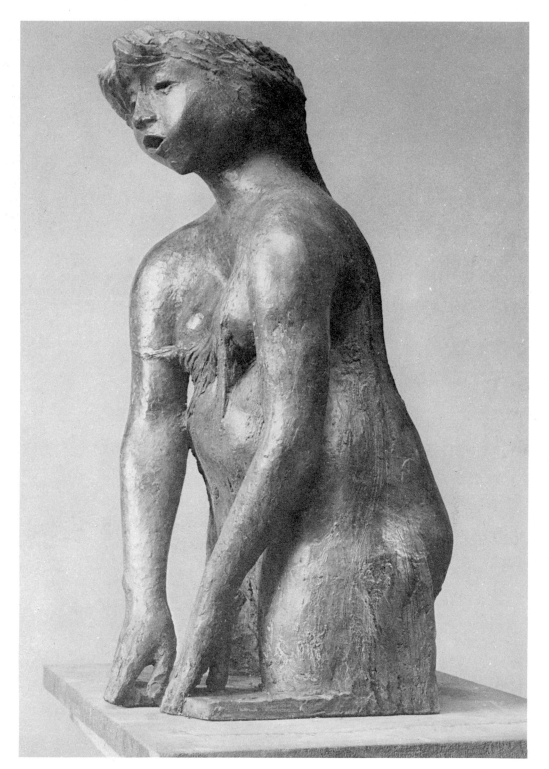

70. Sidney Simon's "Girl," a ceramic cast of a sculpture thirty-one inches high, is for those—including, at times, the artist himself—who despair of saying anything fresh with the untortured human figure.

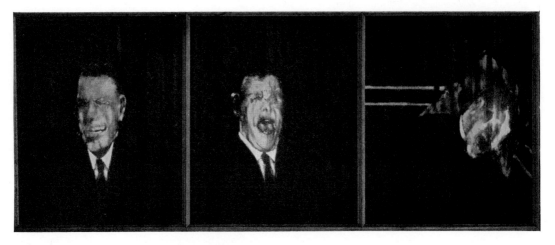

71. Francis Bacon's "Three Studies of the Human Head" owes something to surrealism, something to cinematic technique, and a great deal to the temper of a time out of joint. Bacon is an Insider to the extent that he seeks "to terrify the beholder into a sense of reality from which he would otherwise choose to hide."

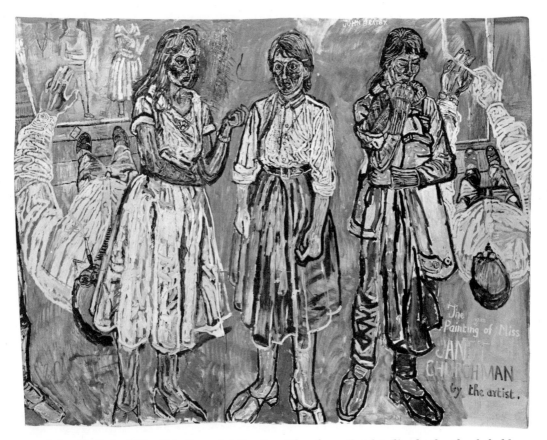

72. John Bratby's "The Painting of Miss Jan Churchman" (detail) shocks the beholder otherwise: by confronting him with the drabness of "reality." Both English artists are, of course, romanticists—Bacon focusing exclusively on the macabre, Bratby on the Bohemian, and neither having any use for formalism.

73. Octave Landuyt's "Essential Surface," an anthropomorphic maplike image in blood-red "floating" in an atmosphere of dazzling blue, has surrealist overtones. The intention, however, seems less to shock than to probe the "experienced" aspect of inanimate nature.

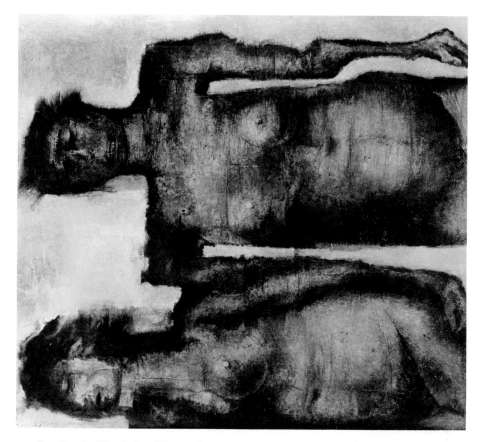

74. Landuyt's "Reclining Figures," measuring sixty-four inches by fifty-seven inches and with oil applied to the wood panel in glazes to bring out both the "lived" quality of the women's brown bodies and the fiery sea in which they are suspended, is the Belgian artist's masterpiece to date.

75. John Cage's "Score." Formalism pushed to such an extremity by overemphasis on "the new" that a composer's manuscript may offer more enjoyment than the sounds it symbolizes—and be offered for sale in an art gallery.

76. Caricature of the great modernist composer Stravinsky made in California during the early fifties by Rico Lebrun.

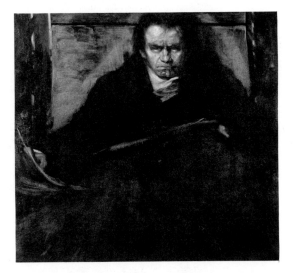

77. Early oil-portrait by Edward Steichen of Beethoven, whose scores, visually ugly and almost illegible with corrections, bear witness to the Insider's struggle to communicate human content at any cost.

# PART TWO

*The Rediscovery of Man*

# 11

## *The Forgotten Master:*
## *José Clemente Orozco*

Among artists of the twentieth century, José Clemente Orozco is the first and still the greatest of the Insiders.

Rouault is of the same stature, but after his first wild, angry declaration of the discrepancy between Christ's teachings and their perversion among Christians, he becomes involved in the French compulsion to make "rich" and uncontroversial statements. Nor did Rouault, except in the "Miserere" print cycle and in a stained glass window or two, ever work outside the psychologically inhibiting format of easel pictures destined, if not designed, for the collections of wealthy connoisseurs of "pure painting" whose morality must have clashed with his own.

Other European artists of the same generation—notably Kollwitz, Grosz and Beckmann among the German Expressionists; and later such men as Landuyt in Belgium, Moore, Bacon, and Bratby in England—share some of Orozco's characteristics. But it is not until the pioneering of such contemporary Insiders as Cuevas in Mexico and Lebrun, Baskin, and Kearns in the United States that Orozco's real contribution is recognized and begins to be influential. In Mexico, of course, Orozco has always been regarded as a giant, but for the most part out of national pride in the magnitude of his mural accomplishment. The fact that Lebrun, Baskin, and Kearns all look up to him as one of the great, if not the greatest, artists of our time is a judgment based entirely on spiritual affinity.

Equally significant has been the indifference, if not contempt, with which Orozco's work has been regarded by the dominant art world since his emergence. One may ascribe the three mural commissions he received in the United States more to the dawning of the Good Neighbor Policy (and perhaps to the fact that at the time of the WPA mural projects, "propaganda"

with a "socialist" message was briefly fashionable and artisans with a competency in true fresco were rare) than to any real sympathy with Orozco's vision. One may be sure that in the period following World War II he would have received no recognition at all. When the late Walter Pach reviewed the first book on Orozco in English,[1] it is significant that he devoted most of his space to explaining why the French do not regard this kind of art as important. The taste of the time rejects it on two counts. First, it is "negative":

We glance again at Mr. Helm's word "fire," a concept of it having been evoked by Orozco himself in his fresco of Prometheus. And I would ask whether we see that Aeschylean hero, "he who brought fire to men," as a bearer of something destructive, or something that gives warmth when we are cold, and light when we sit in darkness? Since the latter answer, the right one, is rarely suggested by Orozco's work, we are compelled to look at much of his testimony on art and life as a negative use of his unquestionable power; his arraignment of conditions proposes no remedy for the evils he denounces. . . . Such a turning (or revolution) of the wheels of art and history as was accomplished by Giotto or Rembrandt, J. L. David or Cézanne, demands positive factors.

Secondly, Pach argues, Orozco's style is based on traditions ante-dating the age of innovation-for-its-own-sake. After recognizing Orozco's links to Goya and Byzantium, the critic adds:

But mentioning Goya and the Byzantines is not altogether favorable to an artist of our time; Élie Faure, when asked about the recent mural painting of Mexico, laughed off the question with his words, "Oh, it's something between Giotto and Michelangelo," as I heard him say more than once. And his meaning was clear: that such work is essentially archaistic, a return (conscious or unconscious) to things of the past, despite its resemblance of modernity.

We should consider these two objections to Orozco's art separately and at some length because they comprise the principal objections raised by other formalist critics to all art by modern Insiders.

Orozco's art is "negative." Every age and every temperament interprets the great myths in terms of its own experience. For Aeschylus, writing at the dawn of an age of enlightenment, Prometheus was to be applauded for bringing man the means to control his own destiny but condemned for carrying his rebelliousness as far as open defiance of the gods themselves. For Orozco—who had lived through the nightmare of massacres and betrayals attendant upon a modern revolution—Prometheus was a dubious gift-bearer for other reasons. The firepower of modern weapons destroys the innocent with the guilty, involved with uninvolved. The means subvert the end, deliverers become dictators, Orozco seems to say; and his Prometheus turns appalled

---

[1] MacKinley Helm, *Man of Fire: José Clemente Orozco* (New York: Harcourt, Brace & Co., 1953). Pach's review appeared in the New York *Herald-Tribune*, August 2, 1953.

from the whirlwind he has loosed. To expect the "right" answer—meaning, presumably, gratitude to science and acceptance of things as they are—of an artist committed to man in the time of man's cruelest holocausts is to ask that the artist be insensitive to suffering. To ask, as Huntington Hartford did in a famous assault on the "ugliness" in modern art, that the artist turn his face away from the "inferno in which he has burned in effigy the normal people of this earth" is to ask for dishonesty. Rico Lebrun asked the accuser: "Who *are* the normal people of this earth? Did Greco paint them? Did Gruenewald or Bosch? Is Michelangelo's 'Last Judgment' an assemblage of normal people? I don't remember many" [2] (Plate 9). Giotto and Rembrandt, from the relative security of their Catholic and Protestant faiths, may present us with a slightly more balanced array of the forces of good and evil. But Pach's selection of David, the cynical classicist, and of Cézanne, the father of formalism, as his other two champions reveals his bias.

Pach's second charge appears, on the face of it, to be more damaging. So committed are we by the critics to the doctrine that style develops chronologically in a straight line—each artist by forced "innovation" upon the body of his predecessor "breaking through" to an innovation wholly his own—that it is very hard for us to take seriously an artist who feels his responsibility to communicable content so strongly that he may bypass the inventive preoccupations of his own age. Of course this is only partly true of Orozco, who drew heavily in his later work on the contemporary German Expressionists. But if Orozco shunned the artful studio constructions, fractured clowns, and impassive odalisques of the School of Paris for a deliberate apprenticeship in the humanist tradition of the Quattrocento fresco painters, it was not because of unfamiliarity with the former.

There was a time when I thought differently. When Tamayo told me[3] that Orozco's response to a project for a contemporary French show in Mexico City had been "Who is Picasso?" I had not believed that the question was a wholly symbolic one. The publication of recent correspondence, however, indicates that Orozco was perfectly aware of the terms of the choice. As far back as 1929 he had felt powerfully drawn to painters whose qualities ("peacefulness, goodness, purity, delight in balance and light") were not his own, even dismissing for the moment those modern masters who seem to us closer to him. Yet the choice he would soon make is implicit in the apologetic tone of his flirtation with the formalists:

Picasso . . . Drawings. Figures copied, or so it seems, from Greek vases seen in museums. . . . He disconcerts, disquiets, wounds, impresses, repulses, only to

[2] This exchange is given at length in Rodman, *The Eye of Man*.
[3] Selden Rodman, *Mexican Journal* (New York: The Devin-Adair Co., 1958), 224-25.

suddenly attract forcefully. One cannot forget him. . . . Picasso is like a glassful of water, cool, limpid, but oh! so desirable. . . .

Matisse, Derain . . . pure painting without flourishes. Grace. Natural. Joy. These are painters who dwell in a garden where their girl-friends join them for the five-o'clock tea. A drawing room with good society, good drinks and a good bed. As for us, we are the revolutionaries, the cursed ones, the hungry ones. . . . Here in New York . . . to praise anything one compares it to the French. It is most exquisite. . . .

Jacques Villon's show . . . truly beautiful: small pictures of great simplicity. Obviously they are the fruit of a milieu of which I know nothing: Paris. Nor do I know the reason why they are made that way. Doubtless behind it are many doctrines and intellectualities, but in spite of it they please me. They procure a pleasant moment, without shakes or shocks. Everything is sweet, elegant, "nice," "peaceful." Imagine that you bypass a group of girls. They are young and pretty. They smell good. You greet them. They smile. That done, you do not give them another thought.

Impressionists are increasingly hard to suffer. I agree they have a place in art *history*, but do they have any place whatsoever in *Art*? [4]

It is surely one of the ironies of the age that the only country willing to enlist the capacities of a major artist throughout his life, and with a people interested enough in art to give such an artist the inspiration of public recognition, should be "backward" Mexico.

Where else today but in Mexico could an artist of Orozco's stature have produced a body of work quantitatively so staggering yet qualitatively so independent of the propaganda purposes for which it was generally commissioned? Mexico, in the years preceding the mural renaissance of 1922, was far enough from Europe to have had a popular tradition of its own, but not too far to prevent a great artist from eventually borrowing what he needed from his peers. As a nation in the throes of a social revolution, Mexico gave its artists a sense of belonging to and working for the people—and the future. As a country of Spanish culture even its provincial schools were not insensible to the "insideness" of Greco and Goya. But above all Orozco and his vigorous colleagues were fortunate in inheriting the *humanistic* revolt against academicism which painting took in Mexico—in glaring contrast to the formalistic revolt which was still going on in the Paris of Manet, Gauguin, Seurat, Matisse and Picasso.

As a young man, Orozco attended classes at the San Carlos Academy where he learned nothing except a respect for Mexican subject-matter and, perhaps from the example of Julio Ruelas, confirmation of a taste he had already developed for pictures of bawdyhouses and the macabre. Orozco's real masters were José Guadalupe Posada and Dr. Atl.

---

[4] Jean Charlot, "Orozco in New York," *College Art Journal* (Spring, 1959).

## The Forgotten Master: Orozco

Posada was the fabulous printmaker whose fifteen thousand engravings, comparable at their best to those of Goya and Daumier and stemming from Mexican folk art, had already given Orozco his basic direction. One of the great draftsman's folk symbols was the *calavera,* or animated skeleton, which, carrying on all the sensual, comic, or brutish activities of day to day life, reminds one of their absurdity. Another of Posada's obsessions was the dishonesty of businessmen and politicians under the Francophile dictatorship of Porfirio Díaz. Orozco was never to lose Posada's sense of a vile world careening to catastrophe.

Dr. Atl, who had just returned from Italy, was the theoretical leader of the younger artists. From him Orozco gained the conviction that it was art's function to express the human conflicts of the present with all the resources of the past. The apprentice stage of Orozco's life came to a close, significantly, when his fellow students (led by Siqueiros, who actually went to jail for stoning the professors) organized a strike *in protest against a new French system for teaching children to draw abstractly.*

One reason, and a symbolic one, why Orozco stood somewhat aloof from the violent revolutionary events of 1910-1920 was that as a boy he had lost the use of his left hand and in part his eyesight as a result of an experiment with gunpowder. During the revolution when Huerta, Carranza, Villa and Obregón were betraying their followers in various ways, Orozco painted prostitutes, drunken half-breeds, and generals gambling with government funds. He even caricatured the incorruptible Zapata on the grounds, as he later stated, that "everything was the same and remained the same as before the uprising." Helm thinks that the moral burden of the years of monumental painting that followed "derived from Orozco's war-begot apprehension of the dualism of barbarity on the one side of humankind, as he knew it, and of pathos on the other. Alone among Orozco's images Jezebel escapes this tension between terror and pity. His earliest symbolic figure, she screams with laughter, the Fallen Woman Triumphant." We accept her one dimension, Helm says, "because she saved her creator from the pitfall of sentimentality, the most dangerous trap in the way of an artist with feeling."

Had Orozco continued to be so easily "saved," his art would have remained one-dimensional in the moral sense, and we would find him at best a less fantasy-ridden Bosch, at worst an angry denunciator of the order of George Grosz. As it turned out, some irrepressible faith, at once naïve and profound, in man's capacity to keep warring with his evil genius saved Orozco's art from being consistently cynical. One must search elsewhere for analogues.

Orozco resembles Michelangelo in style as well as in temperament. Like the Florentine, the Mexican was a violently unorthodox but essentially reli-

gious painter. Both artists were indifferent to landscape and nature, cavalier with color, contemptuous of decorative "taste" in adapting murals (morals!) to architecture. Both use the human body, tortured by ignoble ambition or warped by disease, as the vehicle for expressing rage and pity in the face of man's inhumanity (see Plates 8, 9).

Like Goya and Daumier, Orozco compounds feeling and farce in such a way as to avoid the sometimes pedantic tone of even so superb a "proletarian" artist as Kollwitz. Hogarth's factual caricature is surpassed, or given grandeur, by an unfailing sense that the poetry of painting must be rendered in a two-dimensional plane. In linear terms, this knowledge is apparent as early as the National Preparatory School frescoes of 1922. In terms of color, it was confirmed by Orozco's discovery of El Greco's Baroque extravagance, a revelation which took place during his trip to Europe just before the experimental Dartmouth murals of 1932. Helm thinks that on that trip Orozco may also have borrowed from the Tintoretto of San Rocco two principles he was later to put into practice in the dome of the Guadalajara Orphanage. For it was there that he first gave his figures space to move about in, without losing them "behind" the picture-plane; and it was there that they begin to take on that extraordinary "continuity" of action which in Tintoretto has been compared with Eisenstein's cinematic montage.

Like Daumier and Goya, and unlike Tintoretto and Rouault, Orozco was not himself a practising Christian. He told his sons that men have mystical potentialities which they ought to cultivate in private. But his painting is from beginning to end the record of his own search for spiritual truth in the brutal history of his time. And it was a happy accident that the oldest church in Mexico was to receive his interpretation of the Apocalypse, the final chapter of his life's work.

It was no accident at all, however, that when the Mexicans started symbolizing their revolution in paint, every one of them, including the Communist Siqueiros, fell back on traditional Christian iconography. Orozco himself painted the Virgin—and was shocked that the public considered painting her in the nude blasphemous. He had planned to include Christ in a subsequent panel, and he did paint Him many times thereafter. In one fresco Christ is destroying his cross in despair over its misuse as a symbol. In another (the Dartmouth version) Christ emerges from a landscape of tanks, howitzers, and shattered idols, axe in hand, the right fist clenched, like the Destroyer of Michelangelo's "Last Judgment," to accuse his followers of betrayal. But the images of spiritual truth that remain with us longest are those of anguish and pity: the Franciscan Father enveloping the starved Indian in his embrace;

## The Forgotten Master: Orozco

Father Hidalgo mourning among his handcuffed fellow prisoners as he writes the word LIBERTY on a scroll.

Sustained as he was by this vision of the spiritual and by the plastic example of the masters of expressive content, Orozco infrequently descends into the banalities of propaganda that occupied his colleagues. Such awkward painting as the New England scenes at Dartmouth may be traced to the simple mistake of trying to deal with material foreign to his background. Orozco's stature is revealed in two, and only two, places: in Mexico City, where the frescoes of 1922-1927 in the National Preparatory School (Plates 10, 11 and 12) measure up, at their best, to the best of Giotto and Masaccio, despite their dependence on these masters; and in Guadalajara (Plates 13-16), where in the three cycles of frescoes (1936-1939) in the Government Palace, the University Theater, and the Orphanage, Orozco finally did invent forms to match his content.

The uses of *narrative* are neglected and sorely missed in modern painting. My first reflection after visiting these masterpieces at Guadalajara was that Orozco was as fortunate as Tintoretto and Greco had been (and more fortunate than Goya) in having an accepted iconography, or "story line," to work from. Greco's and Tintoretto's story line had been the Christian mythos; Orozco's was the Mexican Revolution (1810-1920). Like them, he did not exactly "accept" his mythos, rebelling against its inconsistencies and excesses and inner corruptions as they did; yet it remained for him, as Christianity did for them, the supreme reality through which his own terrifying inner struggles could be dramatized.

Picasso is the only other modern painter whose powers of invention are as awe-inspiring, yet beside the mighty Hidalgo cycle in the Government Palace, such a cerebral symbolization of inhumanity as "Guernica" seems almost like a game with cutouts. The subject is the same—the horror and pity of war—but, whereas Picasso felt compelled to invent visual symbols related to little in the common heritage, Orozco was able to take a number of perfectly familiar historical events (familiar to the Mexicans, that is) and on that "story line" magnify the human material into images of universal significance. These images, far from losing their reality in the process, become more personal as they become more heroic.[5]

As early as 1930, when Orozco was in New York working on the mural in the New School for Social Research, he had been thrown off the track

---

[5] For detailed descriptions of the Guadalajara murals and other Orozco works, see Rodman, *Mexican Journal*. Conversations and interpretations of the artist by his close friends in Mexico are included.

(his track) by a recurrence of the mirage of an "objective" art. He had fallen prey to the theory of dynamic symmetry as expounded in the treatises of a Canadian theorist, Jay Hambidge. Hambidge had believed the relation between static and dynamic forms to be calculable, and the drawings Orozco made while persuaded of the plausibility of this fantastic theory are a key to the nonecstatic forms in the unsuccessful New York mural. Later, in Paris, he had been disturbed by an exhibition of the latest Picassos; he sensed there, perhaps, a vitality lacking in most of those travelling his way. Still later, in 1940, Orozco was deflected from one of his most expressive works, the great black-and-white wall paintings at Jiquilpan, to paint six portable panels for the Museum of Modern Art as a public demonstration of how the Mexicans painted their murals. The result, "Dive-Bomber," is probably the coldest of Orozco's works, and the explanation he wrote for the museum is as abstract and uninspired as the mural itself. Helm observes wryly that Orozco was not at home with the "subjectless object" and adds:

He had hitherto filled small left-over spaces with object (as against subject) motifs, but now he thought he would try a big object painting; he said, we know, that the six big panels could be shown in any casual order. But the formalist effort failed to come off effectively. Its content was simply not interesting enough to engage the attention. Orozco had gone to the newest of churches but he sat uneasily in a stranger's pew. He had grown up and reached his maturity in a milieu in which sound doctrine had it that painting, at least by intention, must play a useful and not merely an entertaining part in the national culture.

Almost Orozco's last work was the abstract-symbolic painting in ethyl silicate on the six-story concrete wall behind the stage of the new National Normal School in Mexico City. Work on it interrupted the painting of the "Apocalypse" and preceded an equally characteristic frieze, unfinished at the time of his death but described in effect when he wrote, "My theme is humanity, my drift is emotion, my means the real and integral representation of bodies." The huge mural abstraction, an illegible pastiche of Léger and Picasso, need only be compared with such a luminously alive late work as the "Stoning of St. Stephen" for one to be reminded where Orozco's heart lay. He had revealed it in words in a letter to a friend:

Error and exaggeration do not matter. What matters is boldness in thinking with a high-pitched voice; in speaking out about things as one feels them in the moment of speaking; in having the temerity to proclaim what one believes to be true without fear of the consequences. . . . If one were to await the possession of the absolute truth, one must be either a fool or a mute. If the creative impulse were muted, the world would then be stayed on its march.

# 12

*Metaphors for Man:*
*The Evolution of Rico Lebrun*

"If Orozco had painted at a time when the great American abstractionists, Pollock, de Kooning, Kline, had had their present widespread influence, he might have achieved that balance of form and content that characterizes the timeless works. But his visualization of his passionate ideas is tasteless, lacking in sensitivity, and so dominated by the revolutionary out-cry of his social climate, that it cannot assume the proportion of great art as we know it."

Thus wrote a young friend of mine who is an abstract-expressionist painter, in answer to my request for his recollection of a conversation with Rico Lebrun on the subject of Orozco. Was he pulling my leg? I knew that Lebrun had never shared my enthusiasm for Shahn, that for a time some years ago he had tried to reconcile his baroque style with the experimental spontaneity of the abstract expressionists, even painting in Mexico a series of nonobjective collages in an effort, as he put it, "to make the surprise of the actual monu-mental." But he had also said, "The abstract expressionists believe in the in-stinctive gesture, a thing which is as old as painting itself, but too often they abandon the object, the real world, out of which the gesture, to be significant, must grow." And I knew that Lebrun admired the Orozco of the Guadalajara Orphanage more than any other artist of our time. I sent him my friend's memory-transcription, and his reaction was instantaneous. The milder part of it follows:

If Pollock had worked with Orozco he would have understood how the whirlwind and flash can become form. . . . I said Orozco was or "appeared to be" without taste in the current trend, to the practitioners of abstract expressionism. I said that his violence was at times brutally challenged and channeled into tangible

forms which look inelegant because they are assuming a greater obligation. So he can look almost unbearably lousy with the force of conviction while the abstract expressionists can look faultless and striking with the air of men who are avoiding the "trap" of a visual world and a world of passion. So they look impeccable and he vulnerable, because he being greater (far greater) is omnivorous. The idea of Orozco going to Kline for advice and sprucing up on plastic methods is similar to that of St. Peter the fisherman reading *Field and Stream* on how to catch souls.

As far back as 1939 when Lebrun dropped his facile draftsman's pencil for the pen "which can't be erased" (Plate 17) and began to fill his sketchbooks with compulsory crosses and burning wheels, the subject of the Crucifixion had been in the back of this artist's mind. In the early forties when mechanized cavalry was crushing the bodies of free men, he had painted farm machinery in the fields, twisted in brush fires, rained on, bleeding with rust. Later, when the horrors of Belsen and Buchenwald were being revealed, he had drawn butchers at their work, blasted tree stumps and up-ended axles like tools of the torturers' trade. But the first conscious link in the chain was not forged until 1947 when the thought occurred to Lebrun that he could talk of something that *everybody* would be familiar with, a legend involving richness of pageantry and at the same time a human story symbolizing the contemporary chronicle of man's inhumanity to man. To handle the most ordinary set of symbols with the most extraordinary means became his goal.

After youthful work in the classical tradition, Lebrun had gone through a phase which, much against his will, had allied him with the neoromantic movement. He had drawn beggars on crutches. The fact that people in rags and bandages blown into frantic farewells by precision bombing should appeal as "romantic" props was significant in itself, he thought. "I imagine they recalled *The Thief of Bagdad* or the mob scenes of Hal Roach's studios to the citizens of Sunset Boulevard or the Bronx; but to me there was nothing romantic about this awful role of helplessness; contrariwise, something discouragingly ancient." With these Neapolitan figures he summed up also memories of participating as a child in the theatricalism of street marionette shows in Naples. This fluctuating world, balancing precariously between comedy and tragedy, reality and make-believe, is profoundly Italian. It is manifested in the paintings of Caravaggio and Magnasco, and it persists throughout the "Crucifixion" series, of whose sleeping soldiers Lebrun wrote: "They are animated combinations of turtle and man . . . reality treated metaphorically."

An art so ambitious and with so many antecedents could not fail to be tagged with the epithet "eclecticism," and indeed Lebrun's style of this period, with its references to the masters of Mannerism and the Baroque on the

one hand and to the Picasso of "Guernica" on the other, infuriated the purists of every persuasion. Developing his theory of simultaneity in art partly as a result of experiences gained while teaching "animation" in the Disney studios, Lebrun had reassessed his contemporaries, focusing on Picasso, Rouault, Orozco, Beckmann, as the four great "animators" whose work was seen as silencing the "prattle about pure line" and "color for its own sake." They were the end of a tradition, and those who asked to continue could not be expected to fill their shoes by the mere practice of "cosmic doodling." What Tintoretto had reached for in his "Massacre of the Innocents"—groups of figures spiraling in depth rather than frontally presented as in the early Renaissance—had been realized in the "Guernica." For Picasso synthesized in effect the "wheel-spokes" of Tintoretto's lower-right-foreground group into a *single but multiple* image. The obligation in Tintoretto to keep each figure separate was discarded in our art, Lebrun thought, because the virtuosity of getting around the dilemma by tricks of perspective and chiaroscuro had become an end in itself. Tintoretto, being a Renaissance man, could not renounce the multiplication of figures, but he could *obscure in the picture that which he wished to de-emphasize*—in his case the anthropomorphic fixture of man in the pre-Copernican world. And he did this by means of chiaroscuro, "which was not then just a technical way of illuminating an object" but a revolutionary insight into the nature of the world.

Does the "Crucifixion" series, with its figures in tortured positions, hungry, emaciated, starved for love as well as food, go back to the shock of the child's first loss, to the terror that comes from realizing that no matter how hard you may scream or kick *you may die?* As Lebrun's symbols progressed from machine to woman to mother, there was evident a recognition that the world's hunger and terror were a part of oneself (Plate 18). In the largest panel of the series the face of Christ was hidden, Lebrun said, because only so could it be taken for the face of any one of us. The ghoulish figure behind Christ represented the man "who just got involved," and so became culpable. "It could be taken as a warning to have nothing to do with that sort of action. Whenever we come to the point where no man in the nation or world can be persuaded to take such a job or fight other men, you can call this a civilized world. Because only He took that position, Christ, even in the Deposition, is alone."

It was not true, Lebrun asserted, that such questions have nothing to do with painting. "You don't make a schoolmarm of yourself by being concerned with sentiment. The sentiments are what cause the altering and transformation of forms. The forms for the occasion then evolve. The transformation of the ladder in the 'Crucifixion' from a smooth one to an awful one, one

hard to climb, is the transformation of the event graphically. The distance between one rung and the next is a psychological problem. The guy who climbed with the nails had to negotiate it. For Mondrian—I grant him that glory—the intervals are untroubled with psychological problems. They are beautifully solved problems of form and nothing more."

Lebrun dislikes comparisons, but I maneuvered him into making one more. He contrasted El Greco's simplicity with that of Georgia O'Keefe. "Greco marshals all the evidence in a complicated world before presenting his simplification." O'Keefe's simplicity was the simplicity of a "collarbone or a horse-collar." The simplification of the so-called functional architect was on the way out because the new modernists were beginning to realize that human beings need more than space and light. "They need design and curves and color and lots of other things too." Could you simplify love by cutting away all but its essence? "Our desire for simplicity, for 'triumphant solutions,' for accomplishments, for the clearcut and the wholly 'original' stems from our Puritanism. We have a fear of mud and blood. If we are to be anything," he concluded, "if we artists are to survive this period at all—which is by no means certain—we will survive as spokesmen, never again as entertainers."

To the charge that his painting at the time of the "Crucifixion" was negative or concerned with death, Lebrun answered: "I am not in love with decay. But I am in love with an object that has *experienced* some kind of existence. Perhaps in my case it has to be tragic experience. I admit the sunny greatness of Renoir, but behind *me* are the frightening, plumed cemeteries of Paolo Uccello. One must stay *with* an image long enough to be delivered of it. Only when it is transferred to the canvas can come the redemptional elements of gay color and splendor."

Everything in Lebrun's early mastery of a great tradition of configuration bore witness to a natural evolution from his Neopolitan background (Plate 19). And everything in his temperament seemed to fit him for the role of a plastic interpreter of human and even moral issues. In the Mexican collages this mastery and temperamental bias might be expressed, but they were not communicated, at least not to me. When, therefore, I visited his Los Angeles studio in 1957 for the first time in four years, I was astonished by the renewal of human content in his work. I remarked that he seemed to have emerged unscathed from his excursion into abstraction.

"I wouldn't call it an excursion," he said with a smile. "As a matter of fact it has added considerably to my means. My aim is a continuous, sustained, uncontrived image, motivated by nothing but passion." This sounded disturbingly like the aim of the abstract expressionists, but he clarified it as he went on. One must move from the particular (the gesture) to the total. This

led me to ask him whether he thought revelation of character, *particular* character, had any place in painting. There certainly was none in the two paintings he was currently working on, "Hostages" and "Buchenwald Cart" (Plate 20). He sensed a criticism—not wrongly. Certainly he was interested in revealing it, he said, though he was not prepared to yet—at least not the psychological characterization that such a painter as Goya had mastered. "Right now," he said, "I'm interested in a kind of plastic or figurative characterization, as in the cold and bewildered aspect of these three "Hostages" in the nude. I want to reveal it through a sustained pictorial handwriting related to the event—not calligraphy indulged in for its own sake."

"Of course," he went on, "once one's premise is precise, any amount of improvisation is legitimate. But you really have to look at things to present their character in paint. Right now in my life I find that I'm painting every time I walk down the street. Every gesture, every feature, every bodily movement I see becomes part of the picture or is stored away for imminent use."

I asked him whether he thought Rembrandt was interested in character in a more specific sense than this. "Yes," he replied, "but Rembrandt moved on to something more profound. He modifies a face—as Raphael did in the interests of a linear monumentality—to reach for the *pictorial character*, in his case the drama of the humble, the mystery of life itself, rather than the eccentricity or peculiarity of one particular face. He loses a face, but he gains a great image."

But Rembrandt *does not* lose a face, or any other element of human particularity, as he increases the "inwardness" of his understanding in his last portraits. Whether or not Lebrun would now concede the point, his own recent work begins to make it. In 1958, by the time he had left California for a year as artist-in-residence at Yale, he had already made a series of magnificent portrait drawings after Goya (Plate 21), retaining the "character" of the Spanish master's subjects while modifying the style to conform to his own. He was also drawing from life with a happy disregard for the "guilt" of his natural or acquired facility (Plate 23).

Baskin had already written me that the exhibition of these new paintings and drawing at the Yale Gallery was "epic, epochal and apocalyptic," and when Kearns[1] and I went to New Haven to see it, we both marveled at the degree to which Lebrun had finally freed himself from his tactical alliances. It was still a theatrical, slightly impersonal form of expression, but the passion now communicated itself freely through a richness of color and imagery that had become a unique style; it was moving rather than merely awe-in-

---

[1] Baskin and Kearns are the artists discussed in the next two chapters.

spiring. Was this because Lebrun had returned to the human image without apology? The fear of "beautiful drawing," if it had not entirely subsided, had come to terms with the necessity of fusing content and form rather than merely disguising or destroying content.

Lebrun has always been a "literary" artist in the best sense of that word so feared by modern artists—inevitably so, in view of his early engagement in metaphor and metamorphosis. His gift for words, evidenced from his very earliest creative stirring,[2] has grown correspondingly. The captions he wrote at Yale to tie the paintings and drawings together were as moving as the graphic work itself; and in this articulateness Lebrun was but following in the footsteps of such earlier Insiders as Michelangelo, Blake, and Van Gogh. If the captions began on a defensive note, one must bear in mind that at Yale Lebrun was an Insider among Outsiders. Some of his own students were confessing to the fear that if they followed his example and permitted even the shadow of a human gesture to appear in their work, the Albers-dominated faculty might refuse to graduate them. That the pedagogic formalists would regard Lebrun's forthright question to his class—"What are your *aims* in art?"—as presumptuous, outrageous, and irrelevant was as predictable as death. But the indignation Lebrun must have felt, he nevertheless controlled:

In painting as in everything else, there are the invulnerable ones and the vulnerable ones. The first pursue a dream of abstract purity; the second, in trying to express what they feel, often fall all over themselves and look ridiculous.

I am on the side of the vulnerable ones. Design is for me the speech of form, tried and altered by vicissitudes. . . .

That palsy of purity which often passes for integrity means to me a terrible lack of gameness, a refusal to look things in the face.

Because of my place of birth the image on a large scale, the ideal of wall painting, is in my blood. But by wall painting I mean tragic ornament and not ascetic linoleum. Paradoxically, the only name I can give to what I wish to do is Interior Decoration. But Interior here has another meaning, and the room, the parlor I wish to speak about is in the edifice of man.

While the figure in painting is being avoided and ignored everywhere, I feel that we have yet to explore it fully. The vertebrate marvel contains new sight for new eyes. Its terrain cannot be prefabricated by geometry, nor found through bizarre accident; it may, now and then, condescend to be measured by love.

### BUCHENWALD

Once, they said, I could draw as the bird sings. Possibly I still can. But there came a time when the image of man was so defaced that bird songs did not seem enough. If I had to lose all my virtues as a passable draftsman for the sake of

---

[2] See Rodman, *Conversations with Artists*, 33-36.

speaking truly about the unmanageable design of our condition, I would do so gladly. Talent is one thing; life another.

Bird songs indeed! And what have classical clarity and unity got to do with the dread unity of the pit at Buchenwald? At best strangers to each other, even in passion, while alive, they were now one single common body.

In working at the image I feel that I am, at least for a while, a piece of that unity. It is my form of prayer.

> *"So long as we consent to live like sheep*
> *And never mention those who disappear . . ."*—Auden

But the answer of many to this is that to mention "those who disappear" is morbid and sentimental.

Morbid is to forget. Sentimental is to make believe that this never happened or will happen again.

The fact is, when their hour struck and they were dumped into the pit, the dial of limbs marked the awful time of day. So composition is born, out of the shocked heart.

## FIGURES AND STUDIES FOR A MEMORIAL TO BUCHENWALD

I wanted to express here the idea that the human body even when disfigured by the executioner is grand in meaning.

No brutality will ever cancel this meaning. Painting may increase it by changing what is disfigured into what is transfigured.

## BUCHENWALD CHAMBER

Someone must go on remembering that this happened. The question is: In spite of the theme of death has the painting a life of its own, is the stillness alive in any way . . . ?

## STUDIES FROM GOYA

In Goya I find all that the human cage can contain of malice, lust, greed; a world of maniacs dolled up like butterflies, or the dual image to express what we all carry in us. The design has fundamentals of its own. They are unspeakable. They cannot be elucidated in the classroom. . . . They call me back when I become too chilled by the fancies of the intellect. Then I am not too worried about reducing my own "personality" to that of the pupil asking questions.

Two further "documents," both dating from the short period that intervened between the Yale exhibit and Lebrun's departure for Rome in June of 1959, will serve to round out the portrait of this great artist in his fifty-ninth year. The first, a conversation on the subject of Alec Guinness' portrayal of the Artist in the motion picture version of Joyce Cary's novel *The Horse's Mouth,* defines the position of the Insider *vis à vis* society in contrast to the Outsider, whose conception of art necessarily casts him in the defiant

role of a Bohemian philistine-baiter. While the character of Gully Jimson exaggerates to the point of caricature the typical modern artist's "outsideness," it is close enough to the truth to give the baited public a reassuring sense that *all* artists are irresponsible clowns.

"This," said Lebrun, "is what people *expect* the artist to be. When he becomes a jolly or desperate fellow, he's admitted to society. But as far as I'm concerned, I'd like to conduct the operation of being an artist on the level; and so I beg to be exempted from that role. If my work is valid, it will survive; if not, not. Was Orozco, who made no furore in the various communities in which he worked, either a jolly or a desperate fellow? And because nobody took any special notice of him, and because he adopted no poses and expected no favors from the majority of society which is *not* artists—does that make him insignificant?"

Lebrun's second testimonial came in the form of a letter elaborating (at my request) his reservations about the "old master" technique of Octave Landuyt,[3] a Belgian Insider from the city of the Van Eycks. Landuyt's subjects —metaphorical landscapes and animals, death and transfiguration, and what he calls "essential (i.e., experienced) surfaces"—were Lebrun's. But Lebrun seemed to feel that the Flemish painter was freezing a first-rate talent under an icing of masterly glazes. Asked to enlarge on this criticism in general terms, Lebrun answered:

This is my curse, that when I see certain finished statements they seem to have come too soon to a *finish*, which *is* finish, because it avoids bloody combat and concentrates on execution. Too soon, too soon, too good, too ready, lacking the intake of breath between one natal or parturient spasm and another; when the body-mind rocks bewildered asking for mercy between one stage of "finish" and another.

The configurations (*ours*, for I am now talking of all of us)—without this dread of being demolished at every step of experience—look like pictures and statuary, yes, but at what cost of truth! It is not a question of being moved by the Jewish song of hope or the Christian will to splendor, final and forever, and of using the usual form of humans at the service of this notion; this is where illustration happens. No, I repeat, it isn't simply a question of that. In my case I cannot let it go at that, not until the form is horror or splendor itself, or both if you will. Angel forms are not people with wings, but angel forms. The guts, voice, heart, sex, soul; *very hard to outline* and delineate and scarify and glaze and carve and woodcut and varnish; impossible to circumvent by skill (Christ save us from our expected skills!): and when now and then we succeed in fixing a moment between two tossings of the thing which is having such a hell of a time proving life, we *may* have a style. Anything else is literature, and of this we, our group, the Insiders

---

[3] See Chapter 20.

as you call us, should be particularly aware. . . . There is such a thing as describing your prison so that you are a man in a room with barred windows. . . . There is such another thing as describing the prison so that the confines of your body, You, as the Figure, modify it, *expanding and surpassing its confines;*—and silhouettes, chiseling and glazing are not fit for this Execution (which is the universal killing the particular).

It is fitting that "Genesis," the work Lebrun is now engaged on and his first major mural commission, should face Orozco's great "Prometheus" fresco in the Pomona College, California, refectory.

# 13

## *James Kearns: The Prodigy of the Familiar*

James Kearns, a much younger and less renowned Insider whose stature along with Leonard Baskin's seems comparable to Lebrun's, does not share Lebrun's aversion to the particular or the literary—or even to glazes, though he does not use them. For one thing, Kearns has not grown up under the overpowering shadow of the Renaissance and the Baroque, with a European's need to fight his way clear of all that is exhausted or conventional in those traditions. Luck favors him in another respect. He has never been a commercial artist; until 1960 he supported a family of six by working full time in a New Jersey arsenal, and so feels no special need to armor himself against "facility" with the defensive weapons of modernism. (I make these points neither in support of Kearns nor in derogation of Lebrun, but to account for their differing stances.) A letter from Kearns containing his observations on the same Landuyt show, as well as on exhibitions of Joan Miró and Elbert Weinberg,[1] may clarify this difference:

You were quite right about Landuyt. He is a master. A Baskin in paint, only more so—which is to say that he has Baskin's originality and intensity, *plus* a scope and tenderness that Baskin may lack. In all fairness, however, I should add that I am comparing masters; youthful masters at that. While an obvious relationship can be drawn between the two (relationship, not influence), Baskin was not the first artist to come to my mind, but rather Gruenewald. Landuyt possesses a sense of inwardness so deep (yet not obscure) that the outer world is illuminated at some point of conversion—which is your Insider credo—and Landuyt is an Insider if I ever saw one. . . .

Miró, as Emily Genauer noted, is a tragic figure. So much that is so wonderful, yet so little. He refuses so insistently to go beneath the surface.

---

[1] See Chapter 19.

## James Kearns: Prodigy of the Familiar

Weinberg's talent, authority and compassion impress me more. Yet when a man accepts, however, profoundly, a convention—religious, social, or whatever—and expresses himself in terms of that convention *uncritically*, he is not digging into the deepest layers of his existence. In fact he's being conventional. I can hear you ask: "Was Michelangelo, or is Lebrun, conventional?" And my answer is, No. Each probes his relationship *as a naked, thwarted organism* in a vast, incomprehensible space, to a particular convention, in their case the Christian-Catholic one. Weinberg has simply accepted the convention that lies behind his Jewish ritual figures without the soul-searching agonies that Mike's giants are convulsed by, or the more sophisticated, baroque, ambivalent horrors that torture Lebrun's otherwise facile line.

Among contemporary artists in America—perhaps in any country—Kearns is unique today for making his statement of expressive humanism without any stylistic palliatives. Lebrun's tangential attack is sometimes grudgingly admired by the formalist critics for its Italianate drama, "rich" color, or concession to automatism. Baskin's woodengravings, whatever the timorous may think of their subject-matter, are conceded to be unrivaled technically; and this artist's sculpture is regarded as sophisticated in its references to archaic styles even by those who call its content "academic." But Kearns exhibits none of these saving graces. His work stands or falls by the unadorned challenge of what it has to say.

Its burden—and very likely Kearns's temerity in saying anything at all—calls down the unmitigated indignation of *Art News* and *Arts*. Kearns's "dramatic paintings and sculptures," complains *Arts*, "show a social comment" and "combustiveness which are out of context with the times." How very true! "The drawings," *Art News* chimes in, "are in the 'To Arms! To Arms!' Kollwitz tradition, except that what would once have been Social Realism today is *Angst*."—As if the anxiety so fearfully reflected in the faces of some of Kearns's protagonists were his own, and as if to deny or cover up this emotion that pervades our civilization in its time of indecision and guilt were a virtue! Since Kollwitz and the early Rouault, only Orozco and perhaps the Shahn of the great war paintings have dared, as Kearns has in a succession of incomparable drawings, to strip man's image of the accumulated masquerade of classical serenity, bourgeois indifference, or proletarian pride and show him in all that defenseless nakedness still a hero.

An American of working-class background whose superior sensitivity and ideals have not inverted him nor given him any of the aggressive snobbism of the typical nonconformist, Kearns's sense of humor begins with himself. He laughs (or smiles ruefully) *with* the various victims of vanity he portrays, never *at* them. Normality, in fact, is the key to both Kearns's character and his art—and what quality today (or since the Renaissance, for that matter,

when craftsmen began to give way to little gods) seems more alien to the artist's spirit? It is reflected, without smugness, in all Kearns's attitudes. Beginning with his view of the artist's place in society:

The artist, as I see it, is not *above* others; he's merely different. He happens to be the only member of society dealing with the total human being. And he can best serve society by honestly revealing himself. Human beings react to their environment subjectively and objectively. The artist's talent focuses *both* aspects, if he's a complete artist. And by so doing he is able to communicate.[2]

More recently, in a letter, Kearns enlarged on this working hypothesis:

Truth, in a work of art, is a perfect synthesis of the subjective and objective factors that went into its composition. A work of itself is important only as a vehicle for transmitting human expressions from one human being to another. The recognition of truth by the individual is a similar synthesis of the subjective-objective aspects of his personality as stimulated by the work.

One judges a work of art for himself. If one can approach it and find it *first* compelling subjectively, and then rationalize that subjectivity with what he knows intellectually and *still* find it pithy, intense and moving on the highest levels of his understanding, then he has participated in a truth. The great work reveals its limitlessness through its direct analogy to the imponderables of life itself. But it would be unfair to the majority of the world's art not to acknowledge that half-truths, quarter-truths, etc. can be compelling, entertaining, even uplifting, endowed with meaning as far as they go.

Art *judgments*, to be complete, must occupy the attention of the whole man, that is the subjective self marshalling all the intuitive data of the subconscious, blended with the objective self that is the custodian of his consciousness.

It follows from such a demanding view of the requirements of art, that Kearns should be critical of that majority of artists throughout the ages which has been content to explore either the self *or* the world revealed to the senses. He is. Insiders, as we have seen, are a rarity in any of the arts, but their rarity does not intimidate Kearns into settling for less. If the artist's function, as he sees it, is to gain insights into the human situation, then living a well-rounded and responsible life is as much the artist's concern as developing special skills. If one is a good human being, one will become a good artist—with talent, of course. "The modern artist's isolation, his feeling that he is rejected by society, is partly his own fault. Anyway, he adds to it by being aggressive, by making huge empty pictures and indecipherable sculptures. I can't reject society—even though, no matter how hard I try to find my place, society may reject me. There are good historical reasons for the isolation of the artist. I want to talk about people in my

---

[2] Rodman, *Conversations with Artists*, 159.

work. And I want to show it, and have it bought. If I'm not communicating, I'm lost."

I asked him whom he felt he was communicating with.

"The art world happens to be the only possible audience right now—and I don't have to tell you how small a part of that little world will even look at our kind of work. But I'd like to have as many people as possible respond to what I'm saying. The first person who has to respond and like the work, though, is of course myself."

We happened to be standing beside Dubuffet's portrait of Joe Bousquet, a picture we both like, and I asked him whether it had everything he looks for.

He said it lacked Rembrandt's penetration into the complexities of character, being in that sense more a work of our time. Its excitement stems from Dubuffet's single-minded violence in annihilating bourgeois portraiture and going back to the raw, unrehearsed scribblings of children. "It impresses me with Dubuffet," Kearns said, "rather than with the man who happens to be his subject. With Rembrandt or Goya or Daumier or Rouault there occurs this synthesis of subjective and objective analysis the true Insider must have. A Wyeth portrait has it—"

"And a Titian—?"

"Rarely. Titian was a great sensualist at peace with his world and content to give voluptuous vision after vision of that relatively remote and limited nature throughout his long painting career. That's one extreme. A neurotic painter like Van Gogh, in his relentless insistence upon a single frenzied insight, is equally limited—to me. Everything Van Gogh paints is seen from that subjective angle, as everything Titian paints is imperturbably objective. The greatest artists, like Michelangelo or Rembrandt, fuse the two visions."

We turned to Mathieu's "sign" and that artist's attempt to equate the search for it with the nuclear physicists' invocation of "probability." Kearns thought that man must bring the cosmos down to human proportions. Unless he limits the means of understanding the universe to reason and the senses, "he is never going to understand anything." As for Mathieu's theory of "Signs and Their Incarnations," this appeared to be no more than "a cute way of restating the proposition of a working hypothesis." Since the "sign's" justification lies "only" in eventual incarnation, what would be the fate of a good painter given to postulating an unworkable hypothesis? "Surely there is more to art and life than the ability to make a good guess." Although it is true (and unfortunate), Kearns added, that painting has been freeing itself from the "burdensome inheritance" of an art founded on "notions of perfection" derived from the handcrafts and that the acceptance of this inheritance

may indeed be burdensome, those who reject it fail to understand that fulfillment in art is, in Degas' words, a matter of "synthesis and renewal" and not an arbitrary acceptance or rejection of ideas to establish a point.

Until very recently, lack of time, space, and money obliged Kearns to work in drawings and small cast-stone figures, rather than in painting or monumental sculpture. The drawings, which usually came in series, seemed to be sketches for larger work, swiftly executed in bold strokes of heavy black, full of motion as well as emotion, the figures often leaping or being pulled or careening across the page from deep shadow to deep shadow, or light to light. Sometimes, as in the Museum of Modern Art's "Ring," the passionately gesticulating figures seem too preoccupied with the poses they are striking to reach the center. And sometimes, as in "Processional" [3] (Plate 32), they seem too involved in collective activity to assume separate identities. Also sometimes, as in "Wheelbarrow" (Plate 25) or "Leapfrog," it is clearly the unnatural, repetitive, or forced action that the artist is crying out against. In such awesome images as "The Kiss" (Plate 24) or "Dethroned" (Plate 27), the symbol (as generally in Kearns's work) seems to have emerged out of an experimentation with observed reality rather than from any didactic intention. In the first instance, there occurred a separation of a single flattened head into two—man's agonized effort to become more than just himself possibly. In the second, the triangled highlight of the nose very likely suggested the reversed points of the crown of thorns. The self-blinding effect of the ironic coronation suggested in this simple but terrible drawing can only be compared with the image of the man in Orozco's "Trinity" (Plate 10) whose hands, clasped as if in prayer, become the very face he seeks to hide.

I asked Kearns about the genesis of his cast-stone "Minotaur" (Plate 28).

"Picasso's 'Minotaur'," he said, "has become a symbol of modern art. The old boy still has a lot of fire in him but he's growing saggy." Kearns didn't say so, but "the old boy" could be modern art as well as Picasso. "I guess," he added, "it's more a satire on Man—here and now." The jaunty pose of this creature, part-bull, part-pig, part-human, holding its long tail as if in pride of animal descent, contains just the right amount of humor to keep it from being either gross or pitiful.

Kearns's second major sculptural symbol, "Boy with Sculpture" (Plate

---

[3] Kearns's first major painting, which has the same title, was completed about a year after this drawing, at the time he gave up his job in the arsenal in January, 1960. Like the drawing it is a view of man on parade, passing by, being looked at, without any sense of its pompous self-importance, but the vain woman on the bier has given way to a corpse, perhaps an extension in time of the two women in profile that precede it, and the corpse could be taken as the lateral arms of a Cross which the crowd bears forward in its anxiety without deriving any comfort from it. The bicycle, pink cake, stilts, and the inflated carnival figure that doubles for an angel are characteristic Kearnsian images (Plate 33).

29), if less playful, is more moving. It originated when someone had criticized his work for being "negative" and "obsessed with ugliness." (Unlike most artists, Kearns welcomes criticism, especially from laymen, and tries to profit by it.) "I thought: what positive statement can I make? The idea of a boy carrying sculpture occurred to me as a symbol of purity. It also affirmed my belief in art. Then, as the work progressed, I suddenly thought: the head he is carrying could be his own when he grows old! So I eliminated the base the head originally had. Ben Shahn told me he thought 'Self-Portrait' would be a better title, but it was too late to change it in the catalogue."

"They're going to accuse you of being a literary artist," I said. "It's about the worst thing they can say about an artist these days."

"I guess I am," he said, without smiling. "I mull over ideas a lot, think of pieces in terms of words, and don't mind at all telling a story. But a visual equivalent has to be found, in terms of your medium and your material— by searching, probing."

Kearns's "Spectators" or "Seven Viewers on a Wall" (Plate 26) are no mere symbols. He saw these children once leaning against each other watching the aftermath of an automobile accident. He has seen them many times, before and after, wrapt in their various degrees of guilt. Only their together-ness may be willed. The faces, without strain or undue particularization, reflect fear, fatalism, indifference, despair, courage, compassion, resignation, exaltation. Unity is achieved, not through any of the time-worn decorative gambits of formalism, but by a complete sense of mutual absorption. The grouping, the relation of one body to another, the facial expressions do the trick. Goya might have carried it off as well.

"Spectacle," Kearns wrote me at the time he was working on a painting that grew out of this drawing, "is an odd word. I can't look at people or situations as a spectacle because the word seems to imply the existence of a detached observer. The phrase 'participating interpreter' occurred to me. A participating interpreter can hardly be a detached observer, but he may properly claim some degree of sensivity and awareness."

It is the quality that makes Kearns, potentially at least, a great portrait painter. His drawings of Rouault (Plate 30), Wyeth, Lee Bontecou, and others are unique among contemporary American efforts to revive this art, because they manage somehow to probe deeply (and sympathetically) into the character of the subject without losing sight of the picture's demand to be considered in its own right an object of imagination and beauty.

At the time Kearns was completing the very complex "Processional," he found time to sketch a series of rugged illustrations for Edward Dahlberg's autobiography, execute a monumental poster-like drawing, "The Revolu-

tionary"—catching memorably the warring idealism and self-worship in the features of Fidel Castro, and model a life-size figure in clay entitled "Blind Girl." This last work, richly sensual as well as compassionate, evolved, Kearns says, "from the idea of a Blind Voluptuary with all the connotations that it can have as a comment on today's mores. But I want it to be a specific human being too." The bunch of flowers that fill this girl's arm, like the pink cake in "Processional," may be this artist's way of saying that simple pleasures are the best, that a gesture of love weighs more than a mountain of invective, that humanity will survive.

# 14

## *Leonard Baskin: Poet of Death*

The legendary hostility Leonardo da Vinci and Michelangelo felt for each other when they met in the flesh is said to have extended as far as a total rejection of each other's work. But if Leonard Baskin might be said to resemble da Vinci in terms of the subtle elegance he aspires to with a strategy at once devious and ironic, and Kearns, Michelangelo in the bluntness of his repudiation of endearing graces, the comparison ends there. Unlike the courtly, withdrawn da Vinci, Baskin attacks the common enemy (in his case inhumanity, hypocrisy, the formalists, and all their works) with a savagery quite Michelangelesque—and far removed from the good-natured though uncompromising tolerance of Kearns.

The hostility Baskin felt for Kearns even before meeting him was tempered, when I brought them together, by an unavoidable recognition of character. But a number of drawings I had taken with me had their effect, too. Baskin continues to insist that Kearns has no talent for sculpture at all. And perhaps, if pressed, he would say that the only quality that saves the drawings from being commonplace in their lack of erudition and finesse is a sort of barbarous impulsiveness more generally associated with "primitives" like Edmondson or Pippin.

Kearns for his part has always admired the style of Baskin's drawings unequivocally. But their content bewilders him. He feels that the extremism of such images as the woodengravings of "Hydrogen Man" (Plate 35) and "Death of the Laureate" (Plate 36) are saved from being ridiculous only by the explosive intensity of their draftsmanship. Faced for the first time during our visit to Northampton with a large number of Baskin's sculptures and hearing Baskin expound a theory based on cylindrical and facial immobility, Kearns remarked afterward: "I don't take any stock in these dogmas of what art should or shouldn't be. Baskin is saved from being turned academic by them only because of his uncontrollable powers as an

artist. 'Truth to materials' was another such stultifying formula of recent vintage. Many people disapprove of Rodin's painterly approach to stone, but I don't; if it made for great surface values and textures, why should these be ruled out in favor of the more abstract ones? For that matter Baskin, like Rodin, keeps working from his drawings to his sculptures, as in the print of the howling dog that he repeats in bronze relief so effectively. But this mystique of the Timeless—well, it's contrary to my nature. It's nonexperimental. It accounts for the dull similarity of those particular sculptures Baskin prefers, with their square heads and impassive expressions—a dullness never to be found in the fluid, personal drawings."

Baskin, had he heard, would have been unmoved. The unrehearsed and at times awkward positions of Kearns's sculptural personae, their closeness to caricature, the common currency of their emotional gestures, the almost perfunctory technical means to which Kearns resorts to catch their raw vitality—these are at the opposite pole from Baskin's idea of style. Not style for its own sake—Baskin is too thoroughly an Insider to work in any direction but from content to form—but style to transmute the particular into the general, the timely into the timeless, the face (as Lebrun puts it) into an image. Above all, style to reanimate the creatures of a civilization without style, turning them consciously into artifacts endowed with so many associations of the unselfconscious past as to take their places easily *anywhere*.

True monumentality, for Baskin, is an achievement possible only in a society having an accepted communal myth. Only in times of such monolithic ideals—the Mesopotamian, Egyptian, Classical Greek, Gothic—could sculpture be conceived as much in terms of its proper spatial disposition and *use* as in terms of its intrinsic content and form. Today, he thinks, we can at best achieve an "ersatz monumentality" by subjecting ourselves (as Blake and Yeats did in the "prophetic" writings through which they labored to provide a mythic core for their poetry) to the styles and moods of the great periods. At least if we do, he thinks, we will be avoiding the boneless, nonindigenous look that sculpture acquired in periods of cross-fertilized art—the High Renaissance, the Baroque, the Modern. The sculptures that Baskin carves out of this theory are completely solid. The emotion that generates them is revealed indirectly: through layers of geologic slag, or fat, through the position of the whole piece rather than through the expression of any of its parts— whether the subject is John Donne in his winding sheet, Queen Vashti in her crown of horns (Plate 39), the obese laureate wrapped like the emperor in the nakedness of his imagined pomp, or the Pompeian sybarite whose peace with the world could be achieved only after firedeath and centuries of erosion.

## Leonard Baskin: Poet of Death

With contempt for realism on the one hand and for abstract expressionism on the other, Baskin once defined his isolated middle position as "total lack of interest in decoration." Nor did he hold it seemly, he added, "that works of art should essentially concern their author's world. I would call myself a realist in the sense of one who communicates ideas, notions, feelings and beliefs about life—every aspect of it. That this necessitates no loss of formal values, the history of art bears witness. I do not close my eyes to the great formal discoveries of the modern movement. On the contrary, my desire is to learn those lessons and complete them to my purpose. I seek enrichment for my work in the natural world, in the world of man, in art itself. If I had to characterize my prints and drawings, I'd call them didactic and moralistic and trust they have become so through the devices of what was once called 'significant form.' "

This is about as close to humility as Baskin admits. Ideologically, he defines his position more characteristically in the words *"Épater l'avant-garde!"* When diverted from time to time by the spectacle of this shock-brigade rejecting the whole history of meaningful expression in order to justify its narcissism, his pen can be quite as tipped with fire as his engraving tool. He had yet to see the antics of Tweedledum and Tweedledee contradicting each other over the "anachronism" of Kaethe Kollwitz's compassionate art,[1] but he might have been anticipating it when he wrote the foreword to the catalogue of a Kollwitz print show at Smith College:

Beyond the inept complaints that Kollwitz's work is too bitter and too terrible to experience, the larger criticism that her prints and propaganda pieces are little better than journalism merits attention. Perceiving the relatively contemporary work of Kollwitz comes as something of a shock to our sensibilities, so sharpened to little nuances by the demands of the newer painting and print-making. The Philistine of our day has acquired a new vocabulary. Where once he savored of artless insipidities and cackled virtuously over indecently decent art, he has now learned to babble an *avant-garde* prattle. The once beleaguered phrases of texture, rhythm, pattern, line, *et al.*, fall cloyingly from him and he is the same Philistine, still not seeing or experiencing. He has been seduced into accepting a fragment for the whole cloth, for works of art have been made poorer and shabbier for the excision of communicable, communal content. The singularity of subjective ambiguity has been traded for the panoply of richness on all levels that can bejewel a work of art. *Avant-garde* art is not complex, indeed it is simple-minded. Have we

---

[1] In the same month of January, 1959, and reviewing the same show, *Art News* was saying "Kollwitz . . . cared so patently about those who suffer and are ground down, what difference does it make that her ideas are like being hit with a wet sponge, her technique as trite as Boardman Robinson's, her contribution to art really a debasement?"—while *Arts*, as if to atone for the smug myopia of both publications, was shedding crocodile tears over "a genius who ranks with the greatest graphic artists . . . showing that artistic excellence can be combined with the statement of a distinct message."

become so feeble that we cannot hearken to a passage of pure color if that color exists for the further purpose of forging a symbol, an image, a fable or a wound?

Two years later, in a lecture at Yale, Baskin gave abstract expressionism the coup de grâce. Wasn't it a wonder, he asked gently, that an aesthetic "compounded of so quaint an admixture as *fin de siècle* preciousness, pre-World War I plastic adventurousness and misconstrued and misapplied philosophical notions from the Orient" should be taken so seriously? At their very best, these artists were capable of expressing sadness or joy; emotional nuances were beyond them. And as for the idea of communicating the "action" of art itself: "It is only through an act of gigantic self-deception that one can experience the meaning of the act of creation." Baskin knew very well what had happened to Lebrun at Yale, and he made a point of quoting only this artist as a prophet crying in the wilderness. "I daresay," he also added pointedly, "there is hardly a student professionally studying (if you permit so reactionary an anachronism as studying) art who has not his eyes fixed in a glassy stare on those ignominious public prints called *Arts* and *Art News*. There the fester is fostered. . . . It is man that has been excluded. It is man that has been denied."

If the Elizabethan playwright Webster "was much possessed by death," as T. S. Eliot put it, and "saw the skull beneath the skin" in a time of ebullient optimism and limited wars, Baskin surely has a right to his dark vision. The rigorous training in Talmudic lore which his father, a Brooklyn rabbi, insisted that he undergo ten hours a day, seven days a week, until his fifteenth year, might be exorcized in such a wildly satiric print as "The Cock-eyed Jew"—("Understanding the labyrinthine logic of the Talmud would make me a wonderful abstract expressionist," he once remarked, "if I didn't have other ambitions")—but the habit of confronting Death familiarly, recognizing the ephemera of mortality as self-delusion and warning the indifferent of a day of reckoning in the trumpet tones of the Prophets, must have become second-nature. Whatever more deep-seated factors of temperament and constant exposure to the sufferings of others may have contributed to Baskin's pessimism, it is not this philosophy that makes Baskin an Insider; it is rather his refusal to settle for anything less than its full projection in his work.

He is aware of the pitfalls. To be in love with Death, in the Wagnerian sense, can provoke sentimentality and "escape from life" quite as disengagingly as the hermit's retreat or the booster's club. "There's a very short distance," he says, "between the exaggeration of compassion and the indictment of inhumanity." I asked him whether this might be the reason most of the "realists" approach the human image so diffidently.

## Leonard Baskin: Poet of Death

"When I hear it objected," he answered, "that there are so few good realists today, my answer is that it's damn *difficult* to say something meaningful and original about the world you see! Picasso has lots of imitators because it's easy to imitate him. But take a man like Orozco. There is *the* great artist of our age—and who will admit it? Quite apart from what he has to say—which is *plenty*—Orozco could draw as well as Lebrun and better than Picasso."

Actually, Orozco drew with great difficulty, and it was perhaps precisely this lack of facility that kept him from either covering up his ultimate image deliberately, as Lebrun sometimes does, or succumbing to his own virtuosity —as Baskin sometimes does. In Baskin's case, the relatively few failures in drawing (and they are failures only in comparison with the successes of the masters) come from the same wilfulness that freezes some of the sculptures in a mold of excessive knowledgeability. Thus in certain drawings adapted from the old masters, or in more "finished" restatements of a successful original image that grew compulsively, the technical resources that enter into Baskin's formidable style take over. Elegance overshadows passion, and intellect, pity. But in such a drawing as the one based on Wilfred Owen's poem "Parable of the Old Men and the Young" (Plate 37), where Biblical mythology is only drawn upon to illuminate the present, all of Baskin's aesthetic resources become the handmaidens of nonaesthetic truth. Isaac, shown at the moment the angel turns him into a ram, is so suffused with the terror of the miracle and its consequences that he assumes the identity of both angel and beast. As the drawing builds up from defenseless feet and legs, past the quivering shoulders already enveloped in feathers, to the half-transposed head emerging from shadow, the viewer is prepared to look into those deep-set, smoldering eyes and receive their fearful message of unwanted transfiguration as his own. One thinks of da Vinci's "The eyes are the windows of the body's prison" and of Pasternak's reminder that "art always meditates on death and thus always creates life."

Hero worship, in the mature and literal sense of worshipping what is heroic in man, is the other side of the Insider's rage over mortality. It grows, historically, with loss of faith in the gods, but only the truly religious feel it. "We still are, and will be for a long time, condemned to heroism," says Romain Gary. Beethoven worshipped at the shrines of Goethe and Handel. Baskin's sculptural tributes to Barlach, Bresdin, Mahler (Plate 41), and Eakins fulfill the positive impulses of his genius, and only the head of his wife Esther (his only woman) expresses a deeper devotion (Plate 40).

Why does Baskin, like Kearns (and fundamentally Lebrun and Orozco, too), dispense with color? The contemporary Insider's reliance on the un-

adorned directness of drawing has its negative and positive motivations. It may betoken the most forthright protest against art-for-art's-sake, whether manifested in the Impressionist's withdrawal into irridescent nature, the aristocratic asceticism of cubism and *De Stijl*, or those most recent rejections of form itself which threaten to give us a generation without craftsmanly disciplines of any kind. More important, I think, these artists, having something to communicate about the world they live in—and in the form of such forgotten specifics for fear, mediocrity, and escape as courage, nobility, and responsibility—have chosen the most naked, most uncompromising way of saying it.

"The Black Ones," said Baskin when I asked him once how he would describe the artists I was later to call "Insiders." "Black," he added, in a subsequent letter, "has enraptured many before us. Erasmus in writing of Duerer holds him greater than Apelles, because he did 'without the blandishments of color.' Redon, too, wrote movingly and mysteriously of black, in his essay on lithography, and Rosetti said, 'Color, that coy mistress.' Black is my light, my color, because I can't imagine color adding either intensity or giving insight. Now this is true for me. Whether it is further true that black is the tonality of rage, of dissent, of violence and unmercifulness, of savagery and of an unguarded direct tenderness, one cannot say. Surely it is true that Black, which encompasses all of the colors, encompasses too all of life. Testimony of this is in the etchings of Rembrandt and Duerer and Goya and Daumier."

Baskin's latest (1960) and perhaps greatest sculpture, "Lazarus" (Plate 43), is not only entirely black, being cast thus in bronze, but it deviates—as Baskin is forever deviating, in the fierceness of his emotion—from his formula of the massive-impassive. Five years earlier he had "deviated" even more shockingly in carving out of wood Mussolini hanging upside down, transfixed with hundreds of rusted finishing nails and even (for ironless irony) an inlaid jewel or two. It did not come off well, and perhaps his distaste for the trickery involved kept him on the straight and narrow for too long. In 1958 he carved out of stone a bloated death-image, despising it almost immediately for defying the canon. "Lazarus," buried in bandages, palled in poverty, a very milestone of the flesh's humiliation yet emerging triumphant over death, testifies once more to an art that feeds on tension too passionately ever to settle for the finalities of being or becoming.

# 15

## *Draftsmen of the Double Edge:*
## *Aubrey Schwartz and Peter Paone*

Baskin's younger contemporary and disciple, Aubrey Schwartz, has been even more singleminded than Baskin in his devotion to the inexorable line. His black grip on reality seldom relaxes. His focus on the microcosm of structure is as obsessive. Yet it could be said that Schwartz speaks for all Insiders when he says, referring to his early "Crying Vendor":

I'm not concerned with how to draw a bum, or a worker coming out of a factory. I know. I was there. I'm interested in what gives with them as human beings—who they are and why; where they are going; their relationship to society and to man. Nobody really cares about these cripples in New York. This particular one is crying because I feel I have to give him consciousness of his condition.[1]

This is the opposite of the Social Realist's aim. The blind peddler may be the Insider's choice of subject precisely because he is unorganizable, unsubject to sociological or evangelical uplift, beyond "reform." He is not the victim of slum housing, juvenile delinquency, or the Oedipus complex, but of spiritual isolation and universal indifference. He is all of us.

Similarly, in the life-size pencil drawing of Poe (Plate 46) that followed several years later, the romantic poet is revealed with the utmost simplicity of means in his tortured duality. All the suppressed tenderness and love that failed to break through the invented fantasia of demons and melodramatic crimes is symbolized in the two eyes. The smoldering one has looked into Hell. And it is the measure of the artist's success that no suggestion of contrivance is conveyed by the "device" of leaving the other entirely blank.

Schwartz's tribute to the Adam and Eve of Masaccio (Plate 47) comes

---

[1] Quoted from Selden Rodman, "A Writer as Collector," *Art in America*, Vol. 46, No. 2 (1957), 29-30. This is the author's first discussion of Kearns, Baskin, and Schwartz as related Insiders.

as naturally as Baskin's to Mantegna and Lebrun's to Goya. Man is as defenseless in all the armor of his modernity as in his original nakedness, Schwartz seems to be saying; as guilty—and as dependent for redemption on love.

Peter Paone, still in his early twenties but long enough with art to have served an abstract apprenticeship and rejected it totally, is as far from Schwartz and Baskin as an Insider could be. His art is inspired very little by other art, and in this he resembles Kearns whose response to the common gesture he shares with as prodigal a fecundity. But in fixing his eye upon all that is tawdry, two-faced, and incongruous in modern life, Paone creates fantasies that rather suggest Bosch, Ensor, and the shocking dreamscapes of the surrealists.

Paone does not identify himself compassionately with the outcast and miscast as Kearns does; at least not yet. His stance is the more arrogant one of exposer, accuser, judge. Man's bumbling effort to organize for social preservation (politics) is summarized in the allegorical drawing of a statesman wrestling with his opponent over the hooded figure of a supporter and entitled "Which of the three is the more dangerous?" (Plate 48) It deals, the artist says, with the problem, "Whom can we trust?" and the answer is that all three are thieves. In a less powerful but equally frightening sketch, a willowy nude is bent backward by four inert time-servers, one a skeleton that roosts on her shoulders so thoughtlessly that the head is lost. Two versions of a painting entitled "Homage to the Supermarket" feature a corpse on the delivery counter, neatly packaged, ready for delivery; one is even labeled "Today's Special: Try Me," lest the point be missed. "Christ's Entry into Philadelphia," derived from Ensor's famous canvas, focuses on a jalopy and the clear implication that the Saviour, as an out-of-towner and obviously parked on the wrong side of the street, will be given a ticket. It is a cruel world, and its creator is frankly pessimistic about it. "Salvation," he writes me, "is a rationalization, a fantasy, a consolation to man for his lack of trust in himself and responsibility for his fellow men. I don't, like Shahn or Baskin, work for the common man. I feel he's quite satisfied with his present situation, and, if you got right down to it, would have it no other way. I'm sure that in the majority (not a small few like the 'Insiders') man has no interest in man—or in art. He must find *something* to keep him busy so he deals with technique and forgets his birthright."

The resulting world is curiously like that conjured up by Ingmar Bergman, the great Insider of the contemporary cinema—that Bergman who suffers fantasies of death, builds his images in disregard of the drama of social protest upon the nightmares of German Expressionism, and wants not faith but

knowledge as he pursues God into the darkest reaches of the heart where "death is a part of life." Like Paone, Bergman works feverishly in this search from image to image looking for what he calls "a brightly colored thread sticking out of the dark sack of the unconscious," something that will at least suggest "the reality beyond reality." Bergman has been described as having a heart of ice and, by a friend, as lacking in either "tenderness or consideration"; yet in his most recent films (*Wild Strawberries, The Magician, The Virgin Spring*) the Swedish master seems to have enlarged the search to include himself and to be saying that only lack of faith and of love make the nightmare meaningless.

Paone's painting of "The Artist" (Plate 49) may represent the beginning of a similar enlargement of perspective. The face is a mask—but with one eye focused very clearly on something outside itself. Why the enlarged hands? Could the upper one in shadow be restraining the lower from pointing its index finger too self-righteously? Paone says only that "the artist cannot afford to think of himself as solitary. He is in the midst of the rat race for survival, but solitary in his vision of it and almost alone in that he cares."

To bridge the gap between this persistent feeling of being "alone" as an artist and "caring" as a human being, Paone may learn more from some of his well-chosen heroes than from the observation of life as a tragicomic spectacle. "The men I have come to admire as the greatest artists of all time," he writes, "Piero della Francesca, Bosch, Bruegel, Rembrandt, Goya, Daumier, Redon, Ensor and Orozco derive their power directly from translation of the social environment. Theirs is a human statement of *reaction*— which is the missing element in the work of men concerned with form or method alone. Theirs (the masters') is a functional art, purpose dictating form, directing it in paths of creativity. I believe firmly that all creation springs from inner necessity, and is not merely an *act*."

# 16

## *Orozco's Heir: José Luis Cuevas*

One day early in 1960 when Paone was attending a show of some of his own work in Philadelphia, he noticed a visitor with a portfolio of drawings under his arm looking at a picture with an expression of startled recognition. Introduced to the artist but not revealing his own name, the visitor opened his portfolio, and Paone looked at the first drawing in it with an equally shocked surprise. Could this visitor, who drew a delirious gnome confronting a stolid bishop so impossibly well, be one of the American realist-fantasists Paone admired—Alton Pickens or Henry Koerner or Hyman Bloom? Surely it wasn't Tchelitchew or Dubuffet, Balthus or Bacon. . . . The visitor introduced himself. It was José Luis Cuevas, en route from Mexico to a show of his own work in New York. The recipient some months before of the first prize for drawing at the São Paulo Biennale, Cuevas was staying in Philadelphia long enough to undertake a monumental experiment in photo-offset lithography.[1]

I had "discovered" Cuevas as unexpectedly myself, the week of my arrival in the capital of Mexico in 1956, after days of looking through the art galleries in vain for some sign that the spirit of Orozco was still alive. I found it in a small lithograph of a twisted magician in a stovepipe hat, pointing with one bony finger at a ball balanced on his toe and with another at the sky.[2] Cuevas, then twenty-three, was abroad. I continued to search vainly during the remainder of my six months in Mexico for any sign that the younger generation was venturing beyond the blandishments of Paris which still smother Latin-American creativity under a second-hand blanket of formalism.

The aesthetic climate of Mexico today is bewildering. Orozco's inimitable

---

[1] Louis R. Glessman and Eugene Feldman (eds.), *The Worlds of Kafka and Cuevas* (Indian Hills, Colo.: The Falcon's Wing Press, 1960).
[2] See Rodman, *Mexican Journal*, 49. Cuevas' caricatures are included.

## Orozco's Heir: Cuevas

(and perhaps inhibiting) testimony to expressive wholeness is almost hopelessly confused with the simple-minded storytelling of Rivera and the grandiose, though undeniably inventive, propaganda posters of Siqueiros. Those who do not take out their dissent in the belated imitation of abstract modes hack their way through the political jungle blindly, mistaking the wood for the trees. Neither tendency is conducive to a clear-sighted reorientation. In a credo entitled "The Cactus Curtain: An Open Letter on Conformity in Mexican Art," [3] Cuevas disassociates himself from the pretense that the muralists speak for the illiterate peasant or worker or that they are getting through to them with their militant messages. He slays the dragon of cultural nationalism. "What I want in my country's art are broad highways leading out to the rest of the world, rather than narrow trails connecting one adobe village with the next." Cuevas goes on to pay tribute to Orozco. And he says that he approves of "many different tendencies and directions . . . free and meaningful extensions of life itself." But the question that is still unresolved in Cuevas' own work is whether, in his eager search for allies, he has been more ready to settle for what is "free" than to insist that it be also meaningful.

Up until very recently Cuevas has limited his cast of characters to monsters, butchers, clowns, and cretinous imps (Plate 50). Although they sometimes lurk in a miasma of pink or blue-gray washes, it is the nervous, marvelously sensitive line that brings them to life.

Asked by a friend [4] why he drew rather than painted, Cuevas replied: "Because drawing is more direct, like keeping a diary of every impression. I'd rather be a writer than a painter. My work *is* a diary. And I am neither denouncing nor sermonizing. I am a simple spectator. The world is a masquerade, all of it subject to satire. So I present humanity as it is, modified by circumstances."

Asked why he singled out butchers and whether his caricatures of the clergy implied a rejection of God, Cuevas answered: "The butcher is only a symbol of destructiveness; being in this guise closer to the beast in man, he could be said to represent what is sadistic and brutal in us. I condemn the clergy for being egotistical or hypocritical. But because man exists godlessly, it does not follow that I have lost faith in God; only in some of his self-styled servants."

Whether Cuevas has it in him to become an Insider in a more positive sense, acquiring the capacity to speak *for* humanity without the assumption

---

[3] *Evergreen Review*, II, No. 7 (Winter, 1959).
[4] Alton Balder, author and editor of *Six Maryland Artists* (Baltimore: Balboa Publications, 1955), who interviewed Cuevas in Baltimore at my request.

of the "artist's" inborn right to separate the sheep from the goats, remains to be seen. In his early work, as in Paone's, humility seemed to come to him only when confronted by the less denunciatory vision of the old masters. His moving variations on Mantegna's foreshortened corpses are cases in point (Plate 52).

More recently, in two series of drawings exhibited in the 1960 New York show, this search for values beyond the realm of the pathological has borne splendid fruit.

The first series is based on Van Eyck's famous wedding portrait of the Arnolfinis (Plate 53). Cuevas makes this image entirely his own without destroying either the dignity or the compassion in the original. "It was not the apparent senility of Arnolfini that appealed to my imagination," he writes, "nor the advanced state of pregnancy of his wife, nor the bed which knew their grotesque pleasures. It was, rather, the mystery emanating from the forms of these two strangers which obsessed me. . . . Does mankind fill me with loathing? Yes, but it also arouses me to pity—even tenderness."

This new emotion in Cuevas is expressed less mockingly in the "Death of a Dictator" series. A softness of modeling in the bodies of the victims carries over to the form of the oppressor himself, suggesting forgivable pretensions rather than absolute, innate malevolence. The subtle colors and contours of the settings contribute a like effect.

Cuevas' *wit* (Goya and Daumier come to mind inevitably) may be becoming inclusive. It begins to go beyond the self-exclusion of the snob which provokes only a sneer. The monster, outside of nature and therefore boring, gives way to the trafficker in debased values, aware of his own shame and absurdity. Recognizing our contemporaries, we laugh. Recognizing ourselves, if we have the courage to, we take heart from the saving grace of self-consciousness. This much a true poet always conjures up out of the most dilapidated wrecks and fatalities. It provides that necessary tension in art which Robert Frost must have had in mind when he remarked recently that, if all the misery and suffering in the world were reduced "to some irreducible minimum of one-hundredth of one per cent, I would still stick to that fraction because without it there would be no more poetry in the world."

Meanwhile, if Cuevas is willing to indulge in more than his share of the Insiders' first act of "housecleaning," who are we, in our more sterile mansions, to condemn him? To be aroused, in such a climate, to much more than contempt for the indifference of the rulers and the complacency of the ruled, would require a philosophic spirit alien to Cuevas—and perhaps to the temperament of any young artist. Balder makes the point that in modern Mexico, where rigid controls mask the conflicts of the upper level and the

lower is left outside "society" to shift for itself, Cuevas is ill at ease. "He is at his best when operating in the centers of anxiety, restlessness and tension. He prefers New York to Mexico City, New York his 'microcosm,' and he likes comparing himself temperamentally with Kafka. He feels that the farther abroad he wanders from those surroundings where neurosis and psychosis breed with a dreadful ubiquity, the less he is compelled to 'write.'"

To write as a major artist and not as a minor one with a major style, Cuevas will have to come home. Pre-Columbian Mexico (whose Nayarit figurines form part of Cuevas' stylistic vocabulary) is part of his heritage. Peasant Mexico, with its capering skeletons and candy skulls, is another. Our mortuary deceit must be as distasteful to Cuevas as it is to his friend Octavio Paz, Mexico's great contemporary poet of the alienated spirit, who writes that a "civilization denying death ends by denying life." The only thing one can predict with any confidence is that, if Mexico manages to stand up against the tidal wave of American economic-cultural penetration which presently threatens her very identity, Cuevas' art could provide the natural bridge between the Mexico of Orozco and the Mexico of a future that accepts its own image.

# 17

*The Search for Lost Content:*
*Jonah Kinigstein, Balcomb Greene,*
*and Others*

Insiders in America whose chosen form of expression is painting encounter additional hazards imposed by that art.

The early ("inside") work of Ben Shahn, Jack Levine, and Hyman Bloom is too well known to warrant extended comment in the present study, and I have discussed it at length in earlier books. Suffice to observe here that Shahn and Levine, artists with a crusading faith in working-class political idealism, encountered difficulty in maintaining effective ardor through a period when their audience's belief in the efficacy of political action (and perhaps their own as well) had subsided. As Levine's content became increasingly subtle, his pictures depended for their impact more and more on his formal ability to conjure up the painterly bravura of the Renaissance masters.

Shahn's magic had been to evoke out of cliché or commonplace whatever was most rejected, poetic, and "American" in the American scene. His thinly painted linear figures were perfectly adapted to illustrating a simple truth so long as this truth was intensely felt. But when he attempted to enlarge his witty, particularized protagonists into universal symbols, difficulties arose (Plate 58). Could a jut-jawed executive double for the Philosopher King? Or an obsequious biochemist for Faust? As in Levine's case, no amount of persistent skill could make these denizens of the urban jungle look quite at home on Mount Olympus.

What happened to Bloom is much harder to determine. A deeply mystical fervor seems to have been the operative emotion in his case, and it may

have been lost. But it is also possible that the efforts of the abstract-expressionist ideologues to claim Bloom's mysticism as a facet of their mystique influenced this great artist to "paint pictures" rather than continue exploring so passionately the terrain of the spirit.

Jonah Kinigstein, one of Bloom's younger contemporaries, has carried on Bloom's love affair with juicy pigments in the service of parables of suffering. He applies the pigments expressionistically, as Bloom used to, but not always convincingly. The subject—whether votive Virgin, concupiscent Cardinal, or mocking skeleton—gets the same "rich" treatment (Plates 55 and 56). This can be disturbing, arousing (justifiably or not) the suspicion that Kinigstein chooses his subjects, not from love or pity, but because the drama of their predicaments lends itself to corruscating panoply. Still this artist is undeniably in love with the human comedy, with life (and death) in their earthiest manifestations, and this is a good deal to be grateful for. In this respect, and because he so obviously wants to communicate his feeling for the sensuous with everyone, Kinigstein is presently a romantic.

Balcomb Greene is a different kind of romantic. Instead of working over an innately tragic image until it dissolves in the beauty of its sensuous ingredients, he begins with a perfectly objective subject and breaks it down—by fracturing it with light or with the chance relationships assumed in the manipulation of paint itself—until an image corresponding to his tragic view of the world emerges.

The hazard of this approach is that sometimes *nothing* emerges—at least nothing recognizable or communicable. Hess, who can be very perceptive about pictures when he is not trying to read transcendental meanings into them, once observed that Greene, in fighting in a picture for what he would *eliminate*, "often denies entry to elements that might bring logical solutions to its problems."[1] The massive, Rouault-like image of "Seated Woman," for example, might be more meaningful if less generalized in terms of the arbitrary play of light and shadow from which she bodies forth (Plate 57).

Greene himself, an intellectual who headed the American Abstract Artists Society in its pioneering days in the thirties, seems to recognize this dilemma. "Since 1942," he writes, "I have worked back to an *apparent* imagery or representation (my italics). . . . Man is difficult to paint because he seems to our disillusioned minds not worth presenting."

"Our"? Does Greene speak for himself? "We should have a respite from the ugly and agonized faces of people without dignity, who demand pity." But have we not been having a very long "respite" from this troubling vision

---

[1] Hess, *Abstract Painting*, 125-26.

of the common man? In fact ever since Gauguin turned the Crucifixion into a picturesque object, and Cézanne, the human face into plane geometry? "We should understand," Greene continues, "that the Christian compassion, which is the principal note in the early Rouaults, must have a terrible evolution. Essential to it is a repudiation of the flesh. Its inevitable sequel is the Pierrot or sad clown of Rouault, no longer presenting the generalized love, but man alone, without sex and without energy—in love with himself."

No, and a thousand times no! Who is to say that Rouault's early compassion "must" suffer this empty denouement? Shall every artist accept Rouault's defeat as his own? The only inevitability involved is that "generalized love" begets generalized despair. Love particularized can never be sexless—nor uncompassionate—nor "alone." Greene is generalizing from art, not from life where true art begins.[2] With the other half of his ambivalent genius he recognizes this almost immediately:

Whoever represents man, assumes a moral risk. Great art must give him more energy, and more virtue of a kind or more heroism, than we commonly find in him. The method is worn out whereby the artist follows his private style and permits the brush strokes to arrange themselves to suggest a figure, with an accidental grotesqueness which pretends seriousness. . . . A return to consciousness in the studio, to an adult and even intellectual consciousness, is the next move. The doctrine of a pure aesthetic which disdains the image of man can only be disputed from the moralist's position, by those who wish to live.[3]

Will artists like Greene take this "next step" and return to "consciousness in the studio"? Greene's most resolved images, like that of the "Seated Woman," seem to point that way.

Though Kinigstein and Greene may be romantics, and Bloom a mystic, all three are expressionists. Levine uses expressionist techniques to dramatize political fables. And even Shahn, the social symbolist, sometimes likes to make the plight of his primitivistic *dramatis personae* more poignant by placing them in an expressionist setting. Alone among major contemporary

---

[2] How far, and to what inconclusive ultimate destination the abstract expressionists have managed to carry this generalizing-from-art, is demonstrated by John Canaday, the brilliant art critic of the New York *Times*, in an analysis of Corrado Marca-Relli's painting "Pamplona." "I find it hard to believe," Canaday concludes in his column of November 1, 1959, "that in the long historical run 'Pamplona' and its kind will be of much more significant interest than descriptions we now have of eighteenth-century firework displays at Versailles. The spectacle is magnificent and in its way indicative of a special aspect of our civilization, its disruption, its excesses, its superficial color. Yet it says nothing of the values that are constant in human endeavor, human hope, and human conduct, values that have brought the world back into balance after other periods as desperate as ours. . . . The why of art has to do with humanism, 'any system or way of thought or action concerned with the interests or ideals of people.'"

[3] Quoted from a manuscript article loaned to me by the artist, entitled "The Doctrine of a Pure Aesthetic."

## The Search for Lost Content

American painters who refuse to be drawn into abstraction, Andrew Wyeth acknowledges no European influence, expressionist or otherwise, bowing only to the nineteenth century realist of Philadelphia, Thomas Eakins. Is Wyeth an Insider? Was Eakins?

Baskin is not an enthusiastic admirer of Wyeth, but he considers Eakins the greatest of American painters. A strong affinity must be felt. I am not sure that I can say why I respond less to Eakins' work than to the best pictures of Shahn, Bloom, Levine, and Wyeth. But I think my reservation has to do with the failure of so many of Eakins' pictures to look "all Eakins," in the way, for example, that all Shahns of the 1939-1949 period look "all Shahn." The typical Eakins, if one discounts an air of inimitable honesty that one may carry over from one's memory of the great pictures, could have been painted by a number of Victorian journeymen. I am not denying the depth of Eakins' penetration into character or the courage with which he rejected the easy avenues to success in a status society that recognized no other value. But Eakins' very self-imposed isolation, a stubborn Puritan decision to go it alone—blandishments be damned—with no concessions to "foreign" cookery, obliged him to conduct all his efforts to achieve style pragmatically. The boundaries within which he conducted his severe researches were too "tasteful." The "research" too often shows.

Wyeth is Eakins' heir in respect to craftsmanship and temperament. He even inhabits the same locale, a supersuburban community of very rich and gentle folk, skulling or riding to hounds—ornaments of leisure, consumers of culture. Wyeth, with the advantages of hindsight, has managed to escape that respectable "look" of Eakins' pictures, their superficial resemblance to the fashionable midcentury academicians of contrived anecdote and brown gravy. Yet in one respect Wyeth's pictures suffer in the comparison. There is a "safer," an often extremely cool, detachment in them.

True Insiders both, for offering the whole weight of their extraordinary means to the service of communicable content, Eakins is the more direct for spurning any formal subterfuge that might serve merely to camouflage the borderline between sentiment and sentimentality. Wyeth seems to succeed in avoiding the trap more consistently, but the device he uses—"magic realism," and no artist ever used it more magically—is sometimes so dazzling in the minutiae of its particles and the incredible illusion of its *trompe l'oeil* that the viewer's attention is diverted from the original emotion.

In such an ecstatic vision of nature as "River Cove" (Plate 60) does the perfection with which the trees' breathless tranquility is reflected in the still water, the undrawn meeting of sand and wave, interfere just a little with our ability to participate in the metaphor? Too perfect an illusion borders on

sterility as too great cleanliness on antisepsis. Is not something of the mystery of the dove's flight across the abandoned threshold of the spirit, in the great canvas of "Mother Archie's Church" (Plate 59), lost in the consummate calculation of cracks, camera angles, and light? Or is it the ultimate in ingratitude to ask for less than perfection from a perfectionist?

Probably so. It is the lack of poetry in Eakins that leaves his humanism sometimes earthbound. The poet in Wyeth never falters. Man may sometimes be lost sight of, but nature is always triumphant. Salute to both!

Salute to Ben Johnson, too, perhaps the modest herald of a kind of art that will revitalize the now-intellectualized formalist tradition. Johnson, happily in love with the singing rondures of the female body (Plate 61), is no intellectual. He paints the glories of the flesh in all its seasons, indoors, outdoors, relaxed, hungering, satiated. Sometimes he paints it for its pattern alone, sheathed in hot colors. Until a perceptive review of his 1959 show appeared in *Arts*, he had been doing just this for thirty years, through the white decades of abstraction, without a breath of recognition. Modigliani and Pascin had done it with more sophistication but less joy; and Matisse had left the body, drained of blood, on the cutting table.

If artists like Johnson manage to revive the fleshly sensorium of Titian and Renoir, their success will serve to remind Insiders that anguish must never be permitted to become an end in itself. The human torso, shredded by Appel, sandblasted by Golub, can become as much an object of renunciation as the squared circle and the stuffed goat.

> This flesh you break, this blood you let
> Make desolation in the vein,
> Were oat and grape
> Born of the sensual root and sap . . .
>
> We are the dark deniers, let us summon
> Death from a summer woman,
> A muscling life from lovers in their cramp . . .
> And see the pulse of summer in the ice.[4]

---

[4] Dylan Thomas, *Selected Writings* (New York: New Directions, 1946).

# 18

*Graven Dialogue:*

*Printmakers June Wayne*

*and Mauricio Lasansky*

June Wayne of Los Angeles, printmaker extraordinary and
interpreter of the metaphysical poets, is a voluptuary of a different sort.
She is in love not with the splendor of the world but with love itself. She
would call herself an Insider except that she feels that most of the artists
to whom the term applies are deficient in this quality. I asked her to define
love in terms of her own work, and this is what she wrote me:

It's an intimate thing, quiet, intense, not right for large paintings the way we
have been doing them. I would like to find a way to paint love, but will have to
work my way to it, invent a means to make it work. So far, it has been right for
drawings and lithography, because between me and the stone it is a matter of
love . . . the way it responds and resists is full of surprises, and defeats and pleas-
ures. It is intimate as an etching cannot be, because an etching takes too long to
make, and too many "things" intervene. Your hand is on the stone, and it takes
every line the way you meant it, and if it reacts as you didn't anticipate, it is be-
cause its inherent life was reacting.

The lithographs illustrating some poems of John Donne were the result of all
this . . . a falling in with someone else's reaction to the same thing though 350
years separated us . . . and this affinity would make it possible for me to do a
Kafka book too. Though not a Dylan Thomas one. . . . Much as I love Thomas'
poetry, it doesn't set me off. I can't be in the middle of it myself because I don't
enjoy the hurt-and-be-hurt thing. It just frightens me. . . .

I remember Joyce Cary once told me how, when he finally realized what he be-
lieved about the world, his writing all fell into place. I don't know whether I have
a "belief" about the world, but I have some sense about who I am, and where my
center of gravity is, and what my limits are in terms of time left for living and

working. I don't know which of my things best exemplifies the quality of love but this quality is what makes it possible to mourn and be angry, as well as be tender. Isn't this why a mother smacks her child after it has just escaped being hit by a car?

I like the way this particular aspect of love is personified in the drawing suggested by Donne's poem, "Whatever dyes, was not mixt equally" (Plate 63). The face of Intellect stares steadfast and unmoved, but not untinged by regret, as the act of love is consummated undyingly in the memory.

"Notwithstanding his complaints about ladies," writes the curator of the Los Angeles County Museum print department, introducing June Wayne's Donne cycle, "the burden of Donne's *Songs and Sonets* is for the greater extent the spiritual 'apartness' of love which he saw under the aspirational aspect of Neoplatonic mysticism. And the artist has extracted his gravity and melancholy as well, placing them against the dark and bright nebulae of an expanding firmament as his own images often reflected the far-reaching astronomical and geographical discoveries of a great exploratory age, and which caused his questioning unsettled spirit."

This spiritual "apartness" of love, conveyed so hauntingly in the art of June Wayne, may well be something every contemporary Insider recognizes and at times expresses. But the quality of romanticism is in the yielding to it, and in so far as the artist yields he is "outside." Speaking not of herself but of other artists, June Wayne once said: "To be great, one must feel pity on the mass level, and none for the individual. Otherwise, one's pity gets in the way, and one is captured and crippled." But is not the measure of the Insider's greatness the extent of his capacity to be captured *without* being crippled? Savonarola, who is said to have loved God so passionately that he had very little love left for man, may be compared to the artist who sacrifices everything for his art. Savonarola faced death courageously in defense of his other-worldly principles, but he has yet to be canonized. Many of the artists whose pictures he threw in the bonfire still give pleasure because their love for man never wavered.

Many—but not all. Some even so long ago give a different sort of pleasure, a pleasure reserved mainly for other artists. The formalist had begun to appear. By the time of Piero della Francesca's "Flagellation," Mary Mc-Carthy reminds us,[1] painting was becoming a secret language. Donatello is reported to have said to Paolo Uccello: "This perspective of yours is making you abandon the certain for the uncertain." Advances in knowledge were giving rise to an increase in doubt. Somewhere between Giotto and Michel-angelo, Miss McCarthy adds, "a terrible mistake was committed . . . a

---

[1] Mary McCarthy, *The Stones of Florence* (New York: Harcourt, Brace & Co., 1959).

mistake that had to do with power and megalomania or gigantism of the human ego."

The modern printmaker, who is committed perforce to intimacy of expression, may, in the renaissance his art has been experiencing of recent years, be helpful to tide art over a time similarly devoted to technical "breakthroughs" and gigantism. Only one of them however, Mauricio Lasansky, has developed a humanity of content commensurate with adventurousness of technique. Others—Gabor Peterdi, Jacob Landau (Plate 64), Otto Fried, Vincent Cappraro, Robert Birmelin, George Lockwood, to mention some of the best—only occasionally rise above the prodigious skill each (in the wake of Stanley William Hayter) has evolved to embellish a personal style.

Lasansky's technique is the most prodigious. His engravings from 1949 on in the "intaglio" process have revolutionized printmaking (Plate 62). They have given it, in the words of one enthusiast, for the first time in history "the potentialities of a major art." But perhaps inevitably the incredible enrichments of tone, texture, and even color thus suddenly made available have led to a very great emphasis on these qualities for their own sake.

In the beginning, Lasansky (like Hayter) was content to let the stock-in-trade of Picasso's imagery double as subject-matter. His brilliant "For An Eye An Eye" series of 1946-1948 is full of hairy satyrs, double-eyed women and X-rayed musculature. Even the familiar profile of the master's big-nosed mistress knifes the shadows. But by the time of "Vision" (1956), "Father and Son" (1958), and the Rembrandtesque "Nacimiento En Cardiel" (1959), Lasansky was on his way to letting the content of his plates dictate whatever cross-hatched distortions and velvety darknesses might be required. He had become an Insider.

June Wayne, reviewing[2] a reprint of the great suite of one hundred etchings Picasso executed for Ambroise Vollard in 1930, laments the absence of such creative patronage in the United States where, she says, "printmakers are the equals (and sometimes the superiors) of the enormously successful graphic artists of Europe who still are supported by just such editors." Such commissions would provide scope, surely, for just such epical voyages beyond the subjective limitations of the easel picture as permitted Goya, Daumier, and Orozco to communicate with mankind. Picasso himself—in this suite, in the "Guernica" cycle, and in "The Human Comedy"—goes beyond mere *art pour l'art*, having an incentive to explore and probe *the theme*:

to laugh and be sombre and tender and dignified, if he likes, because each print illuminates and completes the one that went before. In the *Suite Vollard* we see the artist with the time and space to develope his idea.

---

[2] June Wayne, *Impression* (Spring–Summer, 1958).

Until a demand for nondecorative mural painting is created once more, some such commissioning of expressive draftsmanship in the print media could offer the Insider a means of communicating with the audience his spirit seeks.

# 19

*Molders of Man:*
*From Moore and Manzu*
*to Zajac and Weinberg*

I have always felt that the reason modern sculpture suffers less than modern painting from the divorce between content and form is that the sculptors have a brand-new medium to work with. No matter how hard they try (for whatever reasons) to be abstract, the possibilities of welding metal, incorporating "found objects" in their work, turning silver, sheet metal, duralumin, fiberglass, and alabaster to account—sometimes in a single work—prove too intriguing a means of exploring life anew to be denied.

Not so the painters. Kandinsky, after all, was using exactly the same combination of paints, brushes, and canvas that a Bruegel or Titian used. And with the possibilities of illusion ruled out, the limitations of the medium become pretty rigid. To an artist dedicated to remaining *avant-garde*, the problem of carrying impressionism beyond Monet, cubism beyond Picasso, or suprematism beyond Malevich, was bound to become a "formal" problem. We have seen where it leads to.

Lots of the modern sculptors—David Smith, to cite one—are just as dedicated to art-for-art's-sake as any of the painters. But try as they will, the sculptors come out with relatively communicable images. They may deny it, but the images are there. Through the very use of their new materials, they are in such close touch with the world we all live in—the world of industry and the physical sciences, in particular—that they cannot avoid legible comments on it.

Such a new art, by its very nature, attracts a new breed of men. Ingenious, physically strong, practical men, perhaps; craftsmen, artisans, mechanics,

engineers. Is it an accident that Gonzales came out of a goldsmith's shop? Calder was trained to be an engineer. Ferber was first a dentist. Hare was a commercial color photographer. Roszak designed aircraft. De Rivera started as a machine-tool and die maker. Lippold was an industrial designer. David Smith once helped assemble Studebakers; during the war he welded armor plate on tanks.

The constructivists, Gabo and Pevsner, the fathers of space sculpture, announced in 1920 that they rejected "mass as an element in sculpture. Depth alone can express space," they said. Their abstractions of glass thread and plastic and metal-welded bronze are cold, but still exciting, because they tie up in the modern mind with such phenomena as gravitational fields of force and the wiring behind a plane's instrument panel. Similarly, Calder always happily manages to fall short of "pure" abstraction through his oblique references to models of the universe and the atom, stars in their orbits, changing nature. Lassaw's cages inevitably recall skyscraper construction or the grid plan of cities. There is a mystical quality to Lippold's wire configurations; but there is a mystery in radar receptors and television antennae too, which they vaguely suggest. And so it goes. There is almost always in this strange new world a natural clue or a practical dimension.

But we are not concerned here with timely adumbrations, peripheral humanity, or "as if." Sculpture, more than any of the arts, endlessly renews itself in man's image; refuses, in the most demanding hands, to settle for less.

In Europe, where the "abstract" possibilities of sculpture were carried to their classic and expressionist limits by Brancusi and Giacometti, two giants among the Insiders, Henry Moore and Giacomo Manzu, have demonstrated that the expansive humanism of Rodin and Lachaise, the more intensive figuration of Bourdelle and Barlach, are far from exhausted traditions.

Moore, though he experimented early in his career with a great variety of Picassoid inventions—free and open forms, cubist and surrealist fantasies, constructions with string and wire—now concedes that the great problem is how to combine sculptural form (which he defines as "primitive power") with human sensitivity and meaning. "Humanism," in his words—

the ideal of the human, survives not through the adoption of a Social Realist position but by means of an art in which the ideal, held in the mind, is fused with the overt physical manifestations of life itself.

Contrasting the range of awareness of life that is to be found in artists like Rembrandt and Michelangelo with the mere "brilliance, charm and talent" of such an Outsider as Tiepolo, Moore observes that "in the last analysis an artist like Michelangelo shows a tremendous engagement; he

was deeply concerned with the problems of life and it is this total commitment which marks him as a great artist." [1]

It is the other aspect of Michelangelo's genius, however, his youthful capitulation to Renaissance canons of classicism (what Mary McCarthy calls "the cold, vain stare of the 'David,' in love with its own strength and beauty") that has exercised a more persuasive influence. Michelangelo himself grew out of this formalism by refusing to accept the social conventions and religious dogmas of his time, by the suffering that this rejection entailed. "Pain," Bourdelle was to say four hundred years later, "is the effect of the universe in man. He who can see, suffers. And the more he sees, the more he suffers. Because in proportion as he sees beauty, it recoils."

It was natural for Bourdelle and Barlach, in the northern clime and Gothic spirit, to hold suffering sacred. In Italy this has never been easy. Classical antiquity is still such an insistent presence that it tends to dissolve in idealistic grace the most determined realism. Moreover, in Italy today the fifteen years of cultural freedom since 1945 have hardly afforded time in which an artist might assimilate the inrush of a hundred clamoring modernisms. Thus, such a gifted sculptor as Marino Marini makes interminable variations on a single neopreclassical horse and rider; while such a great one as Manzu leans on Attic serenity as if it were a prop, creating a dozen cool ballerinas, arrogant Roman hostesses, and elongated churchmen for every Christ Deposed (Plate 65) or Mussolini Hung.

In England, with no sculptural tradition at all to fall back on, the sculptor-as-Insider struggles almost frenetically against the multiplicity of outside trends.

Reg Butler, the most talented of the post-Moore generation, has broken with the forged stick-forms of his "Unknown Political Prisoner" (1954-1956) to symbolize the eroticism of woman in a series of bronzes (1956-1958) that depart very little in their thrusting expressivity from the observed potential of the human figure. It is the expressivity of the drawings for "Guernica" that one finds in these unparticularized, almost faceless, women.

Kenneth Armitage, a young member of the same generation, deals with the human figure exclusively. "Abstract sculpture, or sculpture concerning subjects other than the human image," he writes,[2] cannot hold my interest for long—it is too polite, like people who are too shy to ever take off their clothes." But Armitage's slab-like families, motionless as eroded stones and gesturing no more than their aloneness, are, as Selz remarks, "far more anonymous and impersonal" than Moore's similar groups. "Like Gregor in

---

[1] Interview with Denys Sutton in the New York *Times,* March 22, 1959.
[2] Peter Selz, *New Images of Man* (New York: Museum of Modern Art, 1959).

Kafka's *Metamorphosis* 'they signify nothing more than the absurdity of the body that the human spirit is condemned to occupy.' "

As for Moore, if many of his own sculptures suffer from a degree of rigidity and coolness, that may be ascribed to his British temperament rather than to his method. The best of his work, like the best of Manzu's have a grave presence and a tenderness that defy classification, national or temporal.

Classicism in American sculpture must be equated not with the face of Apollo, as variously defined from Pheidias to Braque, but with the machine. José de Rivera's immaculately tempered nickel rods are its purest expression. George Rickey, whose intricately balanced clusters of metal petals oscillate with the most lyrical of rhythms, defines its ethos in the formula: to make something as machine-like as possible, assuming only that it shall have no possible use. Such poets of the "found object," as Paolozzi with his totems of pressed machine parts and Stankiewicz with his assemblages of cunningly personified junk, take no risk of being interpreted as utilitarians. They disturb us with their reminders of dehumanization, but go no further.

If America's promise is to be fulfilled only when its inherited idealism becomes one with its genius for the practical, then it is clear what dimension is lacking in this kind of sculpture. We have already witnessed the search for archetypal images in the sculpture of Baskin and for fresh familiar ones in Kearns. But the revolt against the free-form welders, those Baskin calls "the do-it-yourself generation," is not confined to consistent Insiders.

Cosmo Campoli, perhaps inspired by such monstrous images as the Aztec "Coatlicue," constructs propitiatory fetishes out of skulls, breasts, interlocking limbs—hideously enlarged or pathetically dimunized. Sidney Simon, a painter-sculptor sometimes carried away by his acrobatic dexterity in both media, can come up with such an eloquent symbol of youthful innocence as his bronze "Girl" (Plate 70). Theodore Roszak, who once welded constructs of a better world along the ascetic lines of mechanization laid down by Moholy-Nagy, now forges what he calls "proto-images that cut across time." Man, though reduced to a hollow shell without flesh or blood, at least reveals through his gestures the human values he has renounced. Wolfgang Behl and Harold Tovish testify, in their dissimilar ways, to the vitality of the figurative tradition.

More consistently close to the Insider temperament are two very gifted young sculptors, Elbert Weinberg and Jack Zajac. Both have done their best work reinterpreting Biblical subjects, though there is no reason to suppose that either is a "believer" in any orthodox sense.

Zajac's "Deposition" in fiberglass for bronze casting (Plate 69), like

Weinberg's cantors and imprisoned angels (Plate 66), simply communicates the emotion of anguished alienation the more readily for its association in the viewer's mind with traditional images of devotion. Both men have passed through the crosscurrents of abstract experimentalism. But neither seems to have lost his natural capacity to express the challenges of today through a face, a limb, or even a fold of clothing.

I don't know what Zajac may have been up against in electing this path of most resistance. His miraculous "Easter Goats" (Plate 68), twisted in all the pangs of their vulnerability, suggest that he has always been close to nature. In Weinberg's case, the merciless criticism of Josef Albers and the arrogant confidence in purism implicit in the abstractions of de Rivera are said at one time to have almost disintegrated his self-confidence. The fact that he is able now to regard the work of both men with detachment may account for that very slight element of detachment in his own work which Kearns detected. He likes to quote a parable of the German Expressionist sculptor Gerhardt Marcks to the effect that art has as many landscapes as the seasons: in summer the air is filled with birds of brilliant plumage, the trees with leaves and the fields with flowers, but winter is no less beautiful for having naked black branches against a cold sky. "If I choose the summer," he says, "and see no reason to work in one consistent style or medium, or even commit the ultimate (for Albers) blasphemy of putting an armature in clay, who is to say I am wrong?"

The question might not occur to him, were Weinberg convinced in his mind that formalism is the ultimate blasphemy. In his heart, which seems to govern the protective unity of such a work as "Bridal Rite" (Plate 67), he must have made the choice.

# 20

*Insiders Abroad:*
*Francis Bacon and John Bratby;*
*Octave Landuyt*

No such stylistic tolerance as Elbert Weinberg's is detectable in the violent modes of representation practised by Francis Bacon and John Bratby in England. Bacon is a surrealist who professes to navigate in the spirit of the abstract expressionists. "Painting today," he says, "is pure intuition and luck and taking advantage of what happens when you splash the stuff down." The much younger Bratby is probably the closest painting counterpart to the "angry young men" of current British letters, those postwar status-seekers whose revolt against society parallels without meeting that of our "beatniks." Both are "Outsiders" by Colin Wilson's definition—Bratby calls himself one[1]—but "Insiders" to the extent that their work is a criticism of the world they live in, designed to be read.

The object of Bacon's macabre painting, as Andrew Ritchie says,[2] is "to terrify the beholder into a sense of reality from which he would otherwise choose to hide." The definition might apply also to Baskin, and indeed Baskin admires Bacon and appears to be influenced by him a little, as in

---

[1] Letter to the author of January 14, 1959: ". . . son of a wine-taster, 'outsider,' bullied, not part of the gang, vastly unintelligent and living in a private world . . . (now) want to paint murals, paint all the time very hard. Presumably Van Gogh, Kokoschka, Bonnard, Stanley Spencer derivative. Am recluse: hide from life, never go out—believe that it is the only way I can work full pressure. Gear everything to painting work: painting my only faith. . . . (But) painting is an expression of the character of the generation amongst whom the painter is included: the painting expresses all or some of the forces, values, standpoints, and even moral attitudes of the generation of the artist—if the artist is truly of his age and not a reversed anachronism. It is the same with all art forms." See also John Bratby's novel *Breakdown* (London: Hutchinson & Co., 1960), with illustrations by the author-artist.

[2] Andrew Ritchie, *Masters of British Painting 1800-1950* (New York: Museum of Modern Art, 1956).

his drawings and reliefs of howling dogs. But images of horror are only part of the repertoire of the American artist and are used to invoke pity or moral reproach. With Bacon, horror seems to be an end in itself, the final chapter of history gone mad, as in the "Three Studies of a Human Head" (Plate 71) where fatuousness gives way to insanity, and insanity to total disintegration. "I would like my pictures," Bacon says in a revealing sentence, "to look as if a human being had passed between them like a snail leaving a trail of the human presence and memory trace of past events, as the snail leaves its slime. . . . A picture should be a re-creation of an event rather than an illustration of an object."

Bratby's approach is quite the reverse. He illustrates the object, piling paint upon it like toothpaste, with loose, broad strokes of the brush or palette knife. The result suggests Van Gogh, but superficially; Bratby is less interested in revealing his emotional anxiety or bringing it to bear sympathetically on the torment of his subjects than in arresting their boredom and purposelessness, and in transfiguring these into a frieze of hieratic permanence. How well he succeeds can be seen in that most Byzantine of his near murals, "The Painting of Miss Jan Churchman" (Plate 72). Best known in America for his stand-ins for the film version of Joyce Cary's *The Horse's Mouth*— which shows him at his worst—Bratby at his best succeeds in conveying the raffish but unpretentious everyday life of his generation with an energy not untouched by affection.

Manifestations of the Insider temperament in France are rare. The triumphs of formalism, with its encouragement to nonhumanistic experimentation, have tended to discourage all but the most desperate nonconformists. Balthus' "inside" world of disturbed adolescents has remained static and without issue, "disturbing" rather than challenging like a portentous dream that refuses to divulge its meaning. The once nervously bristling line with which Bernard Buffet enclosed his attenuated manikins of poverty quickly froze into the most modish of formulas, as Buffet became the victim of his own success.

Only in bypassed Ghent, Belgium, where the Van Eycks painted with passionate exactitude the highlights of a thousand humble objects to prove the omnipresence of God, has a painter come forward with humility enough to subordinate the glories of master-craftsmanship to an expression of inner truth. "Mystery without dream," Octave Landuyt's morphological world has been called; and if the phrase serves to remove him wholly from the world of the surrealists, he may come to be thankful for it. The surrealist magnifies and distorts detail to prove that the world of common beauty exists only in

the sick eye, that innocent response is self-delusion. Landuyt is testifying to the *continuity of matter*, not to its indeterminacy or irrelevance; to the persistence of spiritual or humane values, rather than to the prevalence of the accidental or the necessity of the irrational.

Even so brilliant a surrealist painter as Matta, who considers himself a humanist,[3] gives an impression of superficiality by merely grouping his autonomist images in such a way as to suggest a pitched battle between the forces of light and darkness, the tyranny of the machine, the creative self-regeneration of the atom, etc. The pattern of ideas appears to be superimposed on the unfathomable data of the subconscious rather than to grow out of it. Landuyt, on the other hand, seems to be saying in his more pedestrian vocabulary that the accumulated evidence of the astronomers, physicists, and Freudian psychologists is as nothing in the face of what the senses reveal when guided by the heart.

Animal, human, plant are fused in Landuyt's "Essential Surface" (Plate 73) to reveal their living identity. "The complex surface," as Emily Genauer well observed, "the color as lustrous and transparent as rubies (or blood, if you will) is no technical fireworks but a symbolic skin containing the mysteries of life and death."[4] The red center of this picture, surrounded by electric blue, is neither the pitted landscape of the moon nor a flayed head nor the anatomy of a single cell; it is all of these.

The almost visibly "working" flesh of Landuyt's "Reclining Figures" (Plate 74) floats in a glazed sea of fire (blood). This could be the artist's way of saying that nothing should be considered lost. These noble, ravaged women could be early martyrs of the Church, innocents in the ovens of Auschwitz, peasants who became part of their red loam. Whoever they are, every particle of the flesh in death testifies to a lived experience and seems to cry out, "This aspect of me survives forever."

"This is my adventure," Landuyt writes me of his work as a whole, "—an adventure that shall not end." And he continues, more obliquely:

The concern to make a "work of art" in thirty years of work has disappeared. The Negro who sculpts a fetish does not make an image but a fetish; a problem of form may not be a problem any longer.

To be able to "go it" pictorially, to be able to creep through the eye of a needle, —or through the eye of a dog, or through the eye of anything, in order to try to represent an object which is evidence of an intense experience.

To take risks with beauty in order to create an essential surface, evidence for

---

[3] "The artist's function," he once told me, "is to understand human relations. When religion was the center of things, we painted Christ and Buddha. Now we paint terrestrial—and public—relations."

[4] New York *Herald-Tribune*, April 19, 1959.

the prosecution in a trial where the truest elements of the human being are at stake. The stripping naked of an over-civilization.

Kearns, reading this statement by the painter he admires, asked to be allowed to "quibble" over the last two words of it:

My attitudes disclaim that there is any such thing as over-civilization. Foul, inept, appalling, indifferent perhaps, but not *over*. Civilizations are a social refinement essential to man. Their failures, when they fail, may be ascribed to man's inability to cope with his own complex needs. The word "over" has implications of a romantic yearning for lost truths. But though the statement as a whole relates to the mood of Landuyt's work—solemn, intense, a bit static—I could quibble endlessly with everything in it but its honesty, its humanity and its obvious poetic conviction. What else matters?

# Illustration Credits

| PLATE | TITLE | DATE | MEDIUM | ARTIST | COLLECTION |
|---|---|---|---|---|---|
| 1 | "Sign" | 1957 | Oil | Georges Mathieu | The Author |
| 2 | "Transverse" | 1957-58 | Oil | Jack Tworkov | Ben Heller |
| 3 | "Cathedra" | 1951 | Oil | Barnett Newman | The Artist |
| 4 | "Paname" | 1957 | Oil | Ellsworth Kelly | Richard Kelly |
| 5 | "Monogram" | 1959 | Combine | Robert Rauschenberg | The Artist |
| 6 | "Madonna of Port Lligat" | 1949 | Oil | Salvador Dali | Marquette University Collection |
| 7 | "Sainte Entouré de Trois Pi-mesons" | 1956 | Oil | Salvador Dali | Salvador Dali, Courtesy Carstairs Gallery |
| 8 | Detail from "The Last Judgment" | c.1541 | Fresco | Michelangelo | Sistine Chapel |
| 9 | Detail from "The Last Judgment" | c.1541 | Fresco | Michelangelo | Sistine Chapel |
| 10 | "The Trinity" (detail) | 1924 | Fresco | José Clemente Orozco | National Preparatory School, Mexico |
| 11 | "Mother's Farewell" | 1922 | Fresco | José Clemente Orozco | National Preparatory School, Mexico |
| 12 | "Study for National Preparatory School Fresco" | 1922 | Pencil | José Clemente Orozco | The Author |
| 13 | "Starvation" (detail) | c.1937 | Fresco | José Clemente Orozco | University, Guadalajara |
| 14 | "Shadowy Forces" | c.1937 | Fresco | José Clemente Orozco | Government Palace at Guadalajara |
| 15 | "The Circus" | c.1937 | Fresco | José Clemente Orozco | Government Palace at Guadalajara |

# Illustration Credits

| PLATE | TITLE | DATE | MEDIUM | ARTIST | COLLECTION |
|---|---|---|---|---|---|
| 16 | "The Wind" (detail) | 1939 | Fresco | José Clemente Orozco | Orphanage Dome, Guadalajara |
| 17 | "Heads" (study) | c.1939 | Pen | Rico Lebrun | The Artist |
| 18 | "Mary" | c.1950 | Pen | Rico Lebrun | James Kearns |
| 19 | "Sleeping Soldier" | c.1951 | Oil | Rico Lebrun | The Artist |
| 20 | "Study for Buchenwald Cart" | 1956 | Oil | Rico Lebrun | The Author |
| 21 | "Goya's Royal Family" | 1958 | Mixed | Rico Lebrun | Mr. and Mrs. Joel Grey |
| 22 | "Study for Dachau Chamber" | 1959 | Oil | Rico Lebrun | The Artist, Courtesy Albert Landry Gallery |
| 23 | "Study of a Woman" | 1959 | Pen, Charcoal | Rico Lebrun | The Author |
| 24 | "The Kiss" | 1958 | Wash | James Kearns | Gallery G |
| 25 | "Wheelbarrow" | 1958 | Conte | James Kearns | Gallery G |
| 26 | "Seven Viewers on a Wall" | 1957 | Charcoal | James Kearns | The Author |
| 27 | "Dethroned" | 1959 | Conte | James Kearns | Barbara Head |
| 28 | "Minotaur" | 1956 | Cast Stone | James Kearns | Barbara Holland |
| 29 | "Boy with Sculpture" | 1956 | Cast Stone | James Kearns | The Author |
| 30 | "Georges Rouault" | 1958 | Charcoal | James Kearns | Dr. and Mrs. Seymour Lifschutz |
| 31 | "Picasso" | 1960 | Oil | James Kearns | Private Collection |
| 32 | "Study for Processional" | 1958 | Conte | James Kearns | Gallery G |
| 33 | "Processional" | 1959 | Oil | James Kearns | Sumner Foundation |
| 34 | "Mid-Century Dirge" | 1954 | Pen | Leonard Baskin | Borgenicht Gallery |
| 35 | "Hydrogen Man" | 1956 | Woodcut | Leonard Baskin | Borgenicht Gallery |
| 36 | "Death of the Laureate" | 1958 | Wood Engraving | Leonard Baskin | Borgenicht Gallery |
| 37 | "Isaac" (detail) | 1956 | Pen | Leonard Baskin | The Author |
| 38 | "Man with Dead Bird" (detail) | 1956 | Wood | Leonard Baskin | Museum of Modern Art |
| 39 | "Queen Vashti" | 1957 | Bronze | Leonard Baskin | Richard Sisson |
| 40 | "Esther" | 1956 | Bronze | Leonard Baskin | Esther Baskin |

| PLATE | TITLE | DATE | MEDIUM | ARTIST | COLLECTION |
|---|---|---|---|---|---|
| 41 | "Homage to Gustav Mahler" | 1958 | Bronze | Leonard Baskin | Borgenicht Gallery |
| 42 | "Glutted Death" | 1959 | Bronze | Leonard Baskin | Peter Paone |
| 43 | "Lazarus" | 1960 | Bronze | Leonard Baskin | Lawrence Bloedel |
| 44 | "Image" | 1959 | Ink | Nicol Allan | Private Collection, Courtesy Cober Gallery |
| 45 | "Old Lady Sleeping" | 1958 | Pen | Bessie Boris | Private Collection, Courtesy Cober Gallery |
| 46 | "Poe" | 1959 | Pencil | Aubrey Schwartz | The Author |
| 47 | "Adam and Eve" | 1959 | Ink | Aubrey Schwartz | Gallery G |
| 48 | "Which of the three is the more dangerous . . . ?" | 1960 | Charcoal | Peter Paone | The Author |
| 49 | "The Artist" | 1960 | Oil | Peter Paone | Private Collection, Courtesy Gallery G |
| 50 | "Madman" | 1954 | Ink | José Luis Cuevas | Gardel Collection, Brazil |
| 51 | "Gentlemen of Frans Hals" | 1956 | Gouache | José Luis Cuevas | Private Collection, Venezuela |
| 52 | "Cadaver" | 1953 | Ink | José Luis Cuevas | A. Carillo Gil, Mexico City |
| 53 | "Arnolfini Marriage No. 1" | 1960 | Wash | José Luis Cuevas | The Author, Courtesy David Herbert Gallery |
| 54 | "Bishop and Prostitute" | 1960 | Wash | José Luis Cuevas | Mr. and Mrs. Douglas McKelvy |
| 55 | "Madonna" | 1958 | Oil | Jonah Kingstein | The Artist |
| 56 | "Calavera" | 1958 | Oil | Jonah Kingstein | The Artist |
| 57 | "Seated Woman" | 1954 | Oil | Balcomb Greene | The Author |
| 58 | "Poem of Ecstasy" | 1958 | Tempera | Ben Shahn | Downtown Gallery |
| 59 | "Mother Archie's Church" | 1950 | Oil | Andrew Wyeth | Addison Gallery of American Art |
| 60 | "River Cove" | 1958 | Tempera | Andrew Wyeth | Private Collection |
| 61 | "Nude Bather" | 1959 | Oil | Ben Johnson | Cober Gallery |
| 62 | "España" | 1956 | Engraving | Mauricio Lasansky | The Contemporaries |
| 63 | "Whatever dyes was not mixt equally" | 1958 | Pen | June Wayne | The Artist |
| 64 | "Status Quo Ante" | 1959 | Woodcut | Jacob Landau | Philadelphia Museum of Art |
| 65 | "Descent from the Cross" | 1955-56 | Bronze | Giacomo Manzu | World House |

| PLATE | TITLE | DATE | MEDIUM | ARTIST | COLLECTION |
|---|---|---|---|---|---|
| 66 | "Captive Angel" | 1958 | Wood | Elbert Weinberg | Wadsworth Athenium, Hartford |
| 67 | "Bridal Rite" | 1959 | Bronze | Elbert Weinberg | The Author |
| 68 | "Easter Goat I" | 1959 | Bronze | Jack Zajac | Museum of Modern Art |
| 69 | "Deposition" | 1958 | Fiber-glass | Jack Zajac | Downtown Gallery |
| 70 | "Girl" | 1958 | Ceramic | Sidney Simon | The Author |
| 71 | "Three Studies of the Human Head" | 1953 | Oil | Francis Bacon | J. Bomford |
| 72 | "The Painting of Miss Jan Church-man" (detail) | 1958 | Oil | John Bratby | The Artist |
| 73 | "Essential Surface" | 1958 | Oil | Octave Landuyt | Albert Landry Gallery |
| 74 | "Reclining Figures" | 1958 | Oil | Octave Landuyt | The Author |
| 75 | "Score" | 1958 | Pen | John Cage | Jasper Johns |
| 76 | "Stravinsky" | 1952 | Charcoal | Rico Lebrun | The Author |
| 77 | "Beethoven" | 1902 | Oil | Edward Steichen | Museum of Modern Art |

# Index

# Index